C000252838

THE NATURAL BEAUTY
OF
DORSET

You may also like

The Natural Beauty of Cornwall
A Portrait of the Surrey Hills
Chichester Harbour: England's Coastal Gem
The North Wessex Downs

THE NATURAL BEAUTY
OF
DORSET

COLIN & SUSY VARNDELL

ROBERT HALE • LONDON

© Colin and Susy Varndell 2014
First published in Great Britain 2014

ISBN 978-0-7198-0930-9

Robert Hale Limited
Clerkenwell House
Clerkenwell Green
London EC1R 0HT

www.halebooks.com

The right of Colin and Susy Varndell to be identified as
authors of this work has been asserted by them
in accordance with the Copyright, Designs and
Patents Act 1988

All images herein © Colin Varndell 2014

A catalogue record for this book is available from the British Library

10 9 8 7 6 5 4 3 2 1

Typeset by Dave Jones
Printed in India by Imprint Digital Limited

Contents

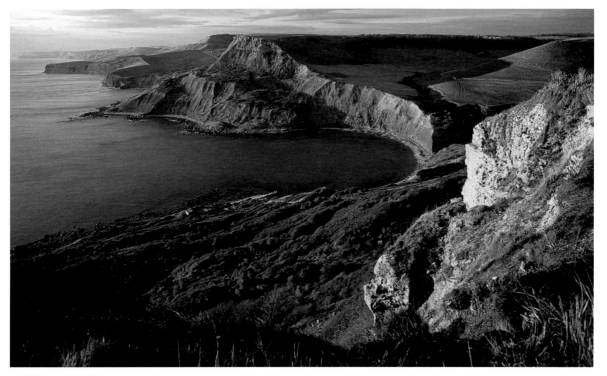

▲ Chapman's Pool.

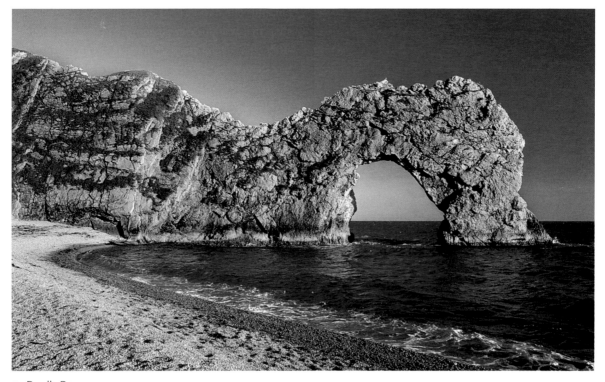

▲ Durdle Dor.

Acknowledgements

The authors wish to thank the following for their kind assistance in helping to produce this book:

Sue Dampney for all her help with the AONB information and maps, and for checking the introduction.

Glen Bishop and Rodney Varndell, for reading the chapter on geology and for making essential suggestions for accuracy of both content and grammar.

Robert, Jim and Andy for each agreeing to be interviewed for current farming opinion.

RSPB Arne reserve warden for help with the smooth snake photos.

Dorset AONB **www.dorsetaonb.org.uk**

Cranborne Chase & West Wilts Downs AONB
www.ccwwdaonb.org.uk

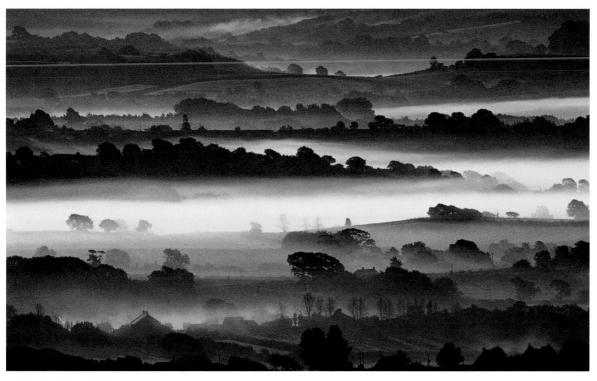

▲ The Marshwood Vale.

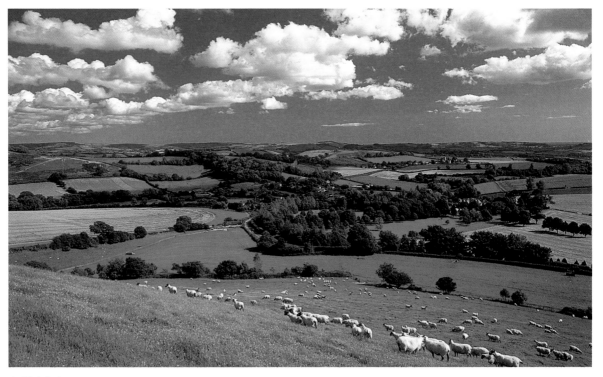

▲ Melplash.

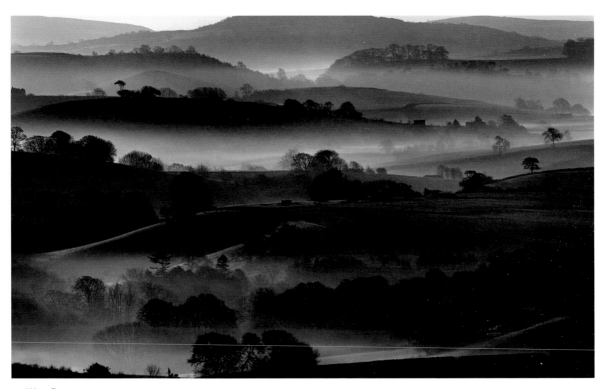

▲ West Dorset.

Introduction

There is only one way to connect with the county of Dorset, and that is on foot – possibly on horseback, maybe on a bike – but primarily on foot. No other way will allow you to explore what Dorset is really like or show you what it was like decades, hundreds or even thousands of years ago. There is nothing that can describe the magic of connecting with what life would have been like pre-mechanization, how hard and tough but real.

Dorset is steeped in history, both man-made and Earth-formed. There are many clues to its past in the landscape we see today. Some of these clues raise innumerable questions, which cannot be answered, while others lead to obvious conclusions. The evidence of geological history on show here is second to none – worldwide. This vast range of geology translates to an equally diverse and beautiful landscape inland.

Dorset is an enchanting county, just over half of which rightly holds the prestige of being an Area of Outstanding Natural Beauty (AONB), which is a protected landscape of national importance. The Dorset AONB covers 1,129 km², making it the fifth largest AONB in the country. The Cranborne Chase and West Wilts Downs AONB covers the remaining ten per cent of Dorset's protected area.

AONBs are designated for their fine quality of landscape, but in addition to the visual appearance of the landscape, its natural beauty, including its flora, fauna, geological and physiographical features, is taken into careful consideration. The combination of these elements together with cultural and historic associations give an area a unique sense of place, enhancing its inhabitants' quality of life.

The Dorset AONB supports a rich historical heritage, seen in the landscape, which has been moulded by human activity for thousands of years. Iron Age hill forts, ancient burial sites, prehistoric barrows and henges, field and settlement patterns with associated hedges, banks and stone walls, literally litter the landscape and give us a tantalising glimpse of the past. The Dorset AONB holds many secrets in its landscape, including numerous monuments, the origin of which may date back thousands of years.

The South Dorset Ridgeway, for example, has been described as 'the land time didn't forget'. It is a ridge of high ground that runs from Osmington to West Bexington and has been an important place for people since Neolithic times (4,000–2,000 BC). There are thousands of prehistoric monuments and earthworks along this dramatic ridgeway, making its importance as an ancient ceremonial landscape unrivalled in Britain.

As custodians of this living landscape, it is our responsibility to enhance it and maintain Dorset's unique character for future generations. Unlike the generations that have gone before us, who did not have the ability to destroy and demolish so quickly and completely, we are in a perilous position of control – able either to annihilate or to contribute to the enrichment of what was left for us.

The natural heritage of the AONB is a huge asset to the county, its inhabitants and visitors alike. It boasts many wildlife sites of international importance including the lowland heaths, Poole Harbour, the Jurassic Coast and the ten-kilometre square near Wareham with the greatest diversity of plant species in Britain.

The wildlife habitats within these landscapes support a remarkable range of species, which include ninety per cent of British bird species and eighty per cent of both mammal and butterfly species. Seventy-five per cent of

the county has some kind of environmental designation and is home to around three quarters of Britain's mammal, bird, reptile and butterfly species, which is an indication of the importance of the county nationally, and in some cases internationally. Due to Dorset's southerly location, the AONB is blessed with a relatively warm climate, enabling many species to thrive here that would not survive further north.

Dorset's diversity is one of its greatest charms. Its long savage coastline boasts inhospitable, angry cliffs, wild headlands and rocky outcrops. Desolate Chesil Beach with its miles of stones and pebbles waits menacingly and patiently, dangerous for man yet ideal for gulls, the wind and other wildlife. In contrast, Dorset also has a selection of some of the finest and safest sandy beaches to be found in the British Isles. The coastline within the Dorset AONB is internationally famous for its spectacular scenery and geological interest. From Lyme Regis to Old Harry Rocks there is an almost continuous sequence of unique coastal features including such places as Golden Cap, the Fleet Lagoon, Worbarrow Bay, Kimmeridge, Lulworth and Old Harry and his Wife. The international geological importance of this stretch of coast, together with that of East Devon, is reflected in its designation as the only natural UNESCO World Heritage Site in England.

Inland the landscape appears gentler with hills disap-pearing into secretive steep valleys, sheep grazing vast areas of chalk grassland and cows peacefully munching on the rich buttercup meadows, lumbering unperturbed. Smooth and ancient hills, rounded against the sky, remind the observer that this is an ancient landscape where relatively little has changed over the recent centuries.

Manor houses and villages help to create a cosy, domesticated appearance, with unhurried streams meandering through the countryside and lanes wandering from village to village in an apparently random, untidy and unhurried fashion.

The Dorset AONB is made up of an assemblage of attractive landscapes, each with its own distinctive attributes, which may be ancient woodland, high hills, chalk downland, ridgeways or clay vales. Frequently, such characteristics are found to be interconnected, resulting in an impressive expanse of magnificent countryside, much of which is unique in Britain.

This astounding variety of landscapes, both natural and man-made, provide the observer with a view of the past in what one sees in the present. Through the large network of footpaths and bridleways (which have more mileage than the roads in Dorset) one can explore and feel connected with the nourishing and uplifting power of the landscape as well as increasing one's understanding of the county itself.

Introduction to Dorset's Geology

The wide range of landscape formations in Dorset is unique amongst the English counties. There are striking disparities between the various scenic characteristics across the county. The large, rounded hills of the north contrast sharply with the wild moors of the Poole basin. The gentle, undulating hills and wooded valleys of west Dorset come to an abrupt end at the magnificent Jurassic coastline. Coming to terms with what happened here to forge this landscape is not easy, as there are unimaginable stretches of time to comprehend. At one time, Dorset formed part of a large landmass south of the equator, but over many millions of years this moved northward due to the collision of plates. Over time, jostling plates and earthquakes combined forces to form the hills, valleys and moorlands of the Dorset we see today.

The landscape here was therefore moved and shifted, heaved and warped for millions of years, long before humans ever walked here. Even when Dorset had settled in its current location, the landscape continued to

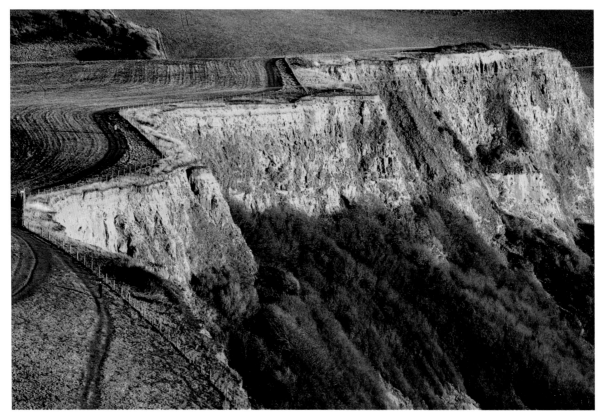

▲ Cliffs of Thorncombe Sands, east of Thorncombe Beacon on the west Dorset coast.

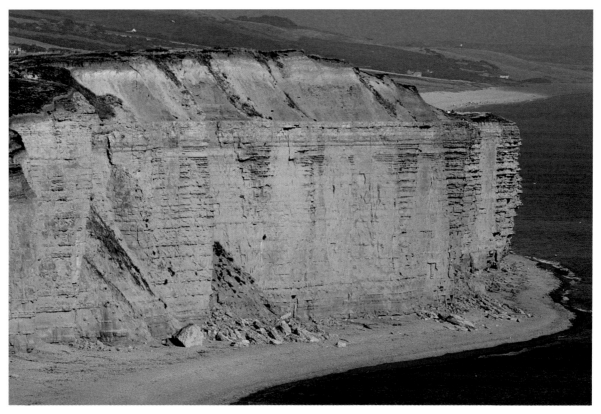

▲ Burton Cliff, west Dorset, displaying alternate bands of hard and soft Bridport sandstone rock.

be fashioned by the continual process of erosion and the effects of a series of ice ages.

Geology is largely the study of rocks and the development of the Earth's crust, but most of this evidence is hidden from us far beneath the ground. Even the geology near to the surface is covered in vegetation or towns and villages. Inland it is only where significant excavations are made or when bore holes are driven deep into the Earth's crust that the layers of rock which formed at various times during the Earth's evolution can be studied. At the coast though, it is possible to study and read the clues of what took place here in the far distant history, even up to hundreds of millions of years ago. It is here on the coast that weather and sea have joined forces to slice away the landscape, revealing a cross section of the Triassic, Jurassic and Cretaceous periods of Dorset's history.

In terms of geological study, the Dorset coast is regarded as an important location worldwide. The earth movements which buckled, folded and crumpled the landscape have provided a unique insight into the geological history of the county. It is only here that geological evidence spanning some 165 million years can be seen up close. Nowhere else on this island or indeed in Europe, and possibly even the world, is such a timeline laid out in historical sequence, and all of it within an Area of Outstanding Natural Beauty.

In Dorset, the strata comprises sedimentary rocks which were mainly deposited in marine, freshwater and terrestrial environments. These layers of rock were laid down as sediment in oceans and floods or in rivers and deltas. It is common knowledge that ponds that are fed by streams silt up, so it is not difficult to imagine this same process happening in seas, rivers or lagoons over vast stretches of time to ultimately create rocks. Sediment forms in layers from sand, silt, mud, and organic debris. As the thickness and therefore the weight increases, the layers of sediment become compressed

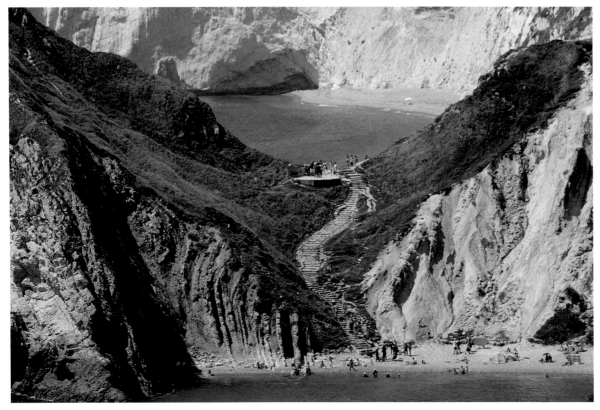

▲ An almost surreal image where people enjoy the sun and sea in Man O'War Cove, in the presence of evidence of colossal Earth movements, which occurred long before we even began to evolve.

under pressure and over vast periods of time turn into solid rock. However, these sedimentary rocks which formed at the bottom of seas may not have remained there. Massive earth movements have caused both lateral and vertical shifts. The surface movement of continents or plates is powered by the heat within the Earth, resulting in areas of sediment rock being pushed sideways or thrust upwards to appear above sea level.

The rocks of Dorset display sediment that was laid down during three geological periods. The Triassic was from 250 to 204 million years ago, the Jurassic from 204 to 136 million years ago and the Cretaceous 135 to 65 million years ago. The Dorset coast is usually referred to as the Jurassic Coast as the majority of its geological features represent the Jurassic period.

As already stated, Dorset's undulating landscape of today is due to a combination of the geology beneath it and the forces of erosion. It is often argued that geology

is the basis of everything. The Earth's surface is made up of various slabs of rock, some denser than others. These slabs or plates have been continuously moving over time, driven by the formation of new oceanic crust. This can result in some plates sliding over or sinking beneath others due to their densities.

To recap, when surface plates collide with each other, massive pressures cause uplifts, buckling the strata to create hills and mountains. Dorset is on a continental plate, which would have been more or less flat before various earth movements contorted the strata. Over vast periods of time, earth movements and plate shunting has caused our plate to crumple and warp, creating the bedrock of today's landscape.

When earthquakes are reported in the news, it is the result of plates shifting as the Earth's geological story continues. Surprisingly, earthquakes occur frequently in Britain, and several hundred are detected by the British

▲ The view from Lambert's Castle towards Hardy's Monument, one of many impressive vistas across the AONB.

Geological Survey each year. However, most are too slight for us to notice. The last significant earthquake in Britain measured 5.2 on the Richter scale and occurred in February 2008. Although the epicentre was near Market Rasen in Lincolnshire, it was felt by people across Dorset. The most recent notable Dorset earthquake occurred on Sunday 26 August 2012, approximately thirteen kilometres south of Weymouth, measuring 2.0 on the Richter scale.

Dorset's varied geology represents a period from just under 200 million years to 40 million years ago. The oldest rocks occur west of Lyme Regis and the youngest rocks of the mid-Tertiary can be seen at Hengistbury Head. Considering the age of the Earth at 4,500 million years, even the oldest rocks on the Jurassic Coast are relatively young at a mere 200 million years or so! To give a very rough analogy of these vast spans of time, and comparing the life of the Earth to a year of our time, if the Jurassic period began in early December, the birth

of Christ would occur at fifteen seconds before midnight on New Year's Eve.

The reason for the vast range of geological history that can be seen on the coast is a regional tilt that occurred, which effectively rose in the west during the Cretaceous period. Sea levels dropped, resulting in the rocks of that era being formed in swamps and lagoons. The dramatic earth movements at that time had tilted all the rocks towards the east; therefore, although the same rocks occur throughout the county, the strata of those visible in the west are buried deep underground in the east.

Inland, the pattern of geological history is very similar but largely unseen, with the oldest rocks in the north west of the county becoming progressively younger in age towards the south east.

During the Triassic period desert conditions persisted, until eventually vast rivers flowed down from the north depositing layers of sand and pebbles on the low-lying plains of east Dorset.

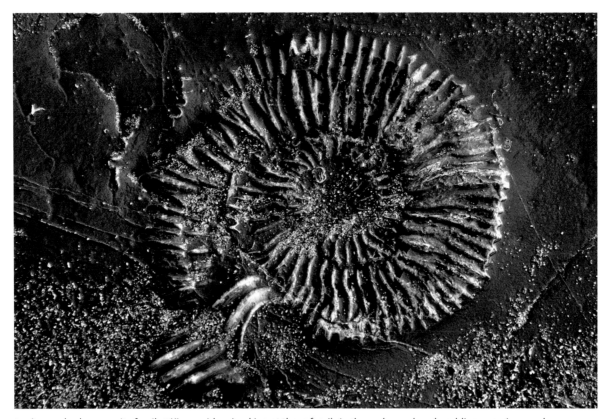

▲ A squashed ammonite fossil at Kimmeridge. Looking at these fossils in the rocks can be a humbling experience, when we consider that these creatures lived so many millions of years ago.

In the early Jurassic era, much of Dorset was submerged in a marine environment of shallow water. The sediment that was deposited during this period resulted in the lower lias floor of the Marshwood Vale. For much of the Jurassic period, Dorset continued to be covered by a sea of fluctuating depth. Great storms and erupting volcanos caused the deposit of various clays, muds, grits and sands. Sea levels eventually rose dramatically to flood the deserts. In these tropical seas ammonites and marine reptiles thrived.

During the early Cretaceous period, Dorset's climate and environment was not dissimilar to that of the Middle Eastern Gulf states of today. Previous sea levels had dropped to form swamps, lagoons and salt flats. Later on in the Cretaceous age, sea levels rose again, allowing sandstone and chalk to be deposited in the deepening marine conditions.

Between 140 to 65 million years ago, a collision between the Africa-Arabian, Indian and Eurasian plates applied great pressure to the rocks in Dorset. This colossal power forced the ridgeway from Swanage westwards upwards, as well as causing the crumpling of rocks which can clearly be seen in Stair Hole at Lulworth Cove.

Different rocks vary in density and therefore the effects of erosion on them by weather and water courses also differ noticeably. Fine sands, grits and soft clays do not offer the same resistance to weathering as the harder chalk and limestones. Therefore, it is the sands, gravels and soft clays that are the bedrocks of low-lying areas, with limestones and chalk forming the higher ground.

Fossils

As plants and animals evolved through time, their remains became fossilized in different layers of rock as it was being laid down. Creatures that lived in the seas

or floods died and came to rest in the layers of sediment. The hard parts of these animals, the bones or shells, were covered with sediment and eventually fossilized. Today, these fossils provide important clues for geologists estimating the age of rocks.

Ammonites first appeared at the beginning of the Jurassic period, and they quickly evolved into variations of the species. It is generally agreed that each sub-species (or ammonite zone) took around 800,000 years to evolve. The largest of these marine creatures was Titanites, discovered in the Portland beds. There are seventy-five known ammonite zones representing these sub-species variations. Therefore the age of rocks in which ammonite fossils occur can be determined according to the identity or zone of the species.

Geologists have developed a number of ways to decipher the clues that fossilized remains provide, the ammonites being a classic example of a tool for the correlation of rocks. The climate of around 137 million years ago has been researched by studying the growth rings of tree fossils like those at Lulworth's fossil forest and others in Portland Quarries. There is a 137-million-year-old tree fossil on show near the roundabout at Portland Heights. Geologists have been able to identify periods of drought or prolonged wet weather by measuring fossilized growth rings.

Fossil types can also provide clues to the type of waterway the sediment was laid down in. Marine fossils generally represent deep offshore water. Fossil remains of marine molluscs indicate shallow water, especially in conjunction with coarse-grain sand and grits.

Through the study of fossils, it is known that dinosaurs dominated Earth for 165 million years, which is thirty-three times longer than mankind has so far. Dinosaurs became so large because they had very little competition. The dinosaurs died out at the end of the Cretaceous period, around 65 million years ago.

Fossils of early extinct mammals, which were mostly shrew- and vole-like, have also been found preserved in rocks. This is somewhat uncommon elsewhere, but many of the world's most remarkable fossils have been discovered here. Certainly, the county continues to be the focus of international geological research.

In conclusion, sediment is not confined to geological history but still continues to form in the seas today. Perhaps in millions of years to come it might be herring, bass or cod which help to date the rocks (in the same way that ammonites do today), unless, of course, they continue to exist at that time, in which case their fossil remains would not aid the dating process.

Stones

It is sometimes possible to study geological layers, or outcrops, which occur in rocks showing aboveground. In Dorset, away from the coast, a fine example of an outcrop of upper greensand can be seen on Eggardon Hill. But such outcrops are few and far between, and it is only along the coast where the geological timescale is fully revealed. The bands or layers of rock on the coast, which represent huge periods of time, also exist and traverse beneath us throughout the land. The chalk cliffs of Old Nick's Ground west of Poole Harbour, for instance, are exactly the same material that forms many of Dorset's great hills in the north and west. Therefore, what we can see along the coast can be translated further inland. For example, the sunken lanes of west Dorset display the same pattern of hard and soft bands of Bridport sandstone as can be seen on the coast east of West Bay.

Much plant life can be directly associated with the underlying geological strata. The chalk-loving species of much of Dorset's downlands are evidence that beneath the thin soil lies chalk. On the Isle of Portland, there are many plants that thrive best in alkaline conditions and are therefore linked to Portland stone. The heaths, which occur on sand and gravel strata support acid-loving plants. Even buildings, constructed in relatively modern times, provide an insight into the local geology. At the time that older cottages and houses in our towns and villages were constructed, the building stones would have been close to hand by necessity. Even many modern houses are still constructed with local stone. For example, buildings in Purbeck villages were constructed with local limestone. The mellow stonework of many west Dorset villages has been built with local stone quarried from Bridport Sands beds.

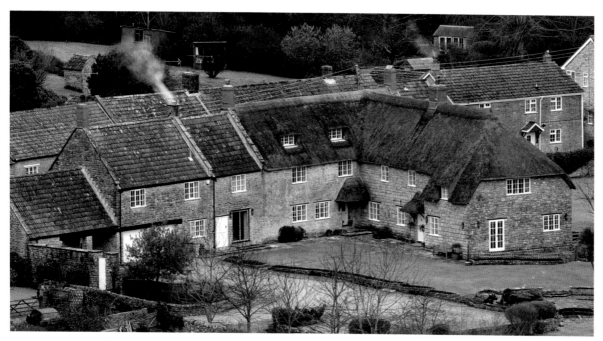

▲ Cottages in the village of Loders, near Bridport, constructed with natural stone from local Bridport Sands beds.

The limestone we see in the buildings of east Dorset villages today was formed from the hard remains of tiny sea creatures. These are unicellular plankton or algae, each enclosed within a collection of hard calcite scales. At the end of the plankton's life the scales come to rest on the ocean floor and build up to form limestone. This is a continual process and it has been estimated that over 1.5 billion kilograms of calcite is dumped into the ocean in this way every year. Inferior oolite is an orange-yellow limestone used extensively in local buildings. Many of the older buildings in Sherborne were constructed with this stone, which had been quarried locally. This stone is lighter in colour than the material quarried in the south of the county, which is due to the fact that the inferior oolite around Sherborne has less iron content. Inferior oolite is also rich in large ammonite fossils.

Portland stone is a limestone which was laid down during the last age of the Jurassic period between 145 and 152 million years ago. The stone first formed as sediment in a shallow, warm sub-tropical sea near to land. The close proximity to land is documented by terrestrial animal fossils as well as those of marine creatures. The warm sea produced calcium carbonate

sediment (similar to limescale build-up in kettles). Tiny fragments of the shells of sea creatures fell into this muddy sediment and became covered by the calcium. The movement of the tides rolled these around into tiny balls known as ooliths (from the Greek word 'oolithus', meaning stone egg). As the ooliths became buried and more calcium cemented them together, the build-up and sheer weight of the sediment, together with the volume of water above, cemented them to form the oolitic limestone we know as Portland stone today.

Over time, Portland stone has become one of the best-known natural construction materials in the world. This is not only because of its attractive grey-white colouration, but also because it is cemented hard enough to withstand the effects of weathering but is not so intensely cemented that it cannot be cut and carved by quarrymen and stonemasons.

Some of the famous buildings constructed with Portland stone include the Palace of Westminster, the Tower of London, Exeter Cathedral, Christchurch Priory, St Paul's Cathedral, the British Museum, the Bank of England, Mansion House and the National Gallery. It was used so extensively in London that it became known

▲ Portland stone continues to be quarried today. There is an international market for it.

in the area incorrectly as 'London stone'. Portland stone has also been exported to many other countries. For example, it was used to construct the United Nations headquarters building in New York and also the government buildings in New Delhi

The Purbeck limestone quarries contain numerous beds, which have been given an intriguing variety of names such as Downs Vein, Thornback, New Vein and Weston. The content of each has somewhat different characteristics in terms of how it can be quarried. Some beds are suited to producing blocks of stone, while others lend themselves to thinner slab production. The variable nature of this stone has meant that certain beds are especially suited to particular functions in constructing buildings. House walls, roofs, floors, lintels and even street pavements have each been made from limestone beds with slightly differing characteristics.

Such versatile use of stone from various beds can plainly be seen in some Dorset villages, especially Worth Matravers and Corfe Castle, where practically all of the structures have been built with material from the local stone beds, thus providing humans with a practical and direct connection with the very rocks which have shaped the landscape around them.

Timeline starting from the west

Dorset's geological history begins with the oldest rocks above ground in the west on Monmouth Beach at Lyme Regis. Monmouth Beach is named after the Duke of Monmouth, as it was the main landing site for the rebellion (also known as 'the Revolt of the West') led by the Duke in 1685.

The most striking feature of the cliffs here are the layers of dark and light beds of blue lias rock, which were actively being laid down some 200 million years ago in the early Jurassic period. The alternate hard and soft beds provide evidence of cyclical environmental patterns, either induced by fluctuating sea levels or by

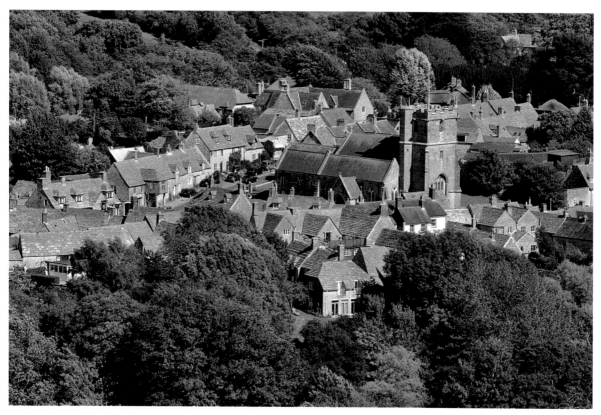

▲ The village of Corfe Castle has been constructed almost entirely with Purbeck stone.

changes in climate or both. These layers of rock slope eastwards, providing important evidence of significant earth movements taking place after they were laid down.

The lias group of rocks occur in an expanse of land in the south west of the county bordered by the settlements of Lyme Regis, Bridport, Beaminster and Marshwood. The word lias is a derivative of 'layers' as it was pronounced by quarrymen. The lower lias is made up of alternating layers of clays and thin shelly limestones which formed as sediment settled in deep, oxygen-starved water. The lias beds are abundantly rich in fossils, and the coastline between Lyme Regis and Charmouth is recognized as one of the most productive marine and reptile fossil locations in the world.

Although the rock layers were laid down as sediment at the bottom of the sea, there have been a number of important fossils of land-living dinosaurs found along the coast here, suggesting that dry land was not very far away.

On Monmouth Beach, many of the large boulders have ammonite fossils in them. These are simple structures with very little detail in the coils. This is because the ammonites were at the beginning of their evolution and were therefore made up of plain coils. With time, as each species of ammonite evolved, its markings became more intricate than those of its predecessors.

Chalk would have been laid down above these cliffs, but this has been completely eroded away in this location. Even so, chalk is found not far away, at Bere along the coast to the west and at Eggardon just a few miles inland.

There can be little doubt that (as with most of Dorset's harbours and bays) the steep-sided valley in which the town of Lyme Regis nestles today was originally carved by the waters of melting ice from the glaciers further north. Today, the River Lym is just a mere trickle by comparison to the violent torrent of water that must have occurred here so many years ago.

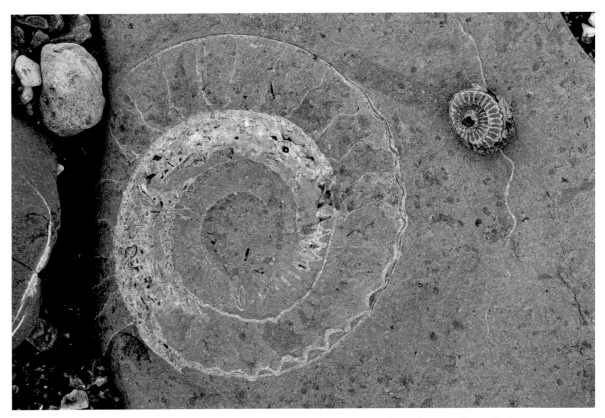

▲ The earliest ammonites occur in the cliffs and on the large pebbles on Monmouth Beach, west of Lyme Regis.

Landslips occur at Lyme Regis because above the lias rocks is a band of gault clay, a stiff blue lias clay that was laid down during the Lower Cretaceous period in a calm deep-sea environment. It was formed around 100 million years ago, overlying older Jurassic rocks and capped by upper greensand. Upper greensand was laid down in a combination of warm, shallow conditions, allowing vegetable and animal matter to mix with grains of mud and sand to ultimately form this very dense rock. This material often contains nodules of chert, or flint as it is more commonly known. Therefore, the upper greensand was further reinforced with the flint to make it more erosion resistant.

The gault is less stable and weaker than the upper greensand and is therefore a fragile support for the harder rock, giving rise to landslides. The effects of this combination can be seen immediately to the east of Lyme Regis where it is aptly demonstrated with frequent mudslides and landslips.

Upper greensand has formed many of Dorset's hills, including Pilson Penn and Eggardon. The Eggardon outcrop of upper greensand is also known as Eggardon Grit. The landscape below upper greensand hills like Eggardon often appears to be hummocky or lumpy; this is due to landslides that occurred in the past.

The resistance of upper greensand to erosion has produced ideal foundations for human settlements. For example, the town of Shaftesbury sits on a high plateau formed of upper greensand. Eggardon, like many of Dorset's steep hills, is encircled with contoured ridges around 30–60 cm apart. Although there is an ongoing debate on the origin of these ridges, it is generally believed that these contours are the result of the downward slipping of soil known as 'soil creep'. Soil creep is the slowest form of mass movement and is caused by the expansion and contraction of water within the soil. For example, a sandcastle can only be made successfully with wet or damp sand because the water surrounds each grain of

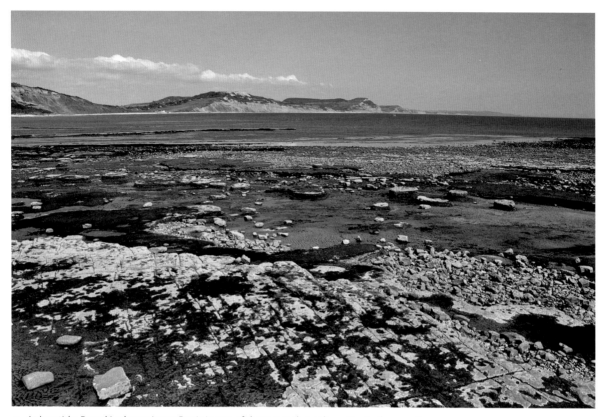

▲ At low tide, Broad Ledge at Lyme Regis is one of the top rock-pooling sites in the country.

sand and binds them together. Pour more water over the sandcastle and it collapses. The same principle applies to soil creep. Moisture in the soil helps maintain a healthy sward, the roots of which help to hold the surface firm. However, heavy rains saturate the ground, causing the soil to expand and slide downslope under the influence of gravity. This is an example of erosion in action.

To the east of Lyme Regis, Broad Ledge is one of the richest rock-pooling sites in Britain. At low tide throughout the year people can be seen crouching over the pools studying the underwater flora and fauna. On the landward side of Broad Ledge, The Spittles (often referred to as Dinosaur Land) is one of the most unstable landscapes in the whole of Europe. Rock falls, landslides and mudslides occur here frequently, spewing rocks, mud and fossils onto the beach. The Spittles is made up of blue lias rock which was laid down during the Jurassic period, dated between 195–200 million years ago. The rock here comprises alternating bands of lime-stone and shale. Shale is a fine-grained sedimentary rock made up of mud mixed with tiny fragments of other minerals and organic matter. As it was laid down in layers, the layers can be peeled or split off easily. This is a fossil hunter's paradise and people can be seen here picking over the rocks at the base of the cliffs on practically any day of the year. Fossils of ammonites and extinct marine reptiles are frequently uncovered, especially after storms, which disturb the soft blue lias mud. Fossils found at Charmouth are often preserved in superb detail, making them exceptionally important to science. Some magnificent specimens have been found here, preserved as complete fossilised skeletons.

Ammonites evolved rapidly to produce differently marked species with distinct shell patterns. As these animals appear and disappear they represent specific zones of time, as already mentioned. At Charmouth, twelve such ammonite zones are represented in the rock formations.

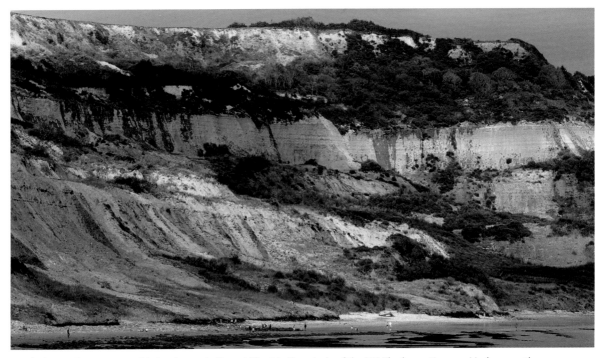

▲ Black Ven, the most unstable landscape in Dorset, if not in the whole of the UK. The lower tiers are Marls, or earthy mudstones, which frequently slide, especially after prolonged wet weather.

Following along the coast to Black Ven, the cliffs and landscape are stepped or tiered as a result of recent land-slips, giving the impression of giant steps. These cliffs are made up largely of soft clay interspersed with harder limestone layers, and are the site of the largest coastal mudslide in Europe. Some areas can remain stable for sufficient time for trees and shrubs to become established. But this is short-lived as winter rains loosen the strata sufficiently for it to slump and slide down towards the beach. At the western end of Black Ven, huge rocks lay strewn on the beach, which have been carried there by mudslides. The mud has long been claimed by the sea, leaving behind the large rocks, which have been rounded by the constant battering of the waves.

How Golden Cap initially got its name we may never know, but although the yellow crown is referred to, the people who first named it probably did not give any thought to how this distinct golden colour had come to be draped across the summit of this prominent clifftop. This magnificent feature is west Dorset's most well-known landmark and at 191 metres above sea level it is the highest point on the south coast of England. At approximately one third of the distance up the cliff a buttress has formed, known as the Three Tiers. The lower grey strata of the cliff comprises Lower Jurassic clays and is dangerously unstable. Horizontal Cretaceous rocks lie on top of sloping Jurassic rocks geologically referred to as the Unconformity. The Jurassic rocks had previously been tilted eastwards by massive earth movements before deep seas invaded the land once more. The events to which these features relate would have occurred over the space of many millions of years.

The sandy coloured cap (also seen on Thorncombe Beacon and Stonebarrow) is formed from weathered upper greensand, which was laid down during the Cretaceous period.

Greensands were deposited in shallow marine environments in which the sediment contained a percentage of grains of the mineral glauconite, which is greenish in colour. Upper greensand was deposited during the Albian age of the Lower Cretaceous period, between 100–113 million years ago. Lower greensand was laid

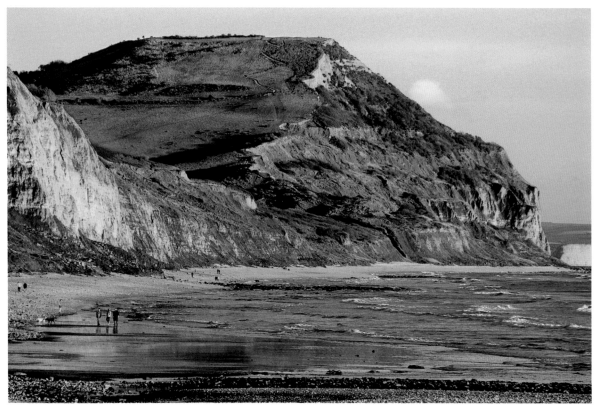

▲ Golden Cap showing the Upper Greensand capping that gives the cliff its name. A recent landslip can be seen on the left side of the photograph.

down during the Aptian age, between 113–125 million years ago. Lower greensand is not well represented in Dorset, but upper greensand is, forming the rigid summits of several of Dorset's hills. Lower greensand can be seen on the coast between Lulworth and Swanage. It has also been recorded near Child Okeford.

Ridge Cliff, east of Golden Cap, is the perfect example of continuous, steady erosion. The face of the cliff gently steps downwards, demonstrating the effects of unremitting weathering of the rock by wind, rain and sea. Above the cliff, the lush green landscape remains serenely composed, oblivious to the fate which awaits it with time.

The east cliff at Seatown offers the classic view of Golden Cap. From here, the difference between the colours of the lower grey ledges against the yellow cap is remarkably distinct. The gurgling stream at Seatown would once have been a raging torrent as the ice waters melted during the thawing of a succession of ice ages, carving out this pretty valley.

The highest point between Seatown and Eype is Thorncombe Beacon at 157 metres above sea level. A permanent fixed fire basket stands here, which is lit to commemorate special occasions. There are many places on the Jurassic Coast that offer breathtaking views, but few are as far-reaching or as impressive as the view here from Thorncombe Beacon looking eastwards. The scene takes in Eype Beach with the distinctly different cliffs either side of West Bay; the succession continues onto Burton Cliff and the Chesil Bank beyond, stretching to the Isle of Portland in the far distance.

At Eype, examples of sections through silts and sands of middle lias are revealed – at this point seas may have been shallower and subject to storms. The cliff comprises Eype Clay which was laid down in quieter times. Above this is the famous Starfish Bed, which

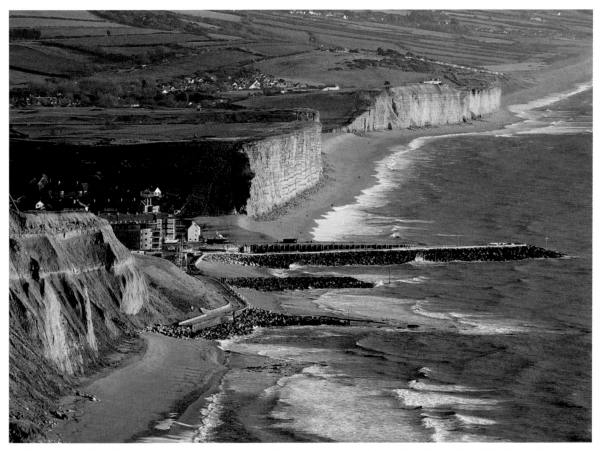

▲ The view east from Thorncombe Beacon, showing the distinct change in rock formation either side of West Bay, with Burton cliff beyond.

contains fossil remains of brittle-stars. It is widely believed that this fossilization occurred in further stormy conditions when huge amounts of sediment were deposited in the sea, smothering and over-whelming the starfish. These middle lias sediments are capped with a bed of Thorncombe Sands.

The make-up of cliffs between West Bay and Eype comprise upper fuller's earth and some forest marble. Fuller's earth is clay that holds a high water content. The name 'fuller's earth' originated in the textile industry when it was used to aid the cleaning of raw wool. The wool was kneaded with a mixture of earth and water (known as 'fulling') to absorb contaminants from the fibres.

The fuller's earth found across much of the south of Dorset was deposited in a deep sea which occurred as the continental shelf subsided around 170–160 million years ago. As the continental shelf sank it forced much of southern Dorset deeper underwater, resulting in the deposits of fuller's earth clays.

The enormous rocks that lay on the beach east of Eype are chunks of forest marble that have come crashing down from the cliffs above. It is not difficult to imagine the force with which these massive stones would have bounced down from the cliff to the beach, a stark reminder that all this stretch of coast is notorious for landslides.

Forest marble is not a true marble but a shelly lime-stone. It can take a high polish and has been used extensively as a marble substitute in construction proj-ects. Examples of forest marble can be seen in Corfe Castle Church.

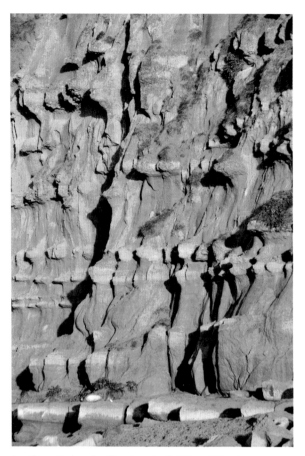

▲ Alternate bands of hard and soft Bridport Sands are displayed at East Cliff, West Bay.

To the east of West Bay stands one of the most extraordinary features of the AONB and the Jurassic Coast. The erect, perpendicular, orange-yellow cliff face appears from a distance like a huge slab of cake which has been neatly cut with a sharp knife. These vertical cliffs are made up of layers of rocks formed from Bridport Sands, which are part of the upper lias division of the Jurassic period when horizontal layers were laid down at the bottom of a shallow tropical sea. The alternate hard and soft layers that can be seen represent a repeating pattern of different weather conditions. This bed reaches inland as far as Yeovil in the north, where the same material is called Yeovil Sands in Somerset.

At the east end of the county the Bridport Sands beds are up to 900 metres below ground and have been identified at one of the deep Wytch Farm drilling wells.

Throughout west Dorset there are a number of sunken lanes on the Bridport Sands, and where these occur the same pattern of horizontal bands of hard and soft rock occur. The harder rock is the same as the soft rock but it was laid down in calm seas, allowing much animal and vegetable matter to settle around grains of sand. As these turned into fossils the seams became denser. The bands of soft rock between the hard layers were formed by grains of sand falling down during turbulent seas. As grains of sand are angular, these could not knit together tightly, but left tiny gaps around each grain. In calm conditions, organic matter would have been able to settle freely, thus filling in the tiny gaps around the grains of sand, and ultimately forming a denser rock. It is also widely believed that the harder beds of rock were caused by creatures on the sea bed stirring up the surface silts during relatively calm periods of time, thus mixing the sand and organic matter thoroughly.

Here, rocks do fall, and the evidence can be seen along the base of the cliff. These are chunks from the harder rock seams that are not weathered away so easily by wind and rain, but fall as the softer sandstone is eroded beneath them. The harder bands of rock remain uneroded as the sea spray and the weather continuously nags at the softer layers of Bridport Sands. Occasionally lumps from the harder rock seams fall, and occasionally even large sections of cliff collapse.

Rock falls can occur in either wet or dry conditions. Returning to the sandcastle analogy, a sandcastle can only be formed with moist sand. If dry sand is used, the sandcastle simply crumbles away. The same could be said of rocks: the drier the soft material that surrounds them, the less support it provides. There are often significant landslips and rock falls along this stretch of coast. A recent rock fall occurred on a fine summer's day in July 2012 near Burton Freshwater when over 400 tons of rock sadly claimed the life of a young woman.

The sandstone cliffs of West Bay and Burton Bradstock are capped with a layer of limestone known as inferior oolite. This rock was formed from ooliths, which were made up of calcium carbonate that formed around grains of sand or pieces of shell. The inferior oolite beds are especially fossiliferous but, at the top of

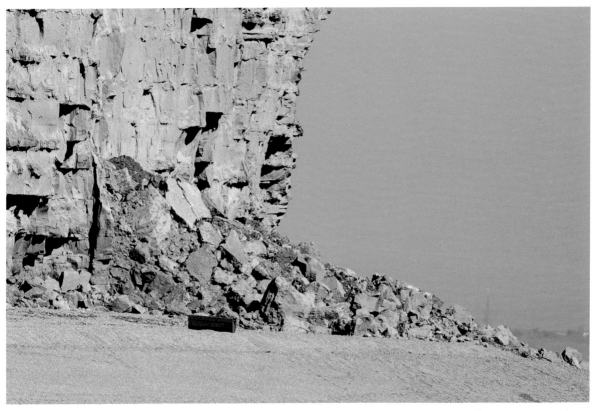

▲ The rock fall at Burton Freshwater, which sadly claimed the life of a young woman: a stark reminder of the danger posed by the cliffs of the Jurassic Coast.

these cliffs, they are inaccessible and therefore it is only following cliff falls that fossils are found.

It has been estimated that the laying down of the oolite and Bridport Sands beds occurred at a rate of only one metre per 20,000 years. The cyclicity shows the bands getting thinner and closer together near to the top of the cliff, suggesting that the alternating weather patterns became more frequent, with each spell lasting for considerably less time.

From Burton Bradstock, the coastline gently dips eastwards with no cliff edge for several miles between here and Weymouth. The strata at Cogden is shingle beach forming part of the Chesil Bank. On the landward side of the beach much of the low ground is constantly inundated, forming a reedbed and a large stretch of open water. At Abbotsbury, Chesil Beach departs the land to form the Fleet Lagoon. The fact that the sea never seems to be able to drag the Chesil away and encroach on the land is something of a mystery. The sea has broached the Chesil Bank in places in the past, and violent storms have also thrown vessels over it!

Weymouth and Portland

The impressive Chesil Bank consists of twenty-eight kilometres of pebbles stretching from West Bay to Portland. These pebbles are rocks which have been constantly turned and rolled by the movements of the sea. The continuous activity of the waves dragging, pushing and rolling these rocks has resulted in their roundness. The pebbles on Chesil Beach are mainly a mix of flint and chert, with some quartzite pebbles that have been carried by tides from as far away as Buddleigh Salterton. The pebbles are graded by the tides and prevailing westerly winds. Larger pebbles are gradually shifted towards the east while small gravel-sized pebbles remain in the west. At the west end of the beach

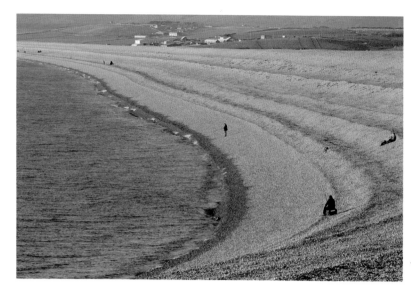

◀ Chesil Beach, stretching away in the west, as seen from Portland.

the pebbles are pea-sized whereas at the Portland end the pebbles are potato-sized (known locally as 'cobbles'). It is said that local fishermen landing on Chesil Beach in fog in days gone by would have known exactly where they were, judging by the size of the pebbles. The Chesil Bank acts as a vital sea defence for the Fleet Lagoon, which is one of the finest examples of a saltwater lagoon in the world. Chesil Bank is known as a 'tombolo', meaning a mound or deposit of land forming a gravel bar that links an island to the mainland. It is often described as the classic tombolo, which has been formed by continuous longshore drift. Portland, therefore, is a tied island, and from the top of the island there is an impressive view of Chesil Bank, stretching far away in the west.

From Ferrybridge, Chesil Bank protects the causeway that links Portland to the mainland. As the beach meets the lower rocks of Portland, the huge shingle bank swings around southwards, tucking into the monumental rising rock face. Portland has remained an island due to the resistant nature of this rock, while the surrounding strata has given way to millions of years of erosion. The Isle of Portland is made up of two principal layers of sedimentary rock: the Portland beds and the Lower Purbeck beds. These rock layers have formed a unique geological structure, which has in turn determined the profile and geographical position of the island.

The impression one gets just about everywhere on Portland is that it is an island of stone. Hard, grey-white blocks of limestone rock are strewn about the landscape, and redundant quarry workings and stone buildings can be seen everywhere. Rocks have tumbled down the western face of Portland to create a slope of scree at the base. On the sheer cliffs near the Cheyne Wears quarry, the level bands of strata have been weathered by millions of years of wind, rain and sea spray, but still they stand rigid and unyielding.

The effects of alternating sea levels between ice ages can be seen near Portland Bill. A wide limestone ledge here is an example of a raised beach showing where the sea level was during the Pleistocene epoch. The ledge is made up of Portland and Purbeck limestone and is sprinkled with sand and shell fragments. This debris was deposited on a prehistoric shoreline around 125,000 years ago when sea levels rose during an interglacial period.

Weymouth's success as a seaside holiday resort and boating marina is owed to its geology. Great rivers, created by thawing ice, levelled the landscape here and dumped vast deposits of fine-grained sand, forming the sprawling beach. This movement of water would also have shaped the landscape of the reedbeds and wetlands of Radipole and Lodmoor.

To the east of Weymouth, the cliff between Bowleaze

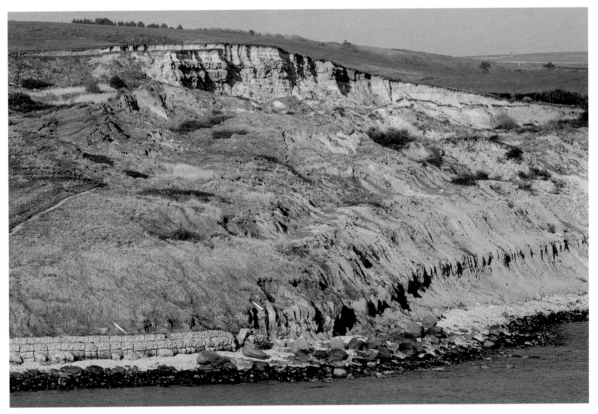

▲ The cliff between Bowleaze Cove and Redcliff Point displays the effects of ongoing erosion.

Cove and Redcliff Point shows remarkable evidence of the forces of erosion at work. The almost orange-coloured rock is Corallian limestone, which was laid down in the Upper Jurassic era. The cliff face steps down in a kind of flowing order of narrow gullies, demonstrating how water and landslips have hurtled down this slope in the past, gorging these elongated fissures into the lower surface rocks near to the shore.

The mid-Dorset Coast

At the base of the cliffs east of Osmington Mills, large spherical nodules occur in the cliff and are scattered across the beach. It is widely believed that these 'doggers', as they are known, formed when the burrows and breeding chambers of animals in the sandy strata became redundant. The burrows acted as conduits for fluids carrying calcite, sand and soupy clays that ultimately became naturally cemented in the shape of the chambers. As the cliffs erode, so these 'doggers' tumble

out onto the beach, creating an extraordinary spectacle.

Further east, along the coast at Ringstead Bay, the first hints of chalk appear in the cliffs leading up to White Nothe. From the top of White Nothe, the view of the landscape below sprawls out in a series of uneven giant steps. An ancient massive landslide caused this rippled effect, and today this area forms a unique and wild nature reserve.

Sea levels around 75 million years ago were probably up to a maximum of 200–250 metres above present-day levels. This resulted in Dorset being completely submerged for some 30 million years. During this time, the algae blooms and plankton, which thrived in tropical conditions, died and came to rest on the ocean floor, forming calcareous ooze. These algae skeletons ultimately built up in their billions upon billions to form the chalk hills we see today. These oozes took vast periods of time to form, with accumulations of only one to six centimetres every 1,000 years. The chalk

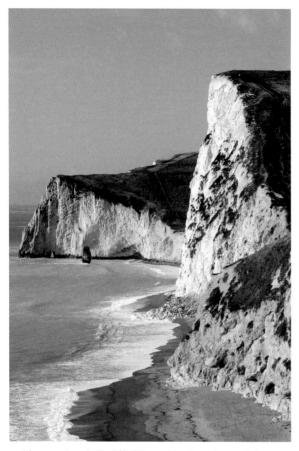

▲ The massive chalk cliff of Swyre Head, at ninety-eight metres, towers above Bat's Head (left) near Durdle Dor.

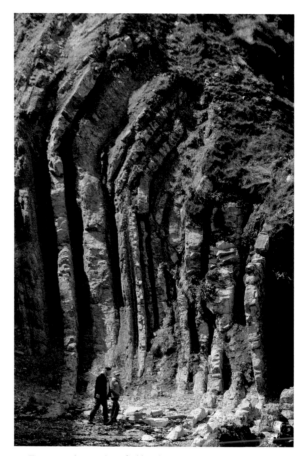

▲ Two people are dwarfed by the spectacular upended strata in Man O'War Cove near Durdle Dor.

deposits in Dorset were laid down during this 30 million-year period, building up to 410 metres of chalk in places.

Chalk is a soft, porous form of limestone made of almost pure calcium carbonate. If you study a piece of chalk under a microscope it becomes clear that it is made up of the shells of minute animals. These creatures lived in warm, clear sea waters. Looking at Swyre Head near Durdle Dor, for example, it is difficult to imagine how many trillions and trillions of tiny creatures were needed to build up this massive height of chalk.

Bat's Head offers sprawling views of the coastline both to the east and the west. Due west, the impressive sheer chalk cliffs extend all the way to the promontory of White Nothe. The view towards the east offers tantalizing hints of Durdle Dor and Lulworth Cove,

both being obscured by the magnificent high chalk cliff of Swyre Head.

The constant battering of the sea results in a relentless act of erosion of the chalk cliffs. Wind, rain and waves repeatedly lash against the cliff face, dislodging rocks and sand-blasting the face. The sea will attack any weakness in the resistance of the cliff and eventually a cave may form. On narrow headlands, such as at Durdle Door, the sea may eventually break through to form an arch. When the upper stones or keystones of an arch collapse a stack is created like, for example, Old Harry. Eventually, after further erosion, the stack will collapse.

The Durdle Dor arch has been formed in strata that was forced almost ninety degrees to the vertical by colossal earth movements. The fact that this vertical rock formed lying flat on the sea bed reminds us of man's own

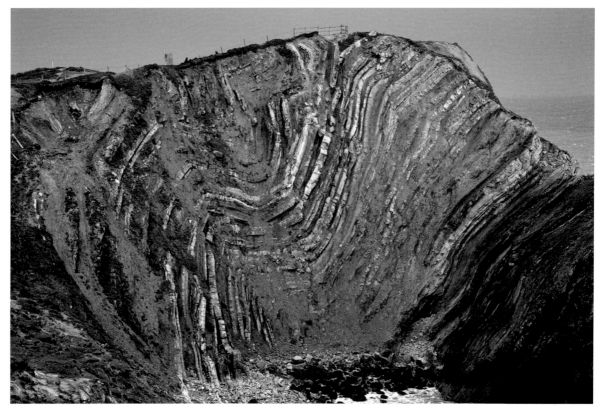

▲ The Lulworth Stair Hole, or Lulworth Crumple, as it is affectionately known to geologists.

insignificance. We may have damaged the surface of the Earth irrevocably, but we can have no influence over the Earth's own movements. In Man o' War Cove on the east side of the Durdle Dor rock formation, the perpendicular bands of strata traverse up and over the cliff face.

This upended strata continues into the sea at Man o' War Cove against the backdrop of the chalk cliffs of St Oswald's Bay. Close inspection of the cliff face here reveals black glossy flints in the rock. Flint nodules are common in chalk. The precise origin of flint is not yet known, but it is generally agreed that it formed after chalk had been laid down. One suggestion is that cavities within the chalk were made by burrowing marine animals. These cavities became filled with gelatinous material which was impregnated by a form of silica. The resulting process of silification (literally, turning to flint or chert) took around 50,000 years under the immense pressure of the increasing weight of chalk.

At the east end of St Oswald's Bay, Dungy Head has

been thrust upwards to a severe forty-five-degree angle. Beyond here, the layers of rock which make up the Lulworth strata lie near vertically, which is thought to be due to the immense pressure caused by the African plate colliding with Europe. It is difficult to imagine how hard, brittle rocks could have been contorted so gracefully without shattering. But at the time this happened these rocks were deep underground and influenced by heat, which would have caused the strata to behave in a much more pliant manner.

The most dramatic geological feature on the entire Jurassic Coast can be seen at Stair Hole at West Lulworth. The so-called Lulworth Crumple is one of the finest examples of the impact of the Alpine Orogeny or Alpine Mountain Building Event as it is also known. This event took place in the Tertiary age, between 65.5 and 2.6 million years ago, when the tectonic plates of Africa and India in the south collided with the Eurasian plate in the north. The resulting immense pressure on

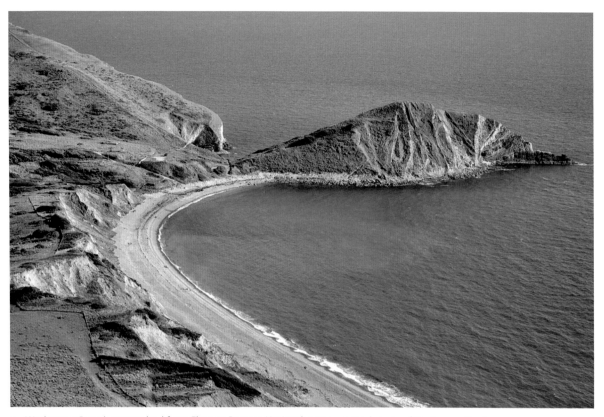

▲ Worbarrow Bay photographed from Flowers Barrow. Notice the near-vertical strata of Worbarrow Tout.

pre-existing rocks caused uplift, faulting and crumpling. These massive earth movements created folds in the Purbeck rocks, and the plateaux of the Dorset ridgeways were formed. The reversed 'S' formation at Stair Hole occurred as the strata of clays and limestones that had previously slipped southwards became compressed and were tilted backwards to a higher level. The softer clays beneath were unable to support the weight so the layers collapsed downwards, resulting in the 'S' shape of the Lulworth Crumple.

The cove itself has been almost perfectly rounded by the constant movement of tides. It began to form when a stream breached the limestone cliff and allowed the sea to enter. The Wealdon beds behind the limestone cliff are less resistant and began to erode with the constant movement of waves. Gradually the bay widened until the sea met the more resistant chalk at the back of the bay. Aerial photography has revealed the circular movements of the waves as they enter the bay and continue to hollow out the rocks into an almost perfect curve.

The fossil forest east of Lulworth Cove formed as remains of algal growth accumulated around fallen trees and stumps in what was a shallow, salty lagoon.

Purbeck

The highest point on the road from East Lulworth to Creech is Whiteways Hill overlooking the army ranges. If you stand here and imagine the sea level being over 100 metres above you, it may just be possible to have a hint of understanding of how debris within that vast volume of water was deposited and accumulated to eventually become sedimentary rock.

Not all rocks were laid down in such deep water. Purbeck sedimentary limestone formed after Portland stone during the Upper Jurassic to Lower Cretaceous period in a shallow freshwater lagoon environment, perhaps no more than one metre deep.

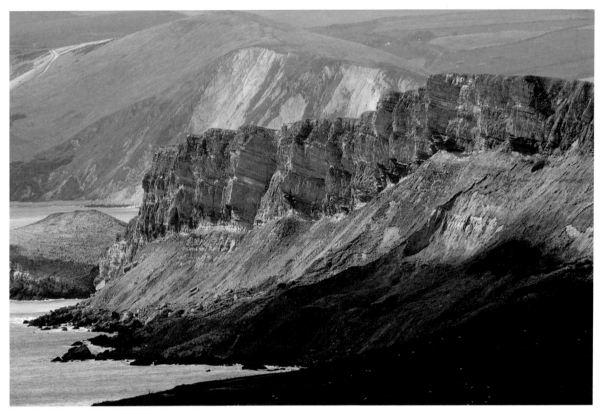

▲ The extraordinary Gad Cliff viewed from Kimmeridge.

Mupe Rocks are situated at the west end of Worbarrow Bay. From here, the eroded clifftop of Flowers Barrow can be seen in the middle distance, as can the acutely sloping landscape to the rear of Gad Cliff, stepping down to Worbarrow Tout. At Mupe Bay the rocks have been severely tilted so that they protrude diagonally upwards at an acute angle from the water's surface.

At the Iron Age earthwork of Flower's Barrow, the combined effects of sea and weather battering the coast can be seen clearly. The hill fort was constructed over 2,500 years ago, but now more than half of this ancient earthwork has been claimed by the sea. The scene becomes even more dramatic when considering that the original position of the fort was most likely to have been some distance inland from the cliff's edge. It has been estimated that, during the Iron Age, the coast of Dorset was around one mile further into the English channel than it is today. Now, a Second World War pillbox stands precariously at the edge of the cliff, tilted seawards, as if

waiting its turn to tumble down to the beach below. An overview of the coast here is one of dramatically sloping strata, apart from that of Worbarrow Tout, which again demonstrates layers of rock that have been shunted to an almost vertical plane.

From Worbarrow Tout, the view west along the beach and cliffs aptly demonstrates the forces of erosion at work. The cliffs have been fashioned to an angled slope, where erosive forces have dragged the rocks down to the sea. The beach is littered with large rocks, which have descended from the cliffs above. Sprawling heaps of scree tell more of this story of constant erosion. Some of the rocks on the beach contain nodules of jet black flint, which is smooth to the touch.

Worbarrow Tout formed from hard Purbeck limestone rock in lagoons at the edge of the land during the late Jurassic period. Trace fossils of dinosaur tracks can be seen in the Purbeck beds, especially in the Worbarrow Tout area. They were created as dinosaurs

walked in shallow water, making impressions with their huge feet in the soft mud.

Gad Cliff is an extraordinary geological feature of the Jurassic Coast. The massive cubed blocks of rock step down with almost measured regularity towards Worbarrow Tout. The jutting angular shapes are further evidence of the immense tectonic forces that affected much of Dorset during the Alpine Erogeny. The cliff consists largely of Portland stone resting on Kimmeridge clay beneath. Water percolates down through crevices and cracks in the Portland stone but cannot enter the impermeable Kimmeridge clay bed. This renders the clay unstable and therefore unable to maintain sufficient support for the heavier rocks, thus resulting in landslips and slides. Beneath the cliff, an angular apron of scree is evidence of previous landslides. The strata on the landward side of Gad Cliff tilts dramatically backwards, in a similar way to that of Dungy Head. This spectacular sloping of the strata can be seen again at Long Ebb and Broad Bench. In the distance at Hen Cliff, east of Kimmeridge, the strata slopes down towards the east.

Kimmeridge Bay rocks formed as sediment in a deep sea, accumulating between 154 and 147 million years ago. In the past, geologists put forward wide-ranging assessments of sea depths during the Kimmeridge Clay formation, but it is now generally agreed that there was a maximum depth of 100 metres. The weight of the accumulation of clay compacted the layers into solid rock. The cliffs here show alternating bands of hard and soft rock, suggesting the sediment was laid down during rhythmical or cyclical environment changes. A tranquil sea allowed soupy muds to settle on the sea bed, forming the beds of Kimmeridge clay. In the depths, the sea water became starved of oxygen by the occurrence of extensive algal blooms. The presence of algal blooms is borne out by the white or very pale bands of strata that can be seen in the cliffs at Kimmeridge today. It has been estimated that the layers accumulated at a rate of one centimetre every 300 or more years. This sediment formed the cliffs we see today, which continue to be eroded by wind, rain, ice and sea. Further inland, Kimmeridge clay is also found in low-lying areas of the Blackmore Vale, a wide, flat landscape extending from

north-east to south-west Dorset on a line roughly from Gillingham to Yetminster. The underlying Kimmeridge and Oxford clays of this region are largely impermeable, resulting in a labyrinth of streams and ditches entwined around a mosaic of lush pastures and copses. The ground in parts is often poorly drained due to the underlying geology, thus giving rise to many of the names of local hamlets like Moorside, Guy's Marsh and Margaret Marsh.

In Kimmeridge Bay, ammonites and other fossils embellish the black limestone rocks and ledges at low tide. In the extreme spring low tides, these ledges stretch out into the sea to reveal even more fossils. The reason for such an abundance of fossils is that, when creatures living higher up in the water columns died, they came to rest on the seabed, which was starved of oxygen due to the algal blooms. The lack of oxygen stifled the activities of scavengers and bacteria to allow dead creatures to remain intact and to become fossilized. It is rare to find a perfect ammonite at Kimmeridge, because the hard remains of creatures that became fossilized were distorted or flattened by the sheer weight of the sediment above them. Although the fossils have mostly been squashed, there are some excellent examples to be seen today of creatures that settled here some 150 million years ago.

On the west side of Kimmeridge Bay, in the dolomite beds of the Flats, intriguing patterns have formed in the yellow-ochre tinted rocks. These are expansion megapolygons formed deep underground and were caused by crystal growth. These polygonal thrusts resemble snakes' heads, especially when viewed in cross-section. The black bedrock that is revealed at low tide contrasts starkly with the yellow boulders to the east that have fallen from Hen Cliff. Standing amongst these boulders and looking up to Hen Cliff, it doesn't take much imagination to work out what is going on. Beds of dolomite rock jut out from the wide, darker bands of shale. All the time, the sound of shale cascading down the cliff face can be heard, making this one of the most dangerous places to linger on the Jurassic Coast.

The nodding-donkey oil rig at Kimmeridge is a visual reminder of Dorset's varied geology. It has been

▲ A pattern of expansion megapolygons in the Kimmeridge Flats dolomite bed.

extracting oil from depths of 500 metres since the late 1950s making this the oldest continuously pumping oil well in production in the world. The nodding donkey continues to extract over a hundred barrels of oil daily.

Further east along the coast, Chapman's Pool is surrounded by Houns-Tout, Emmetts Hill and St Aldhelm's Head. Two streams, which would have been raging torrents during interglacial times, carved their route to the sea and still trickle down the cliffs to this bay. The erosion of the landscape beneath Emmetts Hill by the unrelenting waves has created this disc-shaped bay, which is similar to that of Lulworth Cove.

St Aldhelm's Head bears a resemblance to some of the Portland Cliffs, which is not surprising as the rocks here are also Portland stone. However, the sloping apron of rocks beneath it are thought to have been the result of thawing permafrost carrying small rocks off the top surface. Water ingress into seams and pores applies pressure to rock when frozen, thus creating fractures. Upon

thawing, pieces of loosened rock are released to form accumulations of scree at the base of cliffs, seen both here and at the base of Gad Cliff.

At Winspit, the beds of grey Purbeck stone are revealed; they rest on Portland limestone. The redundant quarries along this stretch of coast between here and Durlston are the legacy of men who literally tunnelled into the cliff face to remove stones for construction and export. In places, pillars of stone were built to hold up the roof of the quarry caves. One shudders at the obvious reasons that this became necessary. Now though, this undulating stretch of the Jurassic Coast offers fantastic scenery and is a walker's paradise.

At Durlston, the famous man-made Tilly Whim caves still exist, but they are too dangerous to enter and therefore access is prohibited. In the cliffs of Durlston Bay the strata does not slope as dramatically as it does further west, but the layers are significantly crumpled and further tell the tale of the colossal earth movements

▲ Bell heather and dwarf gorse are typical of the acid-loving flora that dominate the sandy soils of the Poole basin.

▲ Forces of erosion at work on the Jurassic Coast at Burton Bradstock.

Poole Harbour. Behind this are the saltmarshes of the harbour, and the heaths of Godlingston, Studland and the Arne peninsula.

As well as the Cretaceous period, Dorset's landscape has been affected by ice ages. Prior to the last ice age, the River Frome flowed eastwards to enter the sea to the east of what is now the Isle of Wight. At that time, the Isle of Wight was joined to Purbeck by a resistant band of chalk. At the end of the ice age, as the massive glaciers of the north melted, the pressure from the weight of ice was released, causing the north of the country to rise and therefore the south to sink in a kind of see-saw effect. The increased flow of the Frome due to the climate change and melting ice allowed the river to break through the chalk barrier and to spill into and drown the valley of what is now Poole Harbour.

During the ice ages, the ice sheet did not cover Dorset, but the permafrost, which was present for long periods of time, would have resulted in the frost shattering the surface rocks. As the ice melted, so these grains and fragments of rock were carried off the upland hills and into the rivers.

As rivers travel down to the sea, they carry or drag materials with them. In times of heavy rain, rivers swell and flow faster. This increased energy provides the river with greater capacity to carry mud, sand, grit and clay within its flow. This is why we notice rivers having a muddy or soup-like appearance following periods of heavy or prolonged rain. In times of flood, rivers burst their banks, dissipating their energy as they flow out across floodplains and at the same time dumping much of their payload onto the ground. This is what happened after the ice ages thawed, and huge rivers deposited gravel and sand on the low-lying areas of east Dorset.

The flora of heathland habitats indicate that what lies beneath the surface soils are efficiently draining geological features. The geology of the Poole basin largely comprises a sediment of nutrient-deficient coarse sands, gravels and clays which are collectively named the Bracklesham Group.

As the ice ages fluctuated so sea levels fell and rose, affecting the formation of rivers. During the last glaciation, as sea water was drawn off by the accumulation of the freezing glaciers in the north, sea levels fell by up to 120 metres below current levels.

As milder summer weather melted the edges of the ice sheet, huge volumes of water cascaded through Dorset, cutting its way to form valleys and ultimately today's great rivers. These movements of water brought with them huge volumes of gravel and sand, released by the melting of ice sheets further north and deposited on tidal flats and floodplains, thus forming the free-draining conditions upon which the acidic soils support heathland flora and fauna.

These clays, sands and gravels, which were deposited across east Dorset, have been quarried to provide valuable raw materials for the construction and road-building industries. Valuable deposits of ball clay, in great demand for the ceramics industry, have been mined from open-cast pits on heaths around Wareham. The name 'ball clay' is due to the miners making balls of the material during extraction.

The freezing and thawing of the ice ages over the last two million years has further moulded the landscape of Dorset, the most recent having thawed around ten thousand years ago. During the ice ages, Dorset was in a constant state of permafrost with the ground frozen to a significant depth. The deep temperatures caused water within limestone and chalk pores and seams to freeze, thus rendering these two materials impermeable. During the slightly warmer summers, the limited thaws resulted in streams flowing across the surface of rocks rather than seeping into them. This pattern of deep freeze alternating with slight thawing of the surface to produce flowing water resulted in streams and rivers cutting drainage routes and ditches into the chalk, a procedure that continued for thousands of years to eventually carve deep valleys. The results of the work of these streams and rivers would have accelerated towards the end of each ice age as the thaw increased in volume. When the ice finally retreated, the streams and rivers dried up, leaving behind the great dry valleys we see in the Dorset chalk downlands today. The Valley of Stones is one such example. The large grey blocks of hard stone lying at the bottom of it are known as Sarsen stones (stones thrown down by the Devil). Initially, this material formed a hard crust over the chalk, but it was eroded during the ice ages and carried down into the valley by the downward pressure of the summer thaws.

So what became of the dinosaurs, the ammonites and the marine reptiles of which there is so much fossil evidence? It appears that there was a devastation that brought an abrupt end to their existence. It is generally agreed that this occurred at the end of the Cretaceous period. A huge comet or asteroid was thought to have struck the Earth in what is now Mexico, resulting in a global firestorm and nuclear winter. The shape of the crater left by this collision suggests that the rock struck the Earth at an acute angle rather than an obtuse one, thus throwing a vast cloud of dust debris into the atmosphere to block out the sun. Dinosaurs were reptiles, essentially needing the rays of the sun for energy to become active. Without this energy they would not have been able to move or feed. Therefore most species that depended upon sunlight declined, due to the reduction of solar energy caused by the atmospheric particles blocking the sunlight.

The Dorset and east Devon coast was designated England's first natural World Heritage site in December 2001. A World Heritage site is a place of 'outstanding universal value', recognized as part of the heritage for all mankind. From Exmouth to Old Harry rocks, these ninety-five miles of coastline record and reveal 185 million years of the Earth's history, with the majority of it falling within the Dorset AONB.

Here in Dorset, therefore, we are custodians of one of the most important geological sites in the world. Where else in the world could you expect to see such magnificent natural wonders as Golden Cap, the sheer cliffs of West Bay, Chesil Bank, Portland and Purbeck, Durdle Dor and Lulworth Cove, all within one relatively short coastline? The Jurassic Coast and therefore this part of the AONB ranks with other internationally recognized sites of global importance, including the Great Barrier Reef and the Grand Canyon.

An Outline History of Dorset

The early history of Dorset can be pieced together from various physical remains but, as there is no written record of this period, it is still relatively unclear and many mysteries remain. Although Dorset's history can be traced back many thousands of years, and it has many visible remnants and relics, there is nothing clear-cut and explicit.

The Paleolithic (Old Stone Age) period

Stone Age hunters and the Mesolithic hunter-gatherers that followed them have left no monuments except for their flint implements. They hunted in chilly conditions as the ground was probably frozen most of the time. Around 8,500 BC there was a rise in temperature and the ground thawed, giving way to birch forest, which covered much of Britain. Many sites of Mesolithic occupation have been found in Dorset including on Portland, in the Stour valley and in the area of Corfe Mullen overlooking Poole Harbour. These people lived by hunting, fishing and collecting wild fruit and seeds, and probably did not stay for long in one place but travelled widely in search of food.

With the Neolithic Age, starting from about 4000 BC, came farming. Animals were kept rather than being hunted and crops were sown and harvested rather than being gathered. Perhaps because less time was needed to hunt and gather food (thanks to farming developments), structures began to appear, which resulted in ancient monuments in the guise of substantial earthworks. The most prominent are the long barrows, which were used for burials. These mounds of earth contain burial chambers of stone or wood into which the dead were laid. But as the bones were laid loose on the floor it has been suggested that the bodies were left exposed pre-burial for the flesh to rot away, before being transferred to the burial chamber (excarnation). Up to sixty long barrows have been found in Dorset, which mostly lie on the chalk uplands.

Probably the most mysterious monument in the county is the Dorset Cursus. This Neolithic monument is a seven-mile-long avenue of earth banks and ditches running through the chalk downs of Cranborne Chase. It starts at Thickthorne Down and ends near the village of Pentridge. Long barrows are clustered near its ends. Its purpose is unknown but it is thought to be the biggest Neolithic site in England, although it can now only be seen as crop or soil marks.

Then there are henge monuments, which are circular earthworks with the ditch inside, probably for ritual use. The high chalk hills provided perfect locations for these defensive settlements.

Neolithic (New Stone Age) sites to visit:
Henge monuments
Maumbury and Knowlton have an aura of holiness
Long barrows
Ridgeway Pimperne, Grey Mare and her Colts (Kingston Russell) and Dorset Cursus

The Bronze Age

The Bronze Age spans a huge amount of time from around 2000 BC to 800 BC and has left its mark by way of the round barrows that are again generally concentrated in the chalk uplands. During this period the climate was considerably warmer than it is now and it is possible to see traces of permanent fields and settlements. There was no sudden move towards the use of bronze tools and weapons; it was a gradual process.

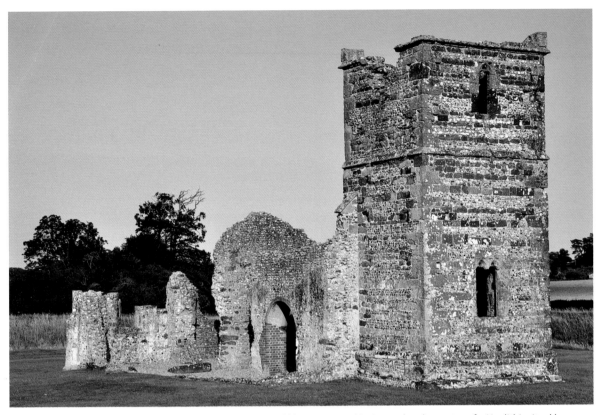

▲ Knowlton is a Norman church, which was built in the twelfth century and is situated at the centre of a Neolithic ritual henge.

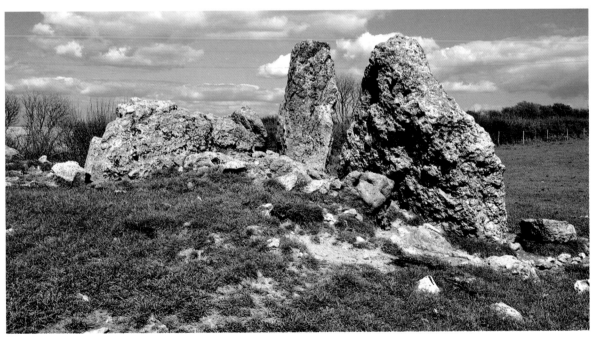

▲ This is a Neolithic chambered long barrow dating from the prehistoric period. These long barrows were used as burial places for many people, men, women and children.

▲ Along the South Dorset Ridgeway there are at least 400 barrows.

Hundreds of barrow remains are scattered all over Dorset, which indicates that it must have been a major population centre of the Bronze Age. Unfortunately, many of these barrows were dug up by landowners in the nineteenth century once it became known that gold could possibly be found, and the results of the majority of finds were never recorded or published. However, Augustus Pitt Rivers ensured that all archaeological finds on his estate were excavated in a meticulous manner and the remains were preserved for posterity.

Augustus Henry Lane Fox (Augustus Pitt Rivers) inherited his great uncle's estate on the Dorset–Wiltshire border in 1880. The Rushmore Estate covered 27,000 acres, but the terms of the will meant that he had to change his name to Lieutenant General Augustus Pitt-Rivers. Once retired, he devoted himself to the meticulous excavation of the numerous ancient and historic sites on his estate and kept detailed records of the position of his finds. He published his findings and displayed his discoveries in local museums. He is widely regarded as the founding father of modern archaeology. He also created the Larmer Tree Gardens, originally the Larmer Tree Pleasure Grounds, designed for the recreation of estate workers and local people. He constructed a variety of buildings intended to enlighten and educate his estate workers and visitors.

The first round barrows contained individual burials, although during this time cremation started to become more popular. The earliest round barrows contained burials (inhumations) as well as 'beakers'. These beakers are thought to be either the result of trade with Europe or the product of an invasion. Dating from the end of the Bronze Age, there exist mounds with as many as 100 pots or beakers containing ashes. Round barrows were typically stone chambers, which were then covered with earth taken from the ditch that was created around the outside of them. Along the South Dorset Ridgeway there are at least 400 barrows. The South Dorset Ridgeway has the greatest number of barrows in any area of the country and the largest group of all is at Poor Lot near Winterborne Abbas where there are at least forty-four barrows.

Bronze Age sites to visit:
Barrows
Ridgeway, Poor Lot (Winterborne Abbas) and Oakley Down
Stone circles:
Kingston Russell and Nine Stones near Winterborne Abbas, stone circles at Rempstone near Studland

The Iron Age

At some time in the eighth century BC iron tools began to appear. This period, up until the invasion of Britain by the Romans, is known as the Iron Age. Iron's distinct advantage over bronze was its strength, which was particularly useful with regard to weapons and agriculture. At this time, the land began to be seriously cultivated and the new Celtic field system was developed, as an increase

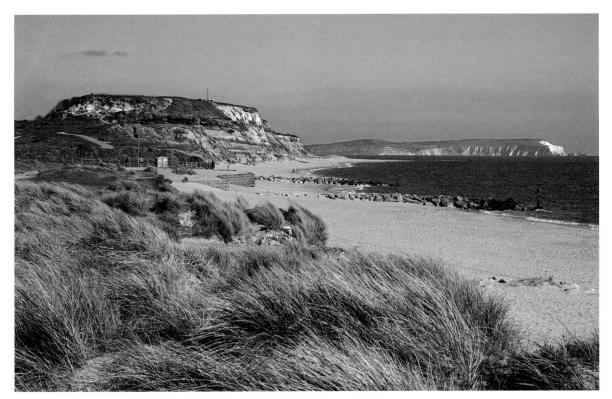

▲ Hengistbury Head hill fort was a major Iron Age centre. It has also been a place of habitation since Paleolithic times. The remains of thirteen Bronze Age barrows exist on the hill fort.

in population meant food production needed to increase, therefore putting more pressure on the land.

The characteristic hilltop fortifications of the Iron Age began to appear around 700 BC. The earliest one in Dorset is probably Chalbury, near Sutton Poyntz, just outside Weymouth, which has remained unploughed for centuries. It is probable that the area known as Wessex was inhabited by various tribes, but the Durotriges appear to have been the dominant one. Their territory extended from Hengistbury Head, a major Iron Age centre near Christchurch, to the River Axe. The Durotriges were the major hill-fort builders of Britain.

To begin with, these hill forts may have been simple affairs with a single bank and ditch following the contours of a hill, which could provide shelter for a whole community together with their animals. They would shelter behind the palisades with skilled slingers for defence. The hill forts then became more complex with more ramparts and ditches and an intricate, inter-locking, maze-like entrance.

The Iron Age produced the most visible and visitable monuments in Dorset. They are found on many of Dorset's hilltops. There are thirty hill forts in the county and some were occupied as towns, the most well-known being Maiden Castle. Its vast multiple ramparts enclose an area the size of fifty football pitches, which is said to represent the largest earthworks in Europe. But these formidable fortifications were no match against the Romans with their siege weapons and tactics in AD 43.

Iron Age sites to visit:
Hill forts
Abbotsbury, Badbury, Coney's Castle, Eggardon, Flower's Barrow, Hambledon Hill, Hod Hill, Lambert's Castle, Maiden Castle, Poundbury, Pilsdon and Rawlsbury, Bullbarrow
Promontory fort
Hengistbury

43

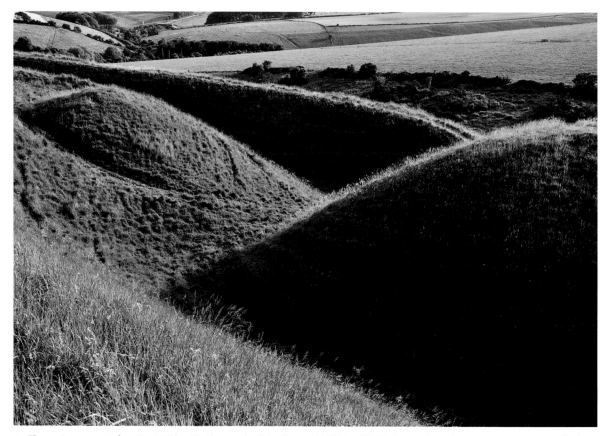

▲ The main ramparts forming Maiden Castle were built in about 600 BC. In 450 BC the castle underwent an expansion, which made it the largest hill fort in Britain.

The Roman invasion and life under the Romans

Roman influence had reached Britain through trade before the invasion of AD 43. Traders from Rome had come to Britain and traded with the tribes here since Caesar's invasion of 55 and 54 BC. They realized that Britain was potentially a very wealthy place and, if the island was properly controlled by the Romans, Rome itself could do very well out of it. When the invasion of Dorset did come in AD 43, the Romans already had a foothold in Hampshire. They had been welcomed by the Arrebates, who had probably realized the sheer power of the Roman army and made peace quickly. The Romans therefore had a secure base nearby. The hill forts of the Durotriges were no match for the sophisticated and well-organized Roman army. Roman supplies were delivered through the harbours of Hamworthy and Radipole. The fragmented society of the Durotriges was easy pickings, and each hill fort was singled out individually and independently. Showers of ballista arrows rained down on to these hill forts; at Maiden Castle, where there is much evidence of bloodshed from the excavations done by Sir Mortimer Wheeler, a skeleton was found still containing a Roman ballista bolt in its spine. The Dutotriges, even with impressive fortresses, could not match the trained fighting force of the Romans. Suetonius, the biographer of Vespasian, the Roman commander, refers to twenty towns being captured in this fashion.

The resulting 'Romanization' of the county can be seen clearly. Durnovaria (Dorchester) was founded on the road from London to Exeter via Silchester, Old Sarum and Badbury (Vindocladia). It became the capital

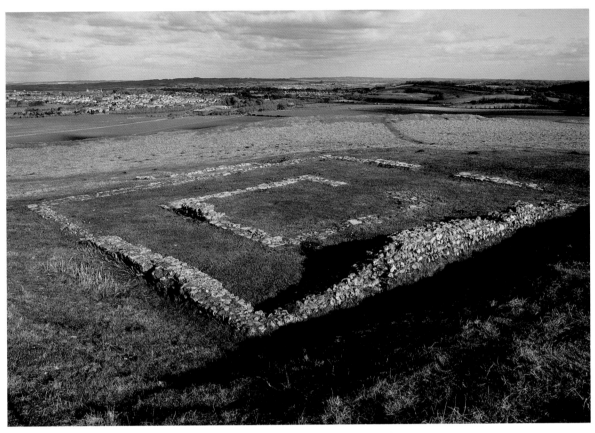

▲ In the fourth century AD a temple was constructed on the hill fort at Maiden Castle.

of the region and it has many Roman remains – mosaics, hypocausts, bathhouses and roads. Maumbury – on the site of an ancient henge – became an amphitheatre which could seat about 10,000 spectators. There are the remains of a Roman aqueduct at Poundbury. Fresh drinking water was brought from the River Frome by a twelve-mile-long surface aqueduct. Roman Dorchester was obviously prosperous; the modern conveniences must have been a great attraction and a help in getting local tribal leaders on-side.

During the centuries of Roman peace the population of Dorset grew and more land was brought into cultivation. By the second century of Roman rule villas were being established. The best-known sites are mostly in the valleys, in particular along the Frome and in the Blackmoor Vale.

Frampton, Fifehead Neville and Hinton St Mary all have villas with mosaics, some with representations of Christ. A large Roman temple was built inside Maiden Castle and another one was built at Jordan Hill near Weymouth.

The native inhabitants must have enjoyed a certain amount of Roman civilization. Roads are one of the major contributions to society that the Romans were responsible for. They were deliberately constructed for military purposes, as straight and direct in design as possible, and they therefore made communications much quicker and easier. A few of these roads are still used today: the one travelling from Dorchester to Eggardon being particularly evident. Ackling Dyke, the best-preserved Roman road in southern Britain, is another of the better-known Roman roads and is particularly obvious as Roman in north Dorset, especially around Bokerly Dyke. But even as the road system developed, earlier ridgeways remained in use and were sometimes incorporated into Roman roads.

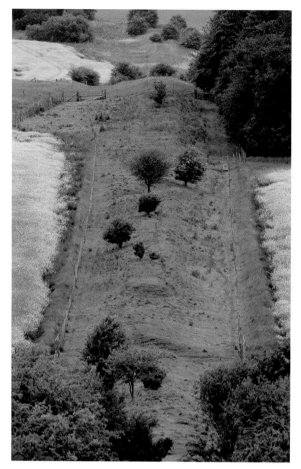

▲ Ackling Dyke was part of the great road that ran from Old Sarum to Exeter via Badbury Rings and Dorchester.

Roman sites to visit:

Temples

Jordan Hill

Maiden Castle

Town

Dorchester – The Walks and wall

Maumbury – the town house and aqueduct

Roads

Thornecombe Woods

Bokerley Dyke

Badbury Rings

Post-Roman and Saxon Dorset

By 410 AD the Roman army had left Britain, possibly influenced by pressure from the Saxons, Picts and Irish.

There appears to have been more than two hundred years before the Saxon invasion made any serious impact on Dorset.

By the middle of the sixth century the Saxon invaders advanced from the Southampton area, through Hampshire and defeated the Britons at the Iron Age fort of Old Sarum before continuing across Wiltshire. The Anglo-Saxon Chronicles give the date of this battle as 552 AD.

Early in the seventh century the Saxon invaders penetrated deep into Somerset, but Dorset still gave fierce resistance. It seems likely that the invaders were halted by the defensive earthwork of Bokerley Dyke. This enormous defence stretched across the neck of the downland in the north east of the county and blocked the main approach into the county from the north. It dates from the fourth century, but after the departure of the Romans it was repaired. When manned by ferocious Britons intent on preserving their homes, this must have been a formidable obstacle and deterrent for the invaders. It still forms the county boundary.

A monk, Gildas, writing about 545 AD, told of a tremendous victory for the British at Mount Badon (or Mons Badonicus). Is Mons Badonicus Badbury Rings and was King Arthur responsible for this victory? Whatever the case, Dorset remained free of Saxon invasion for quite some time. As stated, this was most likely due to the strong defences at Bokerley Dyke as well as the Roman legacy of improved organization, combined with a build-up of numbers and strength resulting from economic prosperity. The main and final Saxon attack came after 665 AD when the Saxons broke through the defences at Bokerley Dyke followed by a swift overpowering of the rest of the area.

Because of the late conquest of Dorset by the Saxons, many were already Christian. Missionaries followed the conquerors, thus Christianity spread rapidly after the Saxon conquest. Dorset played an important role in Saxon politics. Coenred, the sub-king of Dorset at the end of the seventh century, was father to one of the most famous of the early kings of Wessex, King Ine (688–725 AD), who instigated a great step forward in the formal organization of the Church in Dorset.

Many abbeys were established in Saxon Dorset including Wimborne (a double monastery, because it consisted of two quite separate establishments – one for men and the other for women), Cerne, Horton, Abbotsbury, Shaftesbury, Milton and Cranborne. These monasteries became important landowners and centres of power. In 705 King Ine created a new diocese of Sherborne and he appointed his kinsman Aldhelm (639–709 AD) as its first bishop.

Dorset was therefore a vital centre of religious and secular power, and a place where kings were crowned and buried. It became a powerful Saxon kingdom in its own right, and one that endured and flourished until the Norman Conquest.

Viking raids started to affect Saxon Dorset from about 790 when a landing party surprised the inhabitants of Portland. Viking attacks along the English Channel coast, including Dorset, began in earnest in 835 and continued for the next few years. It was difficult to organize defence against such mobile attackers, who could turn up anywhere along the coast with little warning.

In 871 Ethelred King of Wessex, who had fought many battles against these marauding Vikings, died and was buried at Wimborne (an indication of the importance of the monastery there). He was succeeded by his brother Alfred, who brought peace and built up some defences for the battle-worn kingdom. But in 875 the Danish army returned under the command of Guthrum, one of the great Danish leaders. The Danish army occupied Wareham and devastated the surrounding area. Wareham provided an easily defendable place situated between the Rivers Piddle and Frome and it was a good place from which to launch further attacks on the rest of the county. Guthrum experienced an unfortunate turn of events when a storm destroyed a large number of his ships and he had to seek terms, with money and hostages changing hands. Alfred finally got Guthrum to leave Wessex in 878.

Alfred then organized fortifications for the four principal centres in Dorset at that time: Bridport, Wareham, Shaftesbury and Dorchester. Mints were established at these places, giving credence to the theory that commerce and trade were expanding. Schools and churches were also built.

The monasteries, already referred to, were richly endowed with estates and wealth of all kinds by Alfred. The nunnery at Shaftesbury, which was founded by Alfred in about 888, had his daughter, Ethelgifu, as the first abbess of the community. King Alfred the Great of Wessex died in 899; he was succeeded by his son Edward the Elder. Alfred's lead in Church reform and revival was continued by his son.

During the years that followed Alfred's death, there was much fighting against the Danes. It was not until the reign of King Edgar, King of all England (959–975) that all the Danes of the north and east were quelled. The unification of England was accompanied by a blossoming of religion and learning.

On the death of King Edgar, his elder son Edward became king. After a day's hunting in 978, in the Purbeck Forest, Edward visited his stepmother at Corfe, where he was poisoned and stabbed by one of her servants. This act of treachery was reported in the Anglo-Saxon Chronicles with shock. He was first buried at Wareham and then his body was transferred to Shaftesbury.

Then came the second wave of Danish attacks. The Chronicles note that three Danish ships plundered Portland in 982. Ethelred II, half-brother to Edward, who was proclaimed king after his death, tried to buy off the Danes, but they came back for more and in 998 the Chronicles record how they continued to systematically plunder and raid for twenty years, during which time St Martin's Church, Wareham, Wimborne Minster and Sherborne Cathedral were most probably destroyed. Eventually, Cnut, son of the Danish King Sweyn, took over the whole of the kingdom in 1016 and Dorset came under Danish rule. But soon after becoming king, this barbarian became a pious Christian and he encouraged the rebuilding of churches. He died in 1035 and was buried in Shaftesbury, after which his two sons succeeded him for a short amount of time.

In 1042 Edward the Confessor was proclaimed the last Saxon king of England, for he died in 1066. Harold was his successor, but the throne was contested by

▲ Large sheep flocks provided wool, lamb and mutton, and helped to fertilize the arable fields.

William, Duke of Normandy. This led to the Battle of Hastings in 1066, where Harold was defeated and killed. So William the Conqueror, a Norman, became king of England, the third king to have ruled England in one year. William had made himself king by force, and his army now expected rewards, so much looting, brutality and rape followed the invasion. This brutal treatment encouraged the Anglo-Saxons to resist further, which resulted in the boroughs of Shaftesbury, Wareham, Dorchester and Bridport suffering greatly as William advanced through Dorset suppressing the revolt. The Domesday Book of 1086 records that of the 757 houses of these four Dorset towns 350 had been destroyed. Seventy-one Dorset estates were bestowed by King William to his half-brother, which also resulted in much opposition from the English landowning class. In 1069 there was a joint attack by men of Dorset and Somerset on the castle being built at Montacute, but the English revolt was heavily crushed.

The Saxon pattern of farming and settlement largely endures to this day. The majority of Dorset place names are of Saxon origin.

The Norman Conquest and Medieval England

Shortly after acquiring the kingdom of England, William the Conqueror ordered a census, but it was not only concerned with the tax capacity of the country. It was also an opportunity for all landowners and tenants to swear allegiance to him. The resulting Domesday Book documents many Saxon settlements in Dorset that correspond to modern towns and it is a great source of knowledge for Dorset (and England as a whole). The Domesday Book is a detailed survey of rural estates and the towns of England, county by county, carried out on William's instructions. It provides a glimpse of economic life in Dorset and helps in reconstructing the county's

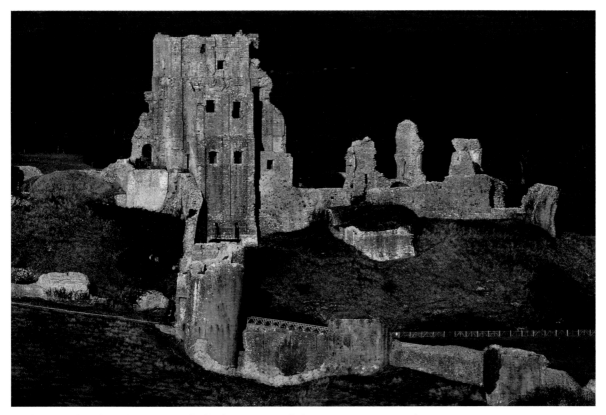

▲ The ruins of Corfe Castle, photographed in low, wintry sunlight on a stormy, January day.

settlement pattern. However, as the survey is based on manors it does not always tell of rural or outlying farms. The survey lists four boroughs: Dorchester, Wareham, Bridport and Shaftesbury. It appears that settlements were fairly evenly distributed over the whole county except for the sandy heathland around Poole Harbour where settlement was sparse. Many villages were strung out along the valleys of rivers such as the Frome, Piddle and Stour, as they are now. The enquiry was meant to establish the identity of the holder of each estate and its value as a basis for the collection of the main tax or 'geld'. This tax varied from two to six shillings on every 'hide'. This hide was a tax unit based on a rough estimate of value, of approximately enough to support a household.

It was only the heads of a household who were counted. In Dorset there were some 500 town households, over 6,000 peasant households and 1,164 slaves. There were probably about 8,000 families in Dorset,

with the population being estimated at between 35,000 and 50,000. For the whole of England the estimate was between 1,200,000 and 1,500,000.

The result of the census showed that, in Dorset, the Church, in the form of the monasteries, held about two-fifths of the land in the county, which was the same before the conquest; land that was held by the king amounted to about one-sixth; the rest was mostly held by Norman barons with a tiny number of English landowners who had given no reason for confiscation for supporting Harold or the later rebellions. The pattern of landholding at the time of the Domesday survey therefore illustrates the predominance of large estates, with royal and ecclesiastical lands far outnumbering the estates of other landowners.

Farming was very obviously the business of most of the population, there are records of very large flocks of sheep in the Domesday Book. A few other occupations are recorded: salt panners and salt workers are

mentioned at Studland in the Purbecks, at Ower in the Weymouth area and around Lyme Regis; and fishermen are mentioned near Lyme Regis and in the Weymouth area.

There are 276 recorded mills in Dorset including twelve at Dorchester, twelve at Sherborne, eight at Burton Bradstock and eight at Wimborne. There was a vineyard at Durweston and Wootton and an orchard is recorded at Orchard near Church Knowle.

Many of Dorset's double-barrelled place names record the original Saxon name with an added 'surname' showing either post-Conquest ownership, the church dedication or some local characteristic. So Bishops' Caundle belonged to the Bishop of Salisbury, Bradford Abbas and Stoke Abbot belonged to Sherborne Abbey, and Compton Abbas to Milton Abbey. Toller Fratrum was held by the brethren of St John of Jerusalem, and the rectory of Whitchurch Canonicorum belonged to the canons of Bath and Wells cathedrals.

Because of threat of invasion or rebellion the Norman kings were active castle-builders. William the Conqueror established the original castle at Corfe, and royal castles were built at Dorchester and Wareham and possibly at Portland in the early twelfth century. The castles built by the king were generally at points of military importance on main routes. The castles built by barons were more like fortified residences that were the control centre of operations for the baron's estate, such as at Powerstock and Chelborough.

Agriculture has always been supremely important to the economy of Dorset, as it is now. Most of the inhabitants traditionally made their living directly from the land. By 1086, at the time of the Domesday survey, the main pattern of settlement had been established as we see it today: Dorset was divided up into small, scattered, rural communities. At the time of the survey there were large areas of wasteland: forest and heathland, also large areas of royal forest, such as that which covered most of the Vale of Blackmoor, the forests of Gillingham and Purbeck, as well as the large area of the Cranborne Chase. Wolves were still to be found here as late as the thirteenth century.

Feudalism

From the Norman Conquest until the late fifteenth century Dorset (like England) was managed politically and economically under the system known as feudalism. Land was held in return for an obligation to provide military service. The lord of an estate or manor passed on part of the land to the largely unfree peasants in return for the cultivation of the land. Thus the aristocracy provided the king with his army and from time to time taxes whilst the peasant, in return for protection by his lord, provided the labour that produced the food. The lot of the peasant was hard. The estates would have consisted of villeins, who were unfree peasants, each holding perhaps thirty acres of arable land in return for three days work each week. Bordars, cottars and cotsets were lesser villeins, having perhaps five or six acres in return for one day's work for the lord each week.

During the twelfth and thirteenth centuries the pressures of an expanding population led to enclosures being made, with the expansion of cultivation up hillsides by the formation of strip lynchets. There was much clearance of woodland. Whilst settlements in Dorset generally remained quite small, the county was, and continued to be, one of large landowners, many of them non-resident.

During the reign of William the Conqueror's grandson, Stephen (1135–54) there was much civil unrest in the county, followed by a strengthening of royal power under Henry II and finally, in the reign of John (1199–1216), the seizing of property of many of his subjects. John used Corfe Castle as a state prison where he starved (amongst other heinous crimes) critics or challengers to his authority. John, who had antagonized the barons with his demands and by breaking the feudal laws, was finally challenged. This resulted in the Magna Carta (1215) in which the king had his powers limited. This then became the basis for English citizens' rights. It was also the beginning of constitutional government in England.

▲ Strip lynchets are terraces formed on hilly arable land, which are usually south facing.

The Black Death

Dorset was badly affected by the Black Death and the Hundred Years' War with France, which lasted on and off between 1337 and 1453. The war was concerned with the disputed control of the kingdoms of England and France. All of the battles were fought in France. Poole, Wareham and Lyme provided twenty-six ships, which were manned by 479 men, for the Crecy expedition. In 1377, raids by the French on the south coast inflicted heavy damage on Poole, Melcombe Regis and Lyme Regis.

The Black Death started in Europe in 1328 and lasted until 1351. It was called the Black Death as it produced a blackening of skin around the swelling, which happened around the lymph nodes. The disease was spread by the bite of fleas from rats and other rodents, which generally lived near people in houses and on ships. The Black Death followed all the trade routes to all countries and it was believed to have originated in the Gobi Desert. In England it raged between 1348 and 1350. It killed between thirty to forty per cent of the population, which at the time was estimated to be about five to six million. Many of the dead were thrown into open communal pits. The oldest, youngest and poorest died first. Whole villages and towns in England simply ceased to exist after the Black Death.

The progress in town and countryside was abruptly halted by the epidemic of the Black Death. Dorset was allegedly the first county in England to be struck down with the disease. It came into the port of Melcombe by a sailor on a ship. It was a frightening disease as it progressed so quickly. Three days after being infected the patient developed a high temperature and a rapid pulse with a severe headache, aching limbs and giddiness. A more serious form of the disease was pneumonic plague, which could be passed directly from human to human by droplet infection. Records of the loss of priests to the plague in Salisbury Cathedral records give

a clear indication of the severity of the outbreak. Mortality among the clergy was higher than in laymen, due to the nature of their work, but it is probable that between a third and a half of the population died of the plague and Dorset's population shrank accordingly.

This devastating disease probably led to the demise of the manorial system. With free labour being at a premium, lords of the manor had to change their ways and scale back their unreasonably harsh demands. Consequently, the Black Death was important for England, and Dorset, because it put a higher value on labour. Feudal law stated that peasants could only leave their village if they had their lord's permission. But many lords were short of desperately needed labour and they actively encouraged peasants to leave their village and work for them elsewhere. When peasants did this, the lord refused to return them to their original village. Peasants were therefore encouraged to demand higher wages, as they knew that the lords were desperate to get in their harvests. This shortage of labour is clear to see when in 1381 the abbess of the convent at Shaftesbury petitioned the king for relief from taxation on the grounds that nearly all the tenants on their estates were dead. The Peasants' Revolt in 1381 was instigated by the fear that the lords of manors would take back the peasant's freedom from serfdom. The peasants were prepared to fight to keep these privileges as well as to free themselves from other onerous burdens at that time. The king, Richard II, eventually gave in to all their requests.

Due to the contracting population, farming changed and the wool industry boomed. Sheep farming became widespread in Dorset as it was less labour-intensive than arable farming. The survey of Church property in 1535 gives an idea of the size of these flocks. The monastic houses of Abbotsbury, Bindon, Cerne, Milton, Shaftesbury, Sherborne and Tarrant Crawford owned between them 15,093 sheep. Wool was a lucrative product and the profitability of sheep farming led to the enclosure of permanent pasture in the fifteenth century, which once again had repercussions for the poor. Indeed, the fourteenth and fifteenth centuries were marked by the expansion of privately cultivated land in Dorset.

The contrast between the agricultural interior of Dorset and the maritime towns became marked in the later Middle Ages. In the rural villages life remained constrained by an unchanging round of agricultural labour and the slim horizons of the parish, while the men of the chartered ports saw something of the outside world, as well as the foreign ships that tied up at their quays.

Boroughs or towns with certain privileges (such as the right to hold fairs and markets, or to have their own courts) became increasingly important. In 1066, Lyme, Weymouth, Melcombe and Poole did not exist, but in the thirteenth century, when trade with France flourished, they all emerged as chartered towns, as the older ports of Bridport and Wareham declined due to silting problems. The importance of these new ports became clear when they were ordered to provide many ships and men for the French wars.

Medieval industry in Dorset was centred around the manufacture of ropes, nets and sailcloth at Bridport, its success being linked to the large-scale production of hemp and flax on the nearby rich soils of the Marshwood Vale. Indeed the rope and net industry of Bridport survives to this day.

The Middle Ages were also a time of growth for quarrying on the Isle of Purbeck. Purbeck stone was being used for Sherborne Abbey and for the building of Salisbury Cathedral. There were therefore many skilled quarrymen and masons in the Corfe Castle area who set up their own fellowship, which became the Company of Marblers and Stonecutters of Purbeck. Most of the marble was exported through the quays at Ower. Although the economic expansion of the thirteenth century led to the development of some new trackways, land transport was still woefully inadequate.

After the Civil War

After the civil war between the two rival branches of the royal family (the House of Lancaster and House of York, the so-called Wars of the Roses) had ended with the Battle of Bosworth in 1485, the Lancastrian Henry Tudor triumphed over the Yorkist Richard III. The new king, Henry VII, founded a dynasty that lasted for

▲ The majestic Sherborne Abbey is sometimes referred to as the cathedral of Dorset.

118 years, due in part to his own shrewdness, but also to his good fortune in having John Morton as his advisor.

John Morton of Milborne St Andrew (1420–1500), rector of Bloxworth, was made Archbishop of Canterbury in 1486 and then Lord Chancellor the year after. He was highly influential in state affairs as he was Henry VII's right-hand man for fifteen years. Morton helped Henry VII build up substantial reserves, but he also became wealthy due to his revenue as archbishop and chancellor. He used some of these riches to rebuild Bere Regis Church, most especially the roof, which is made of oak and has twelve carved and painted figures representing the apostles at the ends of the hammer-beams.

By the end of the sixteenth century all Dorset villagers were free men although land was still cultivated using the strip system and each tenant had the right to put animals out to graze on the common. Basically this was an open-field system, which was composed of unenclosed cultivation strips arranged within two or three 'great fields' with each field containing a different crop. A process of rotation amongst these fields allowed a proportion of the land to lie fallow, and therefore to recoup nutrients through grazing, whilst cultivation continued elsewhere. The individual strips within these fields were normally arranged in blocks of arable or pasture known as furlongs, and separated from others by shallow parallel ditches, raised ridges or ledges called 'headlands'. This system meant that an expensive ox and plough could be shared easily between groups of families in the village. The manorial court still continued to oversee the arrangements.

However, sixteenth-century Dorset saw some examples of enclosure. This meant that some of the land, which was part of the open-field system with its scattered strips, was removed. It was then substituted by compact holdings enclosed by hedges, fences or walls and the common or waste land, which had until then been available for general grazing, was converted into

▲ The nave roof of Bere Regis Church is generally thought to have been the gift of Cardinal John Morton, who was not only Rector of Bloxworth but also Archbishop of Canterbury and Lord Chancellor to Henry VII.

enclosed plots. Sometimes these enclosures were carried out amiably, but equally many enclosures were carried out ruthlessly and caused much distress. Indeed, this was one of the reasons for the depopulation of Dorset in Elizabethan times: land was taken from the peasant and returned to the lord of the manor.

Dissolution of the monasteries

Henry VIII's dissolution of the monasteries met with very little opposition in Dorset. Bribes were offered to Thomas Cromwell and to the king by some monasteries to try and obtain an exemption, but to no avail. All the great abbeys of Dorset were swept away in March 1539; they were all taken over in the space of fifteen days by the king's commissioners. All stores of wealth, monastic and chantry property passed into the hands of the king, who then passed it on to local gentry on whom he could rely for support. One of the commissioners, Dr John

Tregonwell, was granted Milton Abbey for £666. He then converted it into a house and home for his family. Most of the monastic buildings in Dorset were destroyed or altered out of all recognition to make mansions. The Dorset monks and nuns who did not resist the dissolution received pensions according to their status. Even after paying these pensions the king was left with vast wealth in the form of land, buildings, fittings and plate.

The effect on everyday life in Dorset was most likely not great. The towns that had grown up round abbeys, like Cerne, Milton and Abbotsbury, continued to flourish as market centres. However, the dissolution did lead to the emergence of a large number of new landowning families. Some rose from yeoman tenant farmers, grasping opportunities, and others acquired land by purchase or marriage. The poor relief that the monasteries had administered had generally been

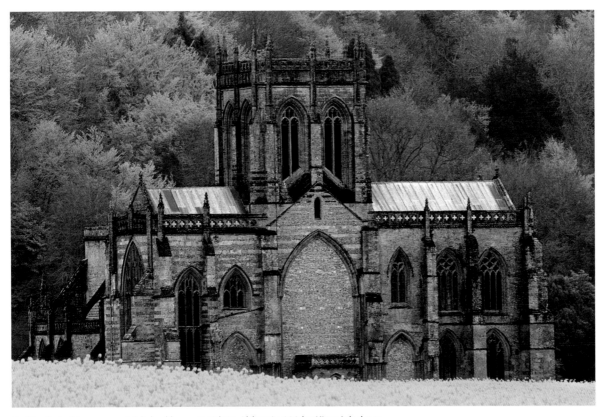

▲ The first abbey was established here, at Milton Abbey in 933 by King Athelstan.

neither large nor well-directed, so was not missed. However, many of the splendid monastic buildings and libraries perished, with little of their wealth used for any public benefit in the county.

The Reformation

Under Henry VIII the doctrines and services of the Church remained basically Catholic, except for the addition of an English translation of the Bible in each church in 1536. During the reign of Edward VI (1547–53) the Reformation entered another radical phase. Parish churches saw the introduction of English services in 1549, the taking down of icons and rood screens, and the obliteration or destruction of many wall paintings, stained glass windows and other 'relics of the popery'. The King's commissioners confiscated all of the surplus plate and other valuables. No parish could retain more than the bare minimum required for the celebration of services. Images and paintings in churches were condemned, the clergy were allowed to marry and all clergy had to use Cranmer's English-language prayer book.

Catholicism had a good deal of support in Dorset but most people found it impossible to remain loyal to the old religion in the face of strenuous governmental pressure. Some of the older families remained loyal to Catholic beliefs during the reign of Elizabeth, including the Turbevilles of Bere Regis, the Martyns of Athelhampton, the Stourtons of Canford and ironically some of the Tregonwells of Milton Abbey, whose fortunes were founded upon the ruin of the monasteries. Most notable of all were the Arundels of Chideock who encouraged and supported many Dorset Catholics. The Catholics, however, remained a minority and it was Puritanism that was to become the strongest religious force in the county.

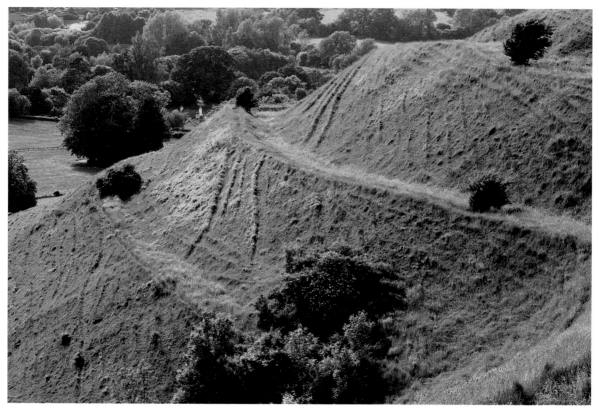

▲ Hambledon Hill is an exceptional place for both wildlife and archaeology and most of the grassland has been untouched by fertilizers or herbicides.

When James I came to the throne in 1603 there arose turbulent times between the King and parliament, and the King and Puritans in the Church of England. When Charles I succeeded his father in 1625 he believed that he ruled by 'divine right'. He therefore ruled without a parliament from 1629 and illegal taxes were levied. Ship money was now required, not just from the coastal towns, but also from landowners inland. Some people refused to pay this unpopular tax until it had been agreed by parliament.

The county had very mixed feelings regarding their allegiance to either parliament or crown. The struggle between Royalists and Parliamentarians often ended up with villages split down the middle. The larger towns generally supported parliament (e.g. Weymouth) while places like Sherborne and Corfe, which had royal connections, sided with the Royalists, and the landowners who had remained Catholic generally sided with Charles.

Civil War

Civil war broke out in 1642. No great battle occurred in Dorset but it did play an important strategic role. Dorset lay on the road to the Royalist stronghold in the south west, and its ports could be relied on to bring supplies from France if need be. The final push came at the Battle of Naseby (June 1645) when, after three years of continual plundering and requisitioning by both sides, the Parliamentarians won the day.

Some Dorset country folk formed a neutral group called the Dorset Clubmen. These ordinary folk were fed up with having their farms and towns overrun by troops who seized their goods and animals, and all the wanton destruction. Armed with clubs, pitchforks and scythes they fought against both sides in a united, but ill-fated, effort to defend their crops and animals. The largest battle in Dorset was in fact waged between the Clubmen and Oliver Cromwell on Hambledon Hill

▲ James, Duke of Monmouth, illegitimate son of King Charles II, landed on Monmouth Beach on 11 June 1685 because of its Protestant sympathies. He then collected an army of volunteers, and began to march towards London.

in 1645. The Clubmen, who outnumbered Cromwell's troops by around four to one fled, with some locking themselves in the church overnight. Most were released unharmed the next day.

The surrender of Portland Castle in April 1646 saw the last Royalist resistance in the county broken.

Charles I was tried and executed in 1649. His son was then acknowledged as King Charles II. His flight after his defeat at the Battle of Worcester to Dorset to obtain a ship to France from Charmouth is well known and documented in the chapter on towns and villages under Charmouth. Charles II eventually escaped to the Continent where he remained until the Restoration in 1660.

The unrest in Dorset was to continue with the succession to the throne of Charles II's Catholic brother, James II, after Charles' death in 1685. The Duke of Monmouth, the eldest of Charles II's illegitimate children, who had gone into exile after the

discovery of a conspiracy in which he was implicated, lived in Holland. He made a bid for the throne and decided to raise a Protestant rebellion in the West Country against the new Catholic monarch. He remembered being well received in the towns of west Dorset and Somerset back in 1665 when he had visited the area with his father. He landed his forces on the beach at Lyme Regis in June 1685 and soon he had many recruits willing to offer their services.

Two customs officials rode hastily to London where they reported the landing to King James II. So Dorset was once again embroiled in national events and the Monmouth Rebellion led to more deaths and executions. The Battle of Sedgemoor saw a decisive defeat for Monmouth and his badly equipped companions who were then brutally treated. Monmouth was executed, and his followers were tried before the cruel and corrupt Lord Chief Justice, Judge George Jefferies. These courts

became known as the Bloody Assizes. On the first morning of these courts, held in the Oak Room of the Antelope Hotel in Dorchester, twenty-nine were sentenced to be hanged, drawn and quartered. The trials were spread over five days with nearly 200 condemned to death and 800 sent to the new world.

James' severe punishments shocked the people of Dorset and when James' wife gave birth to a son who would be reared as a Catholic, an invitation was sent to James II's Protestant son in law, William of Orange, the ruler of Holland, to bring an army to help expel James. This he did, and it was from Sherborne Castle, where he was staying with the Digbys, that he proclaimed he came as a liberator rather than a conqueror. James fled, and was deemed to have abdicated. He was replaced by William of Orange (King William III) and his wife Mary (James' daughter, now Mary II). Thus William and Mary became joint rulers, both Protestants, in 1689.

THE BILL OF RIGHTS AND PARLIAMENT

After the Glorious Revolution of 1688, where the monarch's powers were limited and they were prevented from being or marrying a Catholic, the gentry led society, and became members of parliament and dealt with local problems as Justices of the Peace. The Revolution ended any chance of Catholicism becoming re-established in England; indeed, Catholics were denied the right to vote and to sit in the Westminster Parliament for over a century. Society had a class structure dominated by landowners. The Bill of Rights of 1689 had become the most important document in the history of Britain. It established limits on the powers of the Crown and set out the principle of frequent parliaments, free elections, freedom of speech in parliament and the right to petition the monarch without fear of retribution. It also included no right of taxation without parliament's agreement. The monarchy has not held absolute power since that time.

However, penalties imposed by the law were still savage, mostly hanging, drawing and quartering, and transportation. Crowds would gather for such spectacles, which they were happy to watch. Even lesser offenders, who were sent to the stocks, were treated as entertainment. Passers-by would throw whatever rubbish they could find at the miscreant. Cruel spectator sports such as bear-baiting, bull-baiting and cock-fighting became popular and duelling left many wounded or dead. The development of horse-racing, hare-coursing and fox-hunting was evident. A race course was established in Dorset in 1729 at Tarrant Monkton: the Blandford Races. Thomas Fownes of Steepleton Iwerne was one of the chief instigators of fox-hunting in the country. Much of this information comes from diaries written at the time by squires from Warmwell and Moreton.

There seems also to have been a great interest in gambling at this point in time (the late seventeenth and early eighteenth centuries). The Wynford Eagle Estate was once offered as a lottery prize by its then-owner, William Sydenham, but this went awry when he failed to provide the promised prize and was sent to prison for fraud.

The ordinary people of Dorset, who worked the land, were mostly free men by the end of the sixteenth century. But life was still hard. As tenants of their land they generally cultivated according to the old system of strips of land scattered over three fields with each tenant having the right to graze animals on the common land. But with the spread of more enclosures to cope with the growing number of sheep in Dorset in the sixteenth and seventeenth centuries, hardship and suffering followed for the small tenant who had few rights.

The enclosure of land again became an issue in the eighteenth and nineteenth centuries when some landowners saw an opportunity to make money by producing wheat more efficiently in small enclosures. Steam power began to be used for threshing by a few and other labour-saving agricultural devices were also invented. Intense economic hardship resulted in social unrest. Work was scarce and the first food riots took place as early as 1756 when the harvest was poor. In the late eighteenth century, parish authorities began to supplement the meagre labourers' wages but the system ended up being corrupted by the overseers. Landowners paid less than the going rate, as they knew it would be made up from the 'poor rates'. The overseer, who may

▲ The small hamlet of Wynford Eagle with its manor house.

also have been the landowner, paid the labourer wholly from the 'poor rates' as reported in the Poor Law Report of 1834. Workhouses were the eventual result of this situation. Parishes grouped together to build one workhouse where conditions were to be so grim and repugnant that they would deter everyone, except the most desperate, from seeking its shelter.

Rural poverty

Subsequently, with the end of military service in 1815 after the Napoleonic Wars, 250,000 soldiers swamped the labour market. This, combined with the beginnings of mechanization as well as cheap corn from the Continent, led to a serious economic crisis across the entire country. Riots began in early June in Kent and by mid-November they had spread to Dorset. Lack of political rights put effective action out of the reach of poor labourers with the result that they could only resort to

crime (theft, poaching, smuggling) or blackmail (incendiarism, machine-breaking) to force farmers to pay more. A new Act in 1816 made even *suspected* poachers liable to transportation. Despite this, cases at Dorchester Quarter Sessions of poaching and related offences (like attacks on gamekeepers) rose sharply. There were riots in various Dorset parishes, which were aimed at persuading farmers to raise wages. Labourers went around violently breaking machines in a bid to get farmers to raise wages. Although the riots achieved a measure of success, it was short-lived.

The government was ruthless in meting out punishment and appointed a special commission of three judges to try prisoners in five counties, including Dorset. Many of the prisoners who were tried were sent to Australia and Tasmania. The threshing machine became a symbol of misery for the people of Dorset, as portrayed in Thomas Hardy's novel, *Tess of the*

▲ Beaminster workhouse, now known as Stoke Water House, was opened for use in 1838 and was designed to accommodate 230 inmates.

D'Urbervilles. Near-starvation hit many families across the county, with hundreds either emigrating or ending up at the workhouse.

In direct response to the food riots of 1830, the men of Tolpuddle instigated a 'Friendly Society of Agricultural Labourers', vowing not to accept any work for less than ten shillings a week. George Loveless, a hardworking labourer, with five other members, was tried in 1834 for making an unlawful oath based on an outdated and irrelevant law of 1797. The maximum sentence of seven years' transportation was imposed on them. They were sent in convict ships to the new world for seven years. The actions of the 'Tolpuddle Martyrs' as they became known, had massive public support, and directly led to the creation of trade unions. In 1934 the Trades Union Congress, who meet every year in Tolpuddle, built six memorial cottages in their honour.

DORSET TO THE PRESENT DAY

From the 1830s to the 1930s Britain was heavily involved with the reform of the electoral system. Originally Dorset had twenty members of parliament representing only one per cent of the population of England and Wales. Voters were generally subject to pressure from local landlords and employers as the voting took place openly at the hustings. Bribery was common. The Great Reform Act of 1832 redistributioned seats leaving Dorset with only fourteen members of parliament, but still too many in relation to its total population. There was still no provision for secret voting and therefore intimidation continued. The 1837 Reform Act, which gave the vote to town workers, left Dorset with 'only' nine members of parliament. Farm labourers were eventually given the vote in the third Reform Act of 1884 and in an Act the following

year the number of MPs for Dorset was reduced to four, one for each of the four divisions.

A Great Reformer

Lord Ashley, who later became the seventh Earl of Shaftesbury on his father's death in 1851, was to become one of the greatest campaigners for the weak, young and exploited in the county, and the country. He was deeply concerned about the plight of Dorset labourers who still lived in squalor and after his father's death he was able to renovate many of the hovels on his estate into decent cottages. Another campaigner for Dorset labourers was Lord Sidney Godolphin Osborne, the rector of Durweston from 1848 to 1875. Charles Kingsley, a curate at Pimperne, shared his views. Sidney Godolphin Osborne (SGO) helped to establish allotments to supplement the incomes of labourers and he also encouraged emigration, even finding the money himself for some groups of Dorset folk to pay for their passage to Australia.

The repeal of the Corn Laws, cheap wheat from the prairies of America and cheap imports of Australian wool all led to a farming depression in the 1870s. There was a similar fall in the price of flax due to foreign competition. Landowners were also badly hit as rents had to be reduced or were not paid. Farm buildings were neglected and water meadows fell into disuse. The number of sheep kept in the county fell dramatically, which eventually made way for dairy farming.

The effect of this depression on a county so dependent on agriculture was widespread. There was a rapid decline in the population between 1871 and 1901 as farmers reduced their labour force. Girls went into domestic service and boys set off for industrial areas to find work. The depopulation of villages was happening at an alarming rate. In 1851 two thirds of the population of Dorset lived in villages but since then this has reversed with at least two thirds of the population at least now living in towns.

With the advent of the railway, Weymouth and Swanage grew steadily as holiday resorts, which also assisted the nearby areas of Dorchester, Poole and Portland. The towns generally managed to retain their level of population or even slightly increase it, as can be seen between the censuses of 1801 and 1951. During the war years of 1914 to 1918 there was a small revival in agricultural fortunes: the return of prosperity was brought about by a need for home-produced foodstuffs. Government intervention in agriculture and rural life was apparent after the war, with the Forestry Commission being created. This was responsible for planting large areas of the Dorset heath with fast-growing conifers, which led to the landscape being dramatically altered in the east of the county.

Since the 1920s, with the arrival of the petrol engine, greater transport opportunities have arrived in Dorset. The isolation of country districts is not so desperate as people are able to commute to their place of work. Small coastal resorts can now be reached by road. Many people are coming to Dorset to retire but rural depopulation is still going on today. Some villages are semi-deserted in winter because of the high proportion of second homes, which has also led to a reduction in village amenities. The proportion of villages with no second homes in Dorset is tiny.

Dorset's Industrial and Cultural Heritage

How man has influenced Dorset

Few people think of Dorset as being particularly industrial, but there is much evidence of a variety of manufacturing activities within the county. The major industries have been agriculture, the quarrying of stone and clay, rope- and net-making, and brewing and milling. For many centuries man has used the natural gifts that Dorset has to offer for his own purposes. The remnants of these activities can be seen all over the county to this day. The Domesday survey lists 278 mills and various salt pans along the coast but it gives no indication of any sizeable industry. Later, in Medieval times, there were many important industries such as the wool, textile and rope industry, making use of the large numbers of sheep that were reared in the county. All these industrial activities resulted in a need for specific buildings or facilities, whether on a large or small scale.

FARMING

Once out of the reaches of Poole and Bournemouth, Dorset is a rural county whose landscape has been greatly influenced by agricultural activities over the centuries. Agriculture has also been the most significant economic activity in the county. Until relatively recently most inhabitants were either directly or indirectly reliant on farming for their livelihood.

Dorset has been farmed for thousands of years. The biggest landowners during the Domesday survey were the Crown with its extensive royal lands and the wealthy Benedictine monasteries. Estate records were carefully kept by the monastic houses and royal officials; the wealth created is obvious when observing the size of the monastic barns at Abbotsbury or Cerne Abbas.

As the population grew, so more land had to be brought into cultivation by creating terraces on hillsides, which could then be ploughed for cereal crops. The chalk downlands bear witness to such activities. Along the South Dorset Ridgeway there is clear evidence of the older Celtic field system as well as strip lynchets. These strip lynchets or 'terraces' meant that more land could be ploughed, thus increasing the food that could be produced. Once the terracing was complete, the slope was reduced, meaning oxen were then able to plough a piece of land that would otherwise have been too steep. Many of these strip lynchets can be observed across the county. A process of rotation within this field system allowed a proportion of the land to lie fallow and recoup its nutrients through grazing, whilst cultivation continued elsewhere. Most of Dorset followed this open-field system during the Medieval period.

The dissolution of the monasteries, with the confiscation and sale of monastic lands and property, led to opportunities for enterprising families to take over released lands.

Enclosures between the sixteenth and nineteenth centuries brought more changes to the landscape and did away with much of the common land where grazing was allowed by any tenant. This resulted in the patchwork field effect that could be seen in much of Dorset before hedgerows were grubbed up to make way for larger fields that would allow larger machinery to be used. The big estates concentrated on the profitable sheep markets to satisfy the demand for wool and cloth as the work was less labour intensive.

Water meadows are an unusual agricultural feature; they were developed in the seventeenth century to improve the grass in the early part of the year for sheep

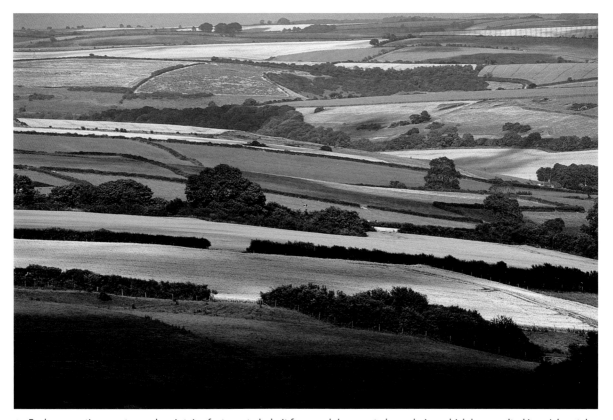

▲ Each generation creates and maintains features to help it farm and demarcate boundaries, which has resulted in a rich patch-work of fields.

and cows. These water meadows were an intricate network of ditches, hatches, channels and drains. The meadows were fed from a fast-flowing chalk stream which would be diverted to cover the land with a thin layer of free-flowing water in order to protect it from frost and encourage the early growth of grass. This also deposited some fertile silt on the land. This system meant that larger herds could be kept. Water meadows are especially evident along the River Frome and its chalk streams; examples can be seen at Nunnery Mead near Maiden Newton, Stinsford and at Winfrith Mead.

The years leading up to the Tolpuddle Martyrs saw undreamt-of prices for farm produce. The desire to increase yields led to many 'improvements' including more enclosures and more pasture being given over to arable farming; the landlord became wealthier at the expense of his tenants and labourers who were kept in poverty, in poor housing and with long hours of work.

The large landowners increased their acreage by amalgamating small tenant farms into their own and bringing together the inconvenient scattered strips of arable land.

Conditions for the agricultural worker were to become even worse, resulting in the Swing Riots of November 1830. New ideas, breeds, fodder crops and techniques were being experimented with at this time, and the farming industry prospered. Labour-saving machines were introduced, which disadvantaged the agricultural workers. The once labour-intensive job of harvesting the corn crops with reapers, stokers and threshers was now completed by one combine harvester. There was more pressure for greater efficiency and productivity, which led to a renewed campaign for more enclosures and a massive extension of cultivation on the downlands.

The chalk downlands, which have a poor thin soil, have generally been maintained by the large number of

▲ Water meadows at Nunnery Mead have channels to carry water on to the pasture and then to drain it off again. The intention is to encourage early growth and to protect the roots from frost.

When the railways reached Dorset in the mid-1800s it meant that farm produce could be transported to burgeoning Victorian centres of population rapidly. The numbers of dairy cattle increased extensively in the clay vales of north Dorset and the lush farmland of west Dorset. Milk, butter and cheese, which was produced on these dairy farms, could be transported to the big cities quickly, ensuring that it reached the customer fresh. In 1873 there were 75,000 cattle in the county and by 1913 nearly 100,000. The growing market for liquid milk ensured dairy producers of a good return with little competition from foreign imports. Pork, eggs and poultry, which were once kept by most rural residents, were also exported to the cities. But quicker and easier transport also meant that artificial fertilizers, machinery and other farming improvements could be transported to Dorset more easily, creating a catalyst for change.

Generally, the inter-war years were hard with no guaranteed prices, and buildings, hedges and fences fell into disrepair. Horses were still the main providers of power for farms. It was not until 1939 that agriculture once again flourished in the county, but with a smaller workforce than before.

It has been since 1939 that the greatest changes in agriculture have been seen. In that year, tractors and horses were used in roughly equal measure. But new technologies and machinery, as well as government subsidies and marketing boards, led to more cereal production and the improvement and further expansion of dairy farming.

Tractors, combine harvesters, grain-driers and milking machines sprouted everywhere due to incentive schemes and subsidies. Changes then came apace with pesticides, herbicides and fungicides being used to maximize crop production along with larger fields and farms. Working horses disappeared from the land and even sheep gave way to new crops like oil-seed rape, maize and linseed. Silage has replaced hay for winter food, leaving traditional hay meadows to fall into disrepair.

The changes have made small, family-run farms more of a rarity. The introduction of milk quotas and supermarket supremacy, with the low prices they were

sheep reared in the county over the centuries, but large areas of this open sheep grazing land was ploughed in the mid-nineteenth century and used to grow cereals. This was made possible due to the use of fertilizers, which then destroyed much of the flora in these areas.

Waterwheels pumped water, ground animal feed, powered equipment such as chaff cutters or threshing machines and in some later cases generated electricity. In the nineteenth and early twentieth century the use of the agricultural traction engine for haulage, ploughing, threshing and sawing was introduced. Horse-drawn portable steam engines could also be found at work on many farms, often hired on contract.

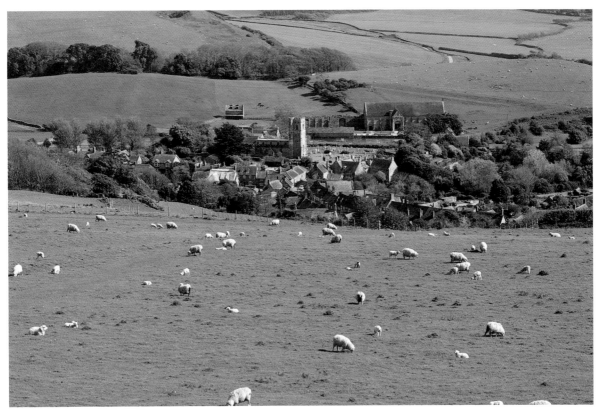

▲ The sheep flock was the pivot for animal husbandry.

paying the dairy farmer, made it virtually impossible for family-run farms to survive. Farms can no longer be run as a way of life, they are big business and have to maximize production in order to stay afloat. Farms have either had to expand to take advantage of the economies of scale or they have had to diversify or specialize in niche markets. Mixed farming is still seen on Dorset farms: sheep, beef, cereals, pigs and even watercress, with some farmers diversifying into allotments, holiday lets, DIY livery and garden nurseries. Organized pheasant shoots have also sprung up in many areas over the last few years, but mostly in west and north Dorset. About half of Dorset is under arable cultivation. Local food production is valued highly, as are high welfare standards for farm animals. Conservation schemes that protect species or habitats that are under threat are helping to ensure the environment remains sustainable for all to enjoy and assisting farmers to maintain their income. However, now only two per cent, or less, of the

total population of Dorset work in agriculture and its allied industries.

Watercress has been grown in Dorset since the 1850s and Dorset is now a large producer and supplier of it. This crop can be grown due to the pure water from the chalk rivers, especially at Waddock Cross, Cranborne and Bere Regis.

Indeed, the rivers and streams of Dorset have traditionally provided power for corn mills in the form of waterwheels and later in the form of turbines. Waterpower was used in the breweries, foundries, flax mills, saw mills, silk mills and paper mills. There were paper mills at Wareham, Wimborne and Beaminster. The relics of these industries can be seen on most of Dorset's rivers. Some of these mills are now being restored and made productive once again. Upwey Mill near Weymouth, for example, is generating electricity for the national grid. Other rural industries being encouraged in Dorset include the production of wood

▲ Upcerne Manor situated in its own parkland setting.

fuel from small woodlands, which are being managed for the benefit of humans as well as wildlife. Farm co-operatives have developed, ensuring that food is grown and prepared locally before being sold at local markets. Generally, it appears that the Dorset farming community is cautiously optimistic about the future of farming in the county.

TEXTILES, ROPE, SAILCLOTH AND NET

Much raw wool was exported from the county through Melcombe and a market for wool was set up there in 1364. Manufactured cloth was also exported. Our knowledge of this largely comes from enactments concerning the evasion of duties. Substandard cloth is also recorded, emphasizing the fact that Dorset cloth did not compare favourably to that of Gloucestershire, Devon, Wiltshire or Somerset. The main types of cloth produced and exported in the sixteenth century in Dorset were 'kersies' (a twilled narrow cloth, made from inferior grades of carded wool spun into thick yarn) and the 'Dorset dozens'; both were coarse woollen fabrics. These were exported to Brittany and Normandy. The wealth created from the wool and cloth trade in the fifteenth and sixteenth centuries is evidenced in the building of many of Dorset's manor houses.

In the seventeenth century serges and lighter cloths were made mostly in Sherborne, Dorchester, Gillingham and Wareham. Shaftesbury and Sturminster Newton were centres for the making of 'swanskin', which was a coarse, white, woollen flannel or cloth used for uniforms and the Newfoundland fishermen (more on them later).

By the 1720s stocking knitting had become an important industry for Wimborne and Stalbridge; as the textile trade declined, other cottage industries sprang up: stocking knitting in Winbourne and Stalbridge; button-making in north Dorset, especially Shaftesbury; glove-making; and lace-making, Blandford lace being

▲ Linseed was the basis for many useful products including fine cloths, strong lines and ropes.

celebrated as some of the finest. Daniel Defoe, writing in 1731, thought that Blandford bone lace was better than that from Flanders, France or Italy. Unfortunately, due to the fire in Blandford in 1731, the entire town was burned down (except for twenty-six houses), which resulted in the lace trade declining. Most of the actual spinning and weaving had been done in labourers' own homes, hence the term 'cottage industry'.

The manufacture of rope, sailcloth, twine and nets are all associated with the Bridport area, which has been a location for making rope since the thirteenth century. In 1213 King John ordered the Sheriff to 'cause to be made at Bridport, night and day, as many ropes for ships both large and small as they could, and twisted yarns for cordage'. The rich soils of the Marshwood Vale were highly suitable for growing hemp and flax, upon which the industry was dependent. The flax was grown on the hillsides and the hemp grown in the fertile, alluvial valley bottoms. Hemp and flax were also grown extensively between the coast and Beaminster. Bridport hemp was said to be the finest in Europe.

Net and rope was in demand by the navy and the shipping industry for centuries. An Act of Parliament secured in 1530 forbade anyone from selling hemp within a five-mile radius of Bridport. It could only be sold in Bridport market. This achieved a virtual monopoly during the later sixteenth century. 'Rope walks' were set up in Burton Bradstock where the oppressive regulations of Bridport could be avoided.

Both hemp and flax were essential for Bridport's net and rope industries and for the production of linen and sails. The evidence of their importance in the past can be seen in names such as Flax Close, Flax Shop Orchard and Hemplands. The 'rope walks', long straight strips of ground, also give an indication of the importance of the industry. Indeed, hemp and flax were so important nationally that a bounty was paid (3d per stone for hemp and 4d for flax) to growers in the nineteenth century.

▲ Portland stone is recognizable by its creamy colour and fossilized shells. It is extremely durable as well as being easy to work.

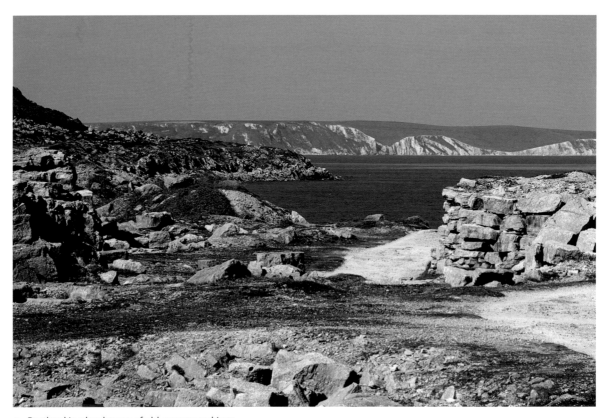

▲ Portland is a landscape of old quarry workings.

Rope making, and the production of sailcloth eventually employed more than half of Bridport's population, while ten times that many worked in the outlying villages, mostly as part of a cottage industry. Net-makers and twine-braiders would often work from their homes.

William Stevenson commented in 1812 on the very large numbers of people who were employed in the rope and sailcloth industry, calling it 'the principal manufactory of this county'. Other occupations associated with hemp and flax included flax-dressers, flax- or twine-spinners, hemp and flax-bollers and hecklers.

The number of mills in Bridport and in the surrounding area is a clear indication of how extensive this industry was. Production methods changed very little until the late nineteenth century. Small-scale flax-growing was not uncommon. A small field would be rented and sown with flax, which would then be kept weeded by the renter and his family. The crop was harvested by hand and tied into sheaves, which were then placed in water. During the winter months the family would separate the fibres from the rest of the stems by 'retting' (or rotting) the stems in streams or ponds. Once dried, the process of swingling began, which meant beating out the unwanted plant material or straw. The flax was next heckled or combed: the fibres were sent through wires ensuring that the fibres were parallel. The fibres were then spun and woven into linen cloth by cottagers in their own homes. Gradually the streams of the area were harnessed for water-power and the flax mills and factories would take the fibres. The seed (or linseed) was saved for next year's crop.

Although Dorset was the leading county for the production of both hemp and flax, the acreage for both crops began to decline dramatically in the face of increased competition from foreign imports. In the seventeenth century Bridport also faced competition from rope walks created in Plymouth, Portsmouth and by the Royal Navy at Greenwich.

The industry then became dependent on foreign, imported raw material. There was a further decline in the industry in the 1960s, due to globalization and new manufacturing processes, and the last rope to be made in Bridport was at Rendall and Coombe's ropeworks in West Allington in 1969.

Bridport Gundry Ltd (amalgamated from J. Gundry and Co. with Bridport Industries) became Bridport Aviation in the 1990s. It had been the largest rope and net producer in Europe in the early sixties but in the nineties began to design and manufacture nets for the aviation industry. The company is now AmSafe and is the largest manufacturer and supplier of pilot, crew and passenger restraints for the aviation market.

STONE QUARRYING IN DORSET

The Purbeck and Portland stone-quarrying areas have enjoyed national fame and reputation and quarrying has been a major industry in Dorset for centuries, generating much employment.

Portland stone is readily quarried and easily worked, yet strong and durable. In 1839 there were fifty-six quarries for Portland stone, employing 240 men. The quarries mostly occur in the Jurassic limestones and quarrying has left the Portland landscape scarred with old workings. Portland stone does not seem to have been used much in the Middle Ages, only a little in London, locally and at Exeter Cathedral. It was not until the seventeenth century that the really extensive use of Portland stone began. It was used on the Banqueting House at Whitehall and, after the fire of London in 1666, the stone was chosen by Christopher Wren for the new St Paul's and many of the other new City churches.

Demand continued throughout the eighteenth and nineteenth centuries. During the nineteenth century, large quantities of Portland stone were used at the Royal dockyards at Chatham, Portsmouth and Devonport. Convict labour was used on the Isle of Portland to construct the massive breakwater and deep harbour between 1848 and 1872. The idea was that Portland Harbour could then be used to shelter and protect ships from storms, as well as to form a strong naval base as a defence against the French. The naval dockyard at Portland, one of the largest man-made harbours in the world, is now a civilian port and recreational area.

Purbeck stone, which can be divided into many categories or 'beds', was first used by the Romans for

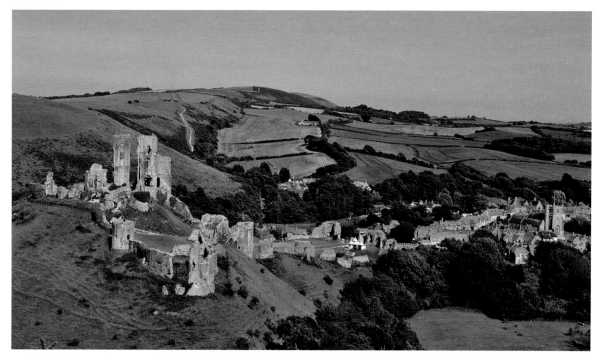

▲ Corfe Castle was the centre of the Purbeck stone industry.

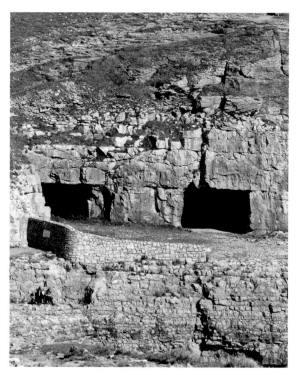

▲ Purbeck marble was mined extensively during the Middle Ages in the Purbeck Hills and exported by boat from Tilly Whim caves.

tombstones and other memorials. Purbeck marble then became famous in the Middle Ages, when polished shafts of it were used in churches all over Britain and abroad. Purbeck stone was also used in the Middle Ages for effigies, fonts, coffin lids and sepulchral monuments of all kinds. The chief centre of the industry was at Corfe Castle where many of the 'marblers' and quarry owners lived and had their yards for dressing and polishing the stone. The stone was sent by sea from Ower, on the shores of Poole Harbour, and from several other places along the coast, from Tilly Whim to Windspit. Later it was exported from Swanage, before it became a tourist destination.

After the Reformation the demand for stone for ecclesiastical purposes ceased but it was still quarried for secular buildings including Dorset manor houses and roofing tiles. Paving stones were exported from the port at Swanage. Daniel Defoe, in the 1720s, commented on the use of Purbeck stone in London for 'paving court-yards, alleys, avenues to houses, kitchens, footways on the sides of the highstreets, and the like'. In the nineteenth century the stone was again in demand for the

large number of new churches being built in the Gothic style.

Limestone quarrying took place around Purbeck, Bridport, Marnhull and Sherborne. Limestone and chalk were quarried to burn in limekilns to produce quicklime. Coal and culm (imperfect anthracite) for burning the limestone were imported. The lime produced was for building mortars, limewash and lime plaster, as well as lime for spreading on the land. From the mid-seventeenth century, lime began to be used as a soil conditioner and a means of reducing soil acidity. Most of these limekilns were small, often serving a single farmer's needs or, at most, those of a hamlet or village. Many of the limekilns were located at isolated spots. The last limekilns still working in the county were at Shillingstone Lime and Stone Co. Ltd.

After agriculture, quarrying has been one of the most important employers of labour in the county.

PORTS, SHIPPING AND FISHING

The sea has been a means of transport since prehistoric times and Dorset's maritime history goes back many centuries. The most visible evidence can be seen in Poole and Weymouth, the largest ports, where warehouses, cranes and repair yards are evident. Fishing has always been an important occupation along the Dorset coast: in the Domesday Survey of 1086 fishermen are mentioned at Lyme Regis and in the neighbourhood of Weymouth. Many men probably combined fishing with farming, or some other occupation, and were not therefore listed as fishermen in the survey.

In the reign of Elizabeth I, Dorset men began fishing off the coast of Newfoundland and by the reign of James I this activity was very important. Throughout the south west of England the cod-fishing industry became a major cultural tradition. Migration to Newfoundland was not unusual, even though the sea voyage was dangerous and demanding. Fishing was one of the hardest occupations on Earth and this migratory fishing was very risky work. These seasonal migrants, who also came from surrounding inland villages and market towns, had to endure the ice-infested waters off the Newfoundland coast, crossing the Atlantic in small

▲ A Purbeck stone pillar, built to support the roof of the quarry.

wooden sailing vessels. Despite this, men and boys would flock to Poole to sign on as sailors, tradesmen, fishermen or servants in the Newfoundland trade. Most returned home in the autumn, but some stayed on for longer periods and some for good. Back at the ports of Poole or Weymouth the benefits of this trade was tangible: new regional economies became established as the fishing industry contributed to the growth of income and wealth for numerous families and many communities. It also furthered trade and business in surrounding inland towns and villages. The Newfoundland trade was dominated by Poole and continued until the nineteenth century. This trade was the foundation of the prosperity of Poole.

▲ The perilous Mupe Rocks, with their intensive folding, were the cause of many shipwrecks.

Early voyages were just for fish but then the ships carried rope, nets and cordage from Bridport, plus cloth and other articles for trade. They also brought back skins and furs. Much of the fish caught was salted and carried to Spain, Portugal and Italy although some was sold in England. The trade also fostered the shipbuilding and fitting industry as well as providing a valuable market for home-produced goods.

At Poole the Customs House, which was built in 1813, can be seen on the quay as well as the Harbour Office, which was built in 1820. Warehouses can be seen on the quayside at both Weymouth and Poole.

West Bay Harbour was in existence in the thirteenth century, and during the Napoleonic Wars (1803–1815) sixteen ships were built here. A large number of ships were registered in Bridport, with many of them being built in a yard where Heron Court now stands. At one time West Bay had six slipways, which could be used for launching and repairing vessels or just for beaching them.

West Bay Harbour was improved in the 1740s and many ships were recorded as using it, sailing in and out of the long narrow entrance as they do today. Ships once sailed the mile up the River Brit to the town to support the vital flax and hemp industry, but it became silted up. In 1793, a total of 1,800 Bridport people and 7,000 from its surrounding areas were employed in the rope and net trade.

On the river near Bridport is the significantly named Port Mill, where flax was boiled or softened by blows of heavy timber. The intensive shipping activity was inseparably linked with the prosperity of Bridport, as without the harbour the rope-making industry could not have flourished. Today, fishing, including trawling, continues and there is much pleasure-boating, the harbour being filled with small craft, but the import and export trade has long since been lost.

The stone quarrying industry used the sea to transport much rock from loading places along the east side

▲ A burial mound on the South Dorset Ridgeway.

of Portland and along the Purbeck coast.

Cliffside cranes, at exposed loading places, lifted the stone onto waiting ships. Using a 'whim', a special type of wooden crane, the finished stonework was lowered from the quarry ledges to a rock ledge almost level with the surface of the water. Another crane was then used to load the stone onto barges. The boats either shipped the stone directly to the stone yards on Swanage Quay or transferred them to large sailing ketches or barges anchored offshore, ready for the next stage of their onward journey.

Barges were also used for transporting Purbeck ball clay from small piers at Ridge, Middlebere and Goathorn to larger ships at Poole, which then transported the clay on to the Staffordshire potteries.

The perils of the sea were and are always present. Many boats were wrecked on Chesil Beach, Portland, Mupe Rocks, Seacombe Cliff and Durlston Head. Medieval manorial lords were keen to obtain the rights

of wreck. Portlanders especially became well-known for praying for wrecks so that they could plunder them rather than rescuing the drowning, as seen in 1795 when six military transports went to pieces on Chesil Beach.

No canal ever reached Dorset but one nearly did. A scheme was planned for the Dorset and Somerset Canal from the Kennett and Avon near Bradford to the Stour below Shillingstone from where the river could be made passable through to Christchurch. But due to the length of time an Act of Parliament took to be completed, the canal mania had collapsed before it was passed, and so it never got started.

ROADS, TRACKS AND LANES

Dorset was almost entirely avoided by the major through routes from London to Devon and Cornwall. This has greatly influenced the history of Dorset and the character of the county.

▲ Roman roads have been incorporated into the modern road network.

The present roads of Dorset are a complex network of ancient trackways which have in places been amalgamated into modern roads or lanes. These ancient trackways provided a system of communication long before the Romans and they continued to be used by pack-horse traffic and sheep- and cattle-drivers for centuries. This communication network was vital for communities in the past. Two of these ancient trackways were supremely important in prehistoric England, with one road running from Salisbury to the south west via Ashmore, Melbury Abbas and on to Lambert's Castle. The second, the Southern Ridgeway, possibly ran from the Isle of Purbeck to the Devon border and beyond across the southern part of the county. This ridgeway route is marked along the whole of its length by burial sites and mounds. The views from it across Chesil Beach to Portland and the English Channel are stupendous.

The Romans added to these ancient trackways, often making use of them if necessary. The road from Dorchester to Eggardon is an example of this. The Romans built their roads to enable rapid troop movement in their quest for conquest. The main one was from London to Exeter by way of Silchester, Salisbury, Badbury and Dorchester. Another ran from Poole Harbour northwards to Badbury and then on to Wiltshire. The third road ran from Weymouth northwards through Dorchester to Yeovil and on to the Fosse Way at Ilchester. This is still part of the modern road system today.

After the Romans there was little road-building in the county for quite some time as the principle of making each parish responsible for the roads passing through it, which dated from the time of Elizabeth I, had never worked well in practice. By law each able-bodied man was required to give six days' labour, or cash in lieu, every year. But work was skimped and badly directed.

The Enclosure Acts had a direct influence on the development on the road system. Land that was once

▲ Most tollhouses were built by turnpike trusts beside their tollgates, like this one at Athelhampton.

arable and cultivated under the ancient open-field system gradually became enclosed by hedges, which resulted in smaller separate fields. Later Enclosure Acts dealt with common and waste ground only, since the large arable open fields had already been enclosed. One important result of the Enclosure was that it compelled the improvement of roads. As fields were now hedged, cutting across the fields was no longer an option, so the enclosed routes had to be given a hard surface to keep them passable in winter or wet weather.

An eighteenth-century development was that private individuals built roads themselves and then charged for their use. A long pole or 'pike' would block the road but once the toll had been paid, the pole would be swung (turned) out of the way, allowing the travellers to proceed. So turnpike trusts evolved. These were intended to make road users pay for the upkeep of roads instead of parishioners. Several of the most important

Dorset routes were 'turnpiked' from 1750 on and others were gradually added up until 1841.

Tollhouses generally stood opposite a tollgate or turnpike. These were single-storeyed or two-storeyed buildings with a bow front. There are a few good examples in the county, like at Bradford Abbas, Dorchester and Athelhampton, but not many have survived as homes. The trusts had their own milestones and mileposts in their own styles, the early ones being stone.

The turnpike roads of Dorset fell into twenty-five trusts, nearly all of which were set up between 1750 and 1780. All had ceased to operate by 1883. At the height of their popularity and influence, about 1840, before the railway came, the turnpikes of Dorset comprised about five hundred miles of road. The most successful route was the east–west route through the county via Blandford, Dorchester and Bridport, which fell under only two trusts. It became the mail coach route after 1784.

For all its shortcomings the turnpike system did at

least make possible the great age of coaching. In 1791 the Weymouth mail-coach did the journey to London in eighteen hours and light coaches managed it in fifteen hours by 1825. The last stage coach ran through Cerne Abbas in 1855, a town avoided by the railway, which meant that it was then totally isolated.

However, with the introduction of the railways, roads in general became less important and the government was finally obliged to step in and meet a quarter of the cost of maintaining turnpiked roads. In 1889 the former turnpikes became the responsibility of the newly founded county councils.

TRADITIONAL DORSET FINGERPOSTS

A legacy of the developing road system is the signage that was used to aid travellers and road users. Dorset has its own distinctive and unique fingerposts, which contribute to the local character of a place. These fingerposts were first erected as a result of the 1903–4 Motor Car Act and each council could develop their own style of directional post. Many of these unique fingerposts were removed, along with milestones, in 1940 after the government decided that these signposts could provide guidance for an invading enemy. Many of these fingerposts, with their directional fingers topped off with a circular finial or roundel, which proclaimed the place name and the grid reference, were therefore sent for scrap and lost forever.

Four of the surviving fingerposts are painted red, which has elicited much conjecture. Are they the sites of gibbets? Of suicides? Or places for overnight stops when conveying convicts on their way to the port for transportation?

There is a project run by the AONB to find and record as many of the Dorset traditional fingerposts as possible. It is then hoped that individuals, parishes, groups or companies might support the project by electing to sponsor the repair and restoration of these posts to their former glory. Indeed, Dorset's iconic fingerposts are already used by many Dorset companies as a feature of their branding.

THE RAILWAYS

Before the railways came to Dorset the census of 1841 showed that its population was 174,743, which was a large increase from the 1801 census. Dorset has very few minerals apart from Portland and Purbeck stone, and had not felt the effect of the Industrial Revolution. A few small industries were established in Dorset – sail-cloth in Bridport, buttons in Shaftesbury and Blandford, silk-working in Sherborne and stocking-knitting at Wimborne. But even the long-distance shipping trade of Poole was completely dwarfed by farming. The distribution of population was decided by agriculture, the size of a village dependent upon the productiveness of the land. Beaminster at this time had six inns, twelve ale-houses, fourteen cobblers, ten tailors, eight butchers, seven blacksmiths and four wheelwrights.

Apart from early horse-drawn tramways on Portland and Purbeck, which were used to transport stone and clay to the quays, the railways did not reach Dorset until comparatively late. The Merchants Railway on Portland was built in 1826 for the quarrying industry, to enable stone to be transported from the top of the island to waiting ships. Otherwise, there were no large towns or industrial centres to attract the railway builders.

The first passenger line in the county was not completed and opened until 1847. It was a single, narrow-gauge line. This was the Dorchester and Southampton Railway, which ran by way of Wimborne, Poole Junction, Wareham, Wool and Moreton to Dorchester. It joined the already-finished London and Southampton Railway and so gave through transport from Dorchester to the capital. This remained the only railway in the county for ten years. Weymouth had to wait until 1857 for its trains: the Wiltshire, Somerset and Weymouth line. The final route was from Westbury through Yeovil, Yetminster, Evershot, Maiden Newton, Frampton, Dorchester and finally to Weymouth. Interestingly, there was a public outcry at the time as the line threatened the hill fort at Poundbury as well as Maumbury Rings, the Roman amphitheatre in Dorchester. Both were saved from destruction.

In 1857 the Bridport Railway opened, running from Maiden Newton through Powerstock and then on to

▲ A selection of traditional Dorset fingerposts.

▲ The railway did not pass through Beaminster, which left the town isolated.

▲ The railway at Maiden Newton still serves west Dorset, providing invaluable links to the outside world.

Bridport. The London to Exeter line via Salisbury and Sherborne progressed to Sherborne in 1860 and then reached Exeter in the same year. This route was particularly important for quickly transporting dairy goods from the Blackmore Vale to London.

In the early days of the railways Bournemouth hardly existed, but as it grew in importance new tracks were laid to approach it from Christchurch and Poole. Not till these were linked up in 1888 and the Hole Bay curve was built north of Hamworthy five years later could the main London line be diverted from Wimborne to run through Bournemouth as it does today. The extension from Weymouth to Portland in 1865 was a direct result of the development of the naval base and the further line to Easton was mainly intended for quarry traffic. Both are now closed to passengers.

Abbotsbury was once reached by a single track railway which was planned in 1877 and completed in 1885, when visiting the seaside became a popular pastime as, no doubt, did visiting the Swannery. The train chugged through the valley from Upwey under Ridgeway Hill, and the engine was housed in a little brick shed. It was axed by Beeching, as it was not profitable, so in 1952 it was closed and finally dismantled.

By 1862 nearly all the important market towns in Dorset (with the exception of Shaftesbury) had railway. However, Swanage and Lyme Regis were still served only by horse conveyance from the stations of Wareham and Axminster. The route to Swanage was opened in 1881, but the Lyme line was so difficult – because of the hills and the steep gradient – that it was not progressed until the beginning of the twentieth century.

▲ The bustling Swanage Railway terminus, where you can begin or end a nostalgic journey on a steam train.

Construction began in June 1900 and it was opened to passengers in August 1903, but it closed in 1965. The inconvenience of the station, being some way from the town, no doubt influenced people's reluctance to use the train. There is now no evidence of the station remaining.

The railway network of Dorset was an important means of transport for farm labourers during the 1880 agricultural depression; they were able to seek work in more prosperous areas or even abroad. It was virtually complete by 1885 and it had a great effect on the life of people who lived in the towns through which it passed: Sherborne, Gillingham, Bridport, Weymouth and Dorchester. They became thriving centres of population. Conversely, the towns through which the railway did not pass quickly went into decline – Cerne Abbas

and Beaminster were left isolated and their prosperity melted away. The turnpike roads were also affected, causing a serious decline in road traffic and therefore revenue.

There was little industry to benefit from the railways, but they made a great difference and influenced the changeover to dairy farming by providing quick transport for milk to the capital. They also opened the seaside resorts to the mass of late-Victorians who could afford, for the first time, a summer holiday. Travelling time between Dorchester and London was cut from fourteen hours by coach to four hours and later to three. But today many of these railways have ceased to operate, or may even have been removed and the stations demolished, leaving most of Dorset once again only accessible by road.

▲ Palmers Brewery on the River Brit was built in 1794 and has been brewing ever since.

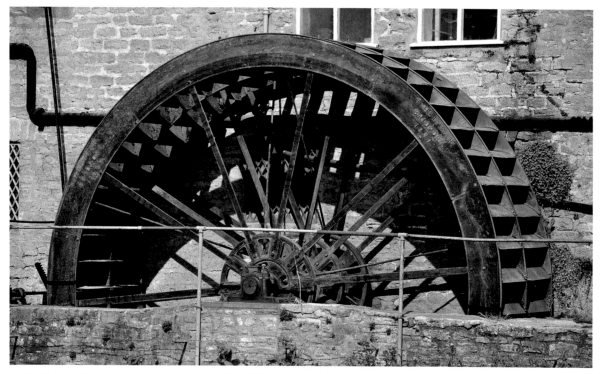

▲ The Palmers Brewery waterwheel was forged in 1879 at a Bridport foundry, and is still in good working order.

BREWING

Dorset's breweries are among its best industrial monuments. In 1889 there were thirty-two brewers in the county. Many villages had their own small brew-houses such as at Marnhull, where there were five malthouses. Cerne Abbas was noted for its malting and brewery until the 1820s. Many village malthouses have become homes, the names of which indicate their history (e.g. Malthouse Cottage). Generally the brewers' malt came from local barley, which was grown throughout the county.

The well-known Dorchester brewery, Eldridge Pope, was built in 1880 with direct sidings from the London and South Western Railway, which enabled hops from the Netherlands to be used as they could be imported via Poole and then transported by train. Eldridge Pope closed in 2003.

Hall and Woodhouse Brewery in Blandford is still brewing. Its origins go back many centuries and the original malthouse can still be seen at Ansty (it is now the village hall).

Palmers Brewery in Bridport has been brewing on the same site since 1794. The thatched brewery is on the banks of the River Brit, along with the waterwheel, which still turns. Only these two Dorset family brew-eries have managed to survive over the centuries. However, the trend of brewing in small villages is returning to Dorset. Ten real-ale breweries have opened since 2003. These are located in villages and towns right across the county.

BUILDING MATERIALS

Historically, most of Dorset's towns and villages were built from materials that were available to builders locally. The geology of the county is therefore responsible for the visual character of the humble dwellings of rural Dorset, which reflect the variety of available building stones. These vary from the dark-brown heath-stone found near Wimborne Minster, to green sandstone found in the north in the Shaftesbury area, golden-coloured limestone in the west of the county and the silver limestone from Purbeck. Churches and larger

houses may have had materials brought from elsewhere, such as the golden Ham Hill stone, which was brought from Somerset for high-quality buildings. Portland and Purbeck stone were also used, though they are both hard and more expensive to work. Cob, the humblest building material, was a mixture of mud, chalk or clay with straw, which was built wet to a certain height and then left to dry before another wet layer was added. It is easily and inexpensively created, hence it was used to construct a great many cottages.

Clay has been used for brick-making throughout Dorset with the greatest concentration around Poole. This clay was also known as 'pipe clay' as it was used for making clay pipes back in 1650. In the eighteenth and nineteenth centuries clay was also exported to the Minton and Wedgewood potteries.

Clay is still produced in the county. Nowadays, ball clay is considered to be of national and international importance because of its special qualities and rare occurrence. Ball clay is relatively scarce globally and is an essential ingredient of perhaps half of the world's production of sanitary ware. One company is now responsible for extraction from surface quarries, which are generally well-hidden behind trees.

The Blue Pool beauty spot was once a clay pit and the deep-blue colour of the water is due to clay particles suspended in the liquid.

Bricks were used for some of the larger houses and in the towns. There are only a few brick cottages, usually found where bricks were actually made. Most of the brickworks were in the south east of the county where there was a great demand for building in Poole and Bournemouth. In the past, brick-making has taken place in at least 170 sites in Dorset. These brickworks would have also produced tiles, water pipes and sanitary ware. The clays from different geological periods produce different-coloured bricks. Some large estates even had their own brickworks, such as at Charborough Park where there is a two-mile brick wall beside the A31. Most brickyards have been destroyed but there are a few clues of past activities in the name of a street or road, like 'Brickyard Lane' or 'Brickyard Cottage', which can still be seen throughout the county.

Dorset is littered with delightful manor houses, most of which grew up as the centre of operations for a large farm or estate. The character of the county of Dorset itself reflects the old pattern of a market town with a cluster of cottages around the church and manor house. The decay of the manorial system and the building of 'gentlemen's seats' in the eighteenth century often meant the destruction of the old manor houses. But generally Dorset was slow to change, which is one reason for its large number of manor houses of the Stuart, Tudor and even Medieval days. The high-quality building stone has also increased the chances of the buildings surviving over the centuries.

THE SOUTH DORSET RIDGEWAY

The South Dorset Ridgeway is a chalk ridge lying from east to west across the south of the county. This high ground stretches from Broadmayne in the east to Kingston Russell in the west and is mainly chalky downland, providing a bridleway and footpath for cyclists, riders and walkers. It is a fantastic landscape covered with lumps and bumps, which provide a tantalizing glimpse of what life might have been like thousands of years ago during Neolithic and Bronze Age times. It also retains an undeveloped rural character and a sense of tranquillity and remoteness. It is an awe-inspiring route, which follows some of the most spectacular coastal views along its entirety.

The route passes near to Abbotsbury, Maiden Castle and Chalbury Iron Age hill forts. It also passes Hardy's Monument, built in 1844 to commemorate Admiral Sir Thomas Hardy (flag captain of the *Victory* at the Battle of Trafalgar), and above the Osmington White Horse, constructed to commemorate the many visits to Weymouth of King George III.

The chalk Ridgeway is pure limestone and attracted settlements thousands of years ago as it supplied many of the requirements for early settlers: flint for making tools, freshwater springs and dry high

ground to facilitate travel. It is now recognized that the South Dorset Ridgeway has an extraordinary wealth of archaeology with over 3,000 sites including barrows, henge monuments, Iron Age enclosures and a possible Romano-British village.

The monument most commonly associated with the Neolithic period is the 'long barrow' and there are at least ten of them on the South Dorset Ridgeway. These are elongated earth and stone mounds most probably used for ceremonial purposes such as communal burials.

During the Bronze Age (around 3000 BC onwards) it was the round barrow that dominated the landscape of the Ridgeway. These round mounds had a funeral purpose, generally for an individual; many have been excavated revealing human remains either as inhumations or cremations with personal artefacts accompanying the remains. Other Bronze Age monuments found along the Ridgeway include stone circles, which were presumably used for ceremonial purposes. Winterborne Abbas and Kingston Russell have fine examples of these stone circles, with many similarities to Stonehenge. They date from 3000 to 2000 BC and it appears that they were a ritualistic meeting place marking important times in the agricultural year. The Kingston Russell stone circle is about twenty-four metres across and all of the eighteen stones are lying down.

The Valley of Stones was probably a quarry and the source of building stone for megalithic sites. Rough blocks of hard sandstone, otherwise known as sarsen stones, are strewn about the valley in an apparently haphazard fashion.

During the Iron Age (around 800 BC) the Ridgeway dwellers would have continued using the Ridgeway as a convenient route for travelling, but their main monument was the hill fort. Abbotsbury Castle, Chalbury Hill and Poundbury Camp are hill forts adjacent to the route as is, of course, Maiden Castle, the biggest and most famous of all the hill forts.

WESSEX RIDGEWAY

The Wessex Ridgeway is a 138-mile trail following a magnificent ridgetop route. It runs from Marlborough in Wiltshire to Lyme Regis on the Dorset coast; it was thought to have once been an important ancient highway and trading route between the Devon and Norfolk coasts. In times past, these ridgeway routes would have provided open uplands for communication and the transportation of animals. Low-lying areas would most likely be muddy, overgrown and less accessible.

The trail forms part of the Great Ridgeway, an ancient highway, and evidence of our prehistoric past is a constant all along the route. There are Neolithic causewayed camps and long barrows, along with Bronze Age barrows which dot the hilltops. There are magnificent Iron Age hill forts such as Hambledon Hill, Hod Hill, Rawlsbury Camp and Pilsdon Pen, which dominate the landscape. Out of the twenty-seven hill forts in Dorset, seven can be found on this route.

Hambledon Hill is also a National Nature Reserve, owned and managed by Natural England. On this 180-acre chalk downland site you will see many butterflies and wildflowers, some of which are very rare.

Hod Hill, which is a large hill fort, covering fifty-four acres, has been used by Bronze Age and Iron Age people, as well as having a Roman base here around the beginning of the first century AD.

Superb views can be had from Hambledon Hill, Bulbarrow Hill and Rawlesbury Camp as well as Lambert's Castle and Coney's Castle. Along the way the explorer will pass many attractive villages such as Sydling St Nicholas, Chilfrome, Lower Kingcombe, Hooke, Toller Whelme and Beaminster. Views of the mysterious Cerne Giant can be glimpsed on the hillside.

The journey is made up of a series of steep ascents which then drop into the valleys, ensuring that the traveller will be compensated with stunning views of the Blackmore and Marshwood Vales. These steep ascents will also ensure that the walker is exhausted!

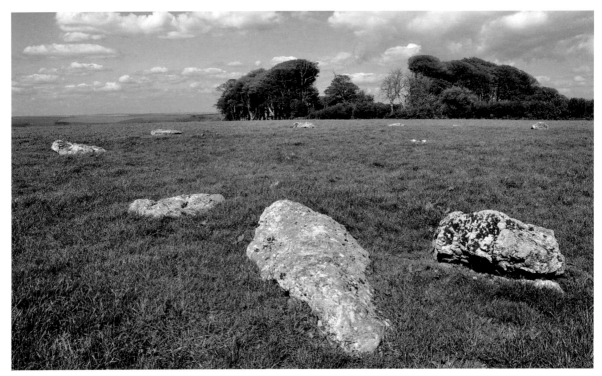

▲ The Kingston Russell stone circle has eighteen stones arranged in a circle, which is roughly thirty metres in diameter.

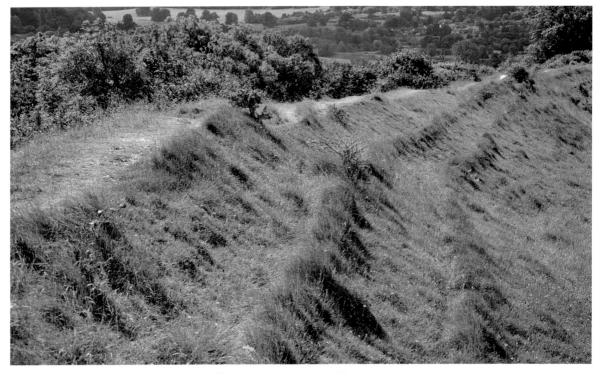

▲ The Hod Hill Iron Age hill fort was captured by the Roman army in 43 AD.

How Dorset has influenced man

Dorset is a county of great beauty and a land of contrast and breathtaking scenery. This rural, rugged landscape with its hills surrounded by steep valleys, its vast areas of chalk grassland, its buttercup meadows with peaceful cows chewing the cud unperturbed, its smooth and ancient hills, rounded against the sky which swell up like waves, lanes that wander from village to village in an unhurried and untidy fashion and rivers, brooks and fickle winterbornes; all these things are an inspiration to residents and visitors alike. This beautiful county holds many secrets of the past in its landscape as well as being the inspiration for many artists, writers and poets through the centuries up to the present day.

THOMAS HARDY (1840–1928)

Thomas Hardy was born in the hamlet of Upper Bock-hampton on 4 June 1840 in a cottage on the edge of 'Egdon Heath'. He was the eldest of four children. He went to school at Bockhampton and then in Dorchester and was later articled to John Hicks in 1856, a Dorchester architect. From 1862 he worked in a London architect's office. Here he was able to take advantage of all that London had to offer in relation to theatres, exhibitions, galleries and public meetings as well as writing in his digs at night, reading extensively and trying out various verse forms. He returned to Hicks in Dorchester in 1867 due to ill health. Here he began to write fiction, encouraged by the fact that there was a vast readership for fiction published in serial form. His first successful book, *Under the Greenwood Tree* was published in 1872 and drew directly on his family and village experiences in Dorset. Indeed, nearly all his major novels are set in Dorset where he vividly and dramatically portrays the countryside – the vale, the down and the heath, the three distinctive parts of the county. Place names are thinly disguised –Abbot's Cernel as Cerne Abbas and Kingsbere as Bere Regis. In addition, his characters reflect the genuine humble folk of the villages and small towns, providing an authentic picture of Dorset life at that time.

Hardy met Emma Lavinia Gifford, his future wife,

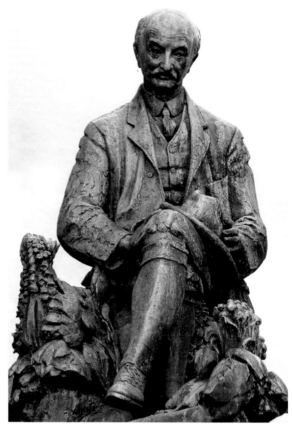

▲ The Thomas Hardy statue is located at the Top o' Town in Dorchester; the memorial was sculpted by Eric Kennington and unveiled in 1931.

when he went to Cornwall in 1870 for his work as an architect, specializing in ecclesiastical restoration projects. They were married in September 1874 and lived in various places for the first few years including London, Sturminster Newton and Wimborne. Hardy eventually acquired land outside of Dorchester on which he could build his own house, which he designed and called Max Gate. They moved in June 1885. This house was a significant contrast to the cottage he was born in. While living at Max Gate he wrote some of his greatest masterpieces: *The Mayor of Casterbridge*, *The Woodlanders*, *Tess of the d'Urbervilles* and *Jude the Obscure*.

On acquiring his first bicycle in 1895 he was able to revisit many old haunts, and new haunts, which once again fired his creative juices. And on the death of his

▲ Barnes' commemorative statue is at St Peter's Church in Dorchester. The bronze statue was unveiled on 4 February 1889 and is the work of sculptor Roscoe Mullins.

▲ William Barnes is buried in the churchyard at Winterborne Came; his grave is marked by a large cross.

wife Emma in 1912 (even though the marriage is said to have only been a mask of respectability) his imagination was awakened and poetry flowed. In 1914 he married Florence Dugdale, his secretary and researcher. He died in 1928 having immortalized the Dorset landscape and people in his stories and poems. His ashes are interred in Poet's Corner at Westminster Abbey, but his heart is buried in his beloved Stinsford.

WILLIAM BARNES (1801–1886)

William Barnes was a nineteenth-century linguist and poet who wrote in the Dorset dialect. He was born in the village of Bagber at Rushay Farm, near Sturminster Newton, in 1801 into a poor farming family. The farmhouse is no more. There were six children in total, five

sons and one daughter. His mother died when he was only five. He had to leave his local school at the age of thirteen but, encouraged by the local parson, he went on to work as an engraving clerk at a solicitor's office and then became a schoolteacher. In 1823 he opened a school in Mere, Wiltshire, to improve his prospects with a view to being able to marry the woman he had fallen in love with, Julia Miles. They were eventually married at the parish church of Nailsea in 1827, where her parents were living. Later they moved to Dorchester where they ran a school.

In 1848, Barnes took an external Bachelor of Divinity degree at Cambridge University and he was ordained into the Church of England in 1850. In 1852 his wife died, leaving him totally bereft, except for their six

▲ The small remote village of East Chaldon, with only a handful of houses, is also known as Chaldon Herring.

children: Laura, Julia, Lucy, Isabel, William and Egbert.

Barnes became parson at Whitcombe with Winterborne Came, a small parish just outside Dorchester, in 1862 and remained there until his death in 1886. He died in his sleep on 7 October and is buried in the little churchyard of Winterborne Came.

Barnes reportedly taught himself sixty languages including Welsh, Hindustani, Hebrew, Greek, Latin and many modern European languages. He was keen to purge the English language of its classical Greek and Latin influences so that it could be understood by ordinary folk without a formal education. He wanted the language to return to its Saxon roots.

His legacy of dialect poetry gives a picture of the life and language of rural Dorset, which had almost disappeared at the time he was writing. His first collection, called *Poems of Rural Life in the Dorset Dialect,* was published in 1844 and translated into 'common' English in 1868. His *Glossary of Dorset Dialect* was published in

1863. His best-known poems include 'The Mother's Dream', 'Evening and Maidens' and 'In the Spring', which was set to music by Ralph Vaughn Williams. He published many books of poetry during his lifetime. The simplicity of the images and sentiments he portrays give a most sensitive feeling for the beauty of nature and the variety of human relationships which would often bring his audiences in Dorset to laughter and then to tears. Barnes' deep love of the Dorset countryside, country ways and country people endeared him to fellow Dorset men who saw in him a simple and genuine human being.

THE POWYS BROTHERS

The three Powys brothers were from a family of eleven children who often visited their grandmother in Weymouth. The three brothers were all novelists who knew and loved the village of East Chaldon. They were: John Cowper Powys (1872-1963), the most

▲ The storm of 23 November 1824, when the sea came crashing over the Chesil Bank, badly damaged the small church at Fleet.

famous of the brothers, who set three of his early novels in Dorset – his ashes were scattered off Chesil Beach; Theodore Francis Powys (1875–1953), who lived in East Chaldon for many years and had his portrait painted by Augustus John; his brother Llewellyn Powys (1884–1939), who also lived in East Chaldon for many years and whose ashes are buried on the clifftop there. His *Dorset Essays* (1935) paint a picture of several parts of Dorset and are an interesting read for someone in the twenty-first century. There is a memorial stone to Llewellyn Powys between the village of East Chaldon and the sea.

HENRY FIELDING (1707–1754)

Henry Fielding, a pioneer of the English novel, spent his early years at East Stour in north Dorset. He also visited Lyme Regis in the summer of 1725. Although his works do not contain specific descriptions of places, much of *Tom Jones* (1740) is set in Dorset and has characters that

are known to have been based on people in Dorset. Mr Oliver, the curate of Motcombe, may well have been the model for Parson Trulliber in *Joseph Andrews*.

JANE AUSTEN (1775–1817)

Jane Austen came with her family to Lyme Regis in 1804 and lived there for some time. Many scenes in her book *Persuasion* are set there and some of the descriptions are even recognizable to this day.

JOHN FOWLES (1926–2005)

John Fowles was deeply affected by the Dorset landscape. The setting for *The French Lieutenant's Woman* is Lyme Regis and gives a broad picture of the town in the 1860s. Fowles knew every inch of the settings he used in the novel but he bought his house in Lyme after he had finished the book. Belmont House, with its far-reaching views and acres of garden, is now to be a residential centre for young writers.

JOHN MEADE FALKNER (1858–1932)

John Meade Falkner wrote the children's adventure story *Moonfleet* (1898). It is a tale of smuggling in the eighteenth century set in the village of Moonfleet. Moonfleet is based on East Fleet on Chesil Beach in Dorset. Portland Bill is the headland called the Snout, and exciting scenes are set among the cliffs and caves of the Purbeck coast. The thriller is full of contraband, coffins, castles and connivances at midnight. The setting is as riveting as the plot.

THE WORDSWORTHS (WILLIAM 1770–1850 AND DOROTHY 1771–1855)

Brother and sister William and Dorothy Wordsworth set up their first home together from October 1795 to 1797 at Racedown Farm, near Pilsdon. Up until that point their lives had been unsettled. Their mother had died when they were eight and seven respectively, and their father died six years later. The five children were then scattered in different places.

William was most enthusiastic about the beauty of the area and would ramble over the rolling countryside for hours at a time. It was here that he really got to know his sister and how imaginative and observant she was after years of separation, but Dorothy missed the Lakeland Fells, otherwise known as the Lake District.

ENID BLYTON (1897–1968)

Enid Blyton was one of the most successful British authors of the twentieth century. The Famous Five, the Secret Seven and Noddy are just a few of the household names she created. She visited Dorset many times a year, which provided the inspiration for many of her books and characters. Kirrin Castle is believed to be based on Corfe Castle and Whispering Island is based on Brownsea Island. In Enid Blyton's day it was owned by a reclusive Mrs Bonham-Christie, who would not endure visitors and allowed the island to return to nature. Blyton described it as 'Keep Away Island'. Mystery Moor is reputedly based on the heath between Stoborough and Corfe, and Finniston Farm is based on Blyton's own farm at Stourton Caundle, which she only ever visited.

SIR THOMAS WYATT (1509–1542)

Sir Thomas Wyatt, the father of the English sonnet, is buried in Sherborne Abbey.

RUPERT BROOKE (1887–1915)

Brooke spent several holidays at Lulworth and reportedly wrote his famous poem 'The Soldier' while training at Blandford Camp.

SIR CHRISTOPER WREN (1632–1723)

Wren used Portland stone after the Great Fire of London in his rebuilding of St Paul's Cathedral. Wren served for a time as MP for Melcombe Regis

J.M.W. TURNER (1775–1851)

Turner was a landscape painter, the master of light, and he toured Dorset and the west in the summer of 1811. He painted many views of Dorset including Poole, Corfe Castle, Lulworth Cove, Lulworth Castle, Weymouth and Lyme Regis, which were then reproduced as a book of engravings called *Picturesque Views of the South Coast of England*.

JOHN CONSTABLE (1776–1837)

Constable was drawn to Dorset and painted Weymouth Bay in the time of Hardy's grandparents when it was a haunt of smugglers. Constable honeymooned at Osmington in 1816, which proved to be an inspiration for many of his paintings.

AUGUSTUS JOHN (1887–1914)

Augustus John lived with his family and artistic friends at Alderney Manor Poole from 1911 to 1927. Many of his paintings had a Dorset setting, especially Swanage, where he had stayed in 1899.

REVEREND HENRY MOULE (1801–1880)

Henry Moule, was not only a rector but also a radical reformer and fearless campaigner. He was convinced that the cholera epidemics in Dorchester in 1849 and 1854 were caused by appalling sanitation. He wrote a series of letters to the Prince of Wales, who was the landlord, decrying the terrible housing conditions of the

▲ John Constable honeymooned at Osmington in 1816 and found inspiration in the local landscape.

poor and accusing the Duchy administrators of neglect. He received no reply. But later this area became the model for Thomas Hardy's Mixen Lane in the Mayor of Casterbridge.

As a result of the Industrial Revolution and the threat to ancient monuments in the county, the poet, William Barnes, and the vicar of Fordington, Rev. Henry Moule, decided to form an organization that would protect the Roman legacy and the natural history of the area. They founded the Dorset County Museum and Library on 15 October 1845.

HENRY JOSEPH MOULE (1825–1904)

Born in Dorset, Henry Joseph Moule was the oldest of the seven surviving sons of the Rev. Henry Moule and Mary Moule. Thomas Hardy, when a young boy, was a frequent visitor to the Moule's vicarage. Between 1856 and 1860 Henry taught Thomas Hardy to paint. Henry remained a close friend of Thomas Hardy for fifty years, until Henry's death.

Henry became curator of Dorset County Museum in 1883 and as Honorary Secretary of the Dorchester Sketching Club he took sketching parties around Dorset. His lasting legacy is a unique record of several thousand watercolours he painted. This was the result of walking out into the locality and countryside every day to sketch the landscape. This record provides a vivid and unique insight into Victorian Dorset and strongly evokes the Wessex of Thomas Hardy's books.

OTHER NOTABLE FIGURES

Dorset also spawned earlier artists such as Sir James Thornhill (1675–1734), Alfred Stevens (1818–75), Giles Hussey (1710–88) and Thomas Beach (1738–1806).

They all worked on various assignments from decorating palace interiors, to sculpture, to portraits, but were not directly inspired by the Dorset countryside.

It is not just artists and writers in the past who have found inspiration in Dorset's truly awesome landscape. Contemporary artists and writers queue up to use the county's mysterious and wild landscapes for backdrops or as the main subject for books or paintings.

Nicholas Hely Hutchinson, who lives in the heart of Dorset, gets much of his inspiration from the surrounding countryside and the coast. He celebrates that he is able to visit the most interesting and varied coastline with its dramatic chalk cliffs and tranquil bays and beaches in a matter of minutes.

David Juniper is inspired by the unspoilt wilderness of west Dorset to create some of his idealized views. Hugh Dunford Wood, who lives in Lyme Regis, was drawn to the place because of the sea and the landscape, which, he says, is feminine, fierce and unpredictable, and still has an edge of wilderness to it. Liz Somerville, from Cattistock, draws inspiration for her work from the varied coastal scenery. John Walker celebrates the ancient, magical and historic landscape of Dorset as well as the mystical monuments where he feels the closeness of those who have gone before and those who are to follow. His images and imagery are drawn from his experience of the countryside and reaction to the folklore of the magnificent Dorset coast.

Dorset is home to many writers, including children's writer and illustrator Babette Cole, author of *Mummy Laid an Egg,* and Rachel Billington, author of *A Woman's Age*. Ian McEwan's *On Chesil Beach* is set in a hotel on Chesil Beach. Dorset-based crime writer Minette Walters uses Dorset as a setting and inspiration for many of her novels including *The Shape of Snakes*, *The Breaker*, *Fox Evil* and *The Ice House*.

Writer Chris Chibnall, who lives in Bridport, found inspiration for the *Broadchurch* series when he was out walking on the Jurassic Coast. He works out his scripts by walking across the cliffs and beaches of west Dorset where he lives.

Julian Fellowes, writer and actor, became famous when his *Gosford Park* screenplay won an Oscar.

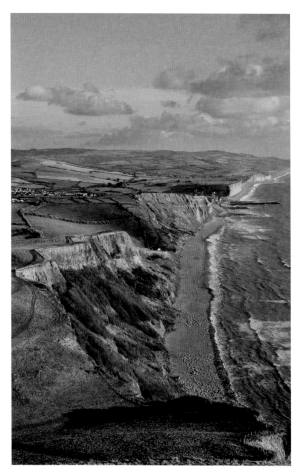

▲ The coast has been, and continues to be, responsible for inspiring artists and writers through the centuries.

Fellowes has also written *The Young Victoria,* a 2009 film starring Emily Blunt, *From Time to Time*, a 2010 film adaptation starring Dame Judy Dench, and the widely enjoyed TV series *Downton Abbey*. He now lives in West Stafford where he involves himself in many local causes and enjoys strolling with his wife and his dogs in the countryside.

And then of course there is Dorset Visual Arts, a charity that aims to develop and manage activities which promote the work of the many artists, designers and makers who live and work in, and find inspiration from, Dorset. During the last Dorset Arts Week there were over 600 studios that could be visited, which is surely an amazing tribute to Dorset and the positive and creative effect it has on people.

Natural History

The diversity of landscape types across Dorset support a greater range of wildlife species than most other English counties. In landscape terms, Dorset is a county of contrasts as the topography can be dramatically different from one area to another. The county coastline, for example, is the border between land and sea. The flat, gentle landscape of the Poole basin contrasts starkly with the great Purbeck Hills. The arable farmland around Dorchester and its hinterland looks very different from the rolling hills and valleys of the south west of the county. From north to south differences are evident between the large, rounded chalk hills of Fontmell and Melbury, Hambledon and Hod and the sinuous ridgeway which runs from Old Harry rocks through the south of the county.

These varied landscapes translate into a range of different habitats, which, in turn, support a vast array of species. Many species of wildlife are specifically linked to particular habitat types and some even require precise micro-habitats within them. For example, the haresfoot clover is a shoreline plant, which can be seen near the Ferrybridge centre on the Chesil Beach side of the Weymouth to Portland causeway. But this plant does not occur on the Portland Harbour side of the causeway

▲ The steep sides of Cowdown Hill near Sydling St Nicholas are of little agricultural use other than for grazing sheep.

because it thrives only near the tideline of mudflats, not on shingle, as is found on the opposite side of the road just a few metres away.

The need for nature reserves to be established for the protection of wildlife surfaced during the latter half of the twentieth century. At that time, naturalists began to realize that some native species of flora and fauna were declining at an alarming rate. Since then, and with the variations of habitats across the Dorset countryside, a multitude of nature reserves have emerged, many of them within the AONB. The National Trust, Dorset Wildlife Trust, Natural England, Butterfly Conservation, Plantlife, RSPB, and even town and county councils all own or manage nature reserves within the county.

Chalk downland

How often have we stood on one of Dorset's impressive hills, like Eggardon or Hambledon, admiring the open countryside stretching away into the far distance before us? A sprawling patchwork of green fields may make magnificent scenery, but the meadows and pastures we view today are not what they once were. In fact, from the point of view of native flora and fauna, this is a green but not a pleasant land. The vast majority of the green fields of Dorset constitute an industrial landscape, which is little more than hostile wasteland to our native wildlife. The advent of chemicals, driven by market forces to eradicate wild insects and plants in order to increase the yield of crops, have turned these once flower-rich meadows into sterile deserts. While standing on one of Dorset's great chalk hills, it is only the habitat immediately beneath our feet that now remains unspoilt or 'unimproved'.

A broad finger of chalk stabs diagonally across the county from north east to south west, before swinging eastwards towards Old Harry and his Wife at the entrance to Poole Harbour. The thin soils on the chalk support a unique and varied range of native plants, many of which can only be found on the high downland hills. These flower-rich downlands have survived because the great chalk hills have proved to be too steep to plough. Their only practical use in farming has been for grazing, mainly by sheep, resulting in a unique habitat of thin soil on calcareous strata, rich in flora and invertebrate life. Some of the best-known chalk downlands in the county can be seen on the hills of Eggardon, Hambledon, Fontmell and Melbury Downs. On the mainland cliffs in east Dorset, chalk downland survives in glorious condition on Old Nick's Ground, Ballard Down and Bindon Hill. In winter, these downland hills can be bleak, with constant south-westerly winds bringing rain from the Atlantic, but during spring and summer the diverse range of native flora and associated insect life transforms the landscape.

Traditionally, these hillsides are managed by sheep grazing in order to maintain the diversity of the sward. The environmental conditions that can affect these habitats include summer drought and winter frosts, together with poor soil quality. These factors, together with the regular grazing, ensure that no individual species is able to dominate the sward, therefore resulting in a very wide range of plant species.

Eggardon Hill can be seen throughout west Dorset, and from its summit there are spectacular views across the west end of the county. It is the final frontier of chalk in the south west, the tip of the finger of white rock pointing southwards. It was the site of an Iron Age settlement; an area of thirty-six acres includes vast defence systems made up of deep ditches and high banks. These man-made banks and ditches provide vital shelter from the westerly winds for the flora and fauna here. Looking across the patchwork of fields and copses to the west it is hard to imagine that at the time the ancient Britons constructed these ramparts, they would have looked out on a landscape covered in broad-leaved trees just like Powerstock Common is today.

Taking in the view towards Maiden Castle from Gould's Hill, on the road from Martinstown to Chickerell, it is easy to see why ancient Britons settled here. The site was chosen as a fortress because it is the largest hill of this shape in the area. Human activity began here as early as 3000 BC, and over centuries the fortress was enlarged. Maiden Castle is, in effect, a chalk downland habitat supporting specialist flora and fauna. The slopes support an interesting variety of wild plants and creatures, due to the calcareous substrata

▲ A veteran oak tree in the oak woods of Powerstock Common, a last remnant of the ancient wildwood which covered most of Dorset.

and the management regime. Just like at Eggardon, a carefully controlled grazing programme is maintained at the site in order to preserve the fine grass sward, which is rich in wild flowers and butterflies.

FLORA

Of all Dorset's different habitats, none boasts such a high density of native flora as unimproved chalk grassland. Most of the county's landscape has been disturbed by man at some time or other, usually resulting in a greatly impoverished flora. However, on many of these steep downland hillsides unimproved grassland has survived in its purest form, erupting in a mosaic of colourful plant life during the summer months.

In early summer, the slopes are speckled with pale yellow cowslips and early purple orchids. The chalk seems to produce a plethora of orchids which include twayblade, greater butterfly, common spotted, pyram-idal, bee and fragrant. Although all of these orchid species are found elsewhere in the county, they are most abundant on chalk downland. In high summer, places such as Fontmell and Melbury Downs are literally smothered in a colourful mix of chalk-loving wild flowers. Some of the flowers typically found on these hills include ploughman's spikeneard, melancholy thistle, wild mignionette, clustered bellflower and squinancywort. The lemon yellow of lady's bedstraw decorates the steep slopes in June and July. The name of this lovely flower is derived from the time when it was picked and placed in the beds of gentlewomen to keep away bedbugs!

Other species to be found in abundance on these hills include small scabious, carline thistle, dwarf thistle, wild thyme, toadflax, eyebright, bird's-foot trefoil, harebell and hoary plantain. At the end of summer, the diminu-tive autumn gentian and a late orchid, autumn lady's tresses, also occur at many of these sites.

▲ The pyramidal orchid is abundant on chalk downland during mid-summer.

INVERTEBRATES

Throughout the flowering season, the downlands are teeming with invertebrates, especially butterflies which feed and lay eggs on the chalk-loving plants. In spring, such species as dingy and grizzled skippers and the Duke of Burgundy fritillary can all be seen on the Cerne Giant hill. During high summer, chalkhill and Adonis blues feed on the nectar of scabious, knapweeds and thistles, the latter laying its eggs on horseshoe vetch. In some years, the chalkhill blue can be extremely abundant with vast colonies building up. Hundreds of individuals may be seen at rest in sheltered ditches, soaking up the last rays of sunshine on summer evenings. The chalkhill blue lays its eggs on vetches, especially bird's foot trefoil. Other butterflies found on these downlands include wall brown, marbled white, clouded yellow, meadow

brown, common blue and the silver-spotted skipper. The latter is an uncommon species, and in Dorset it is only found reliably on some of the great chalk hills like Fontmell and Melbury. At first it appears like a tiny day-flying moth, but closer observation reveals the typical butterfly antennae tipped with orange. The insect gets its name from the silvery spots on the undersides of the wings. This is a restless butterfly and is difficult to observe as it flies quickly and close to the ground, stopping only occasionally to sip nectar from dwarf thistles or to lay its eggs on sheep's fescue grasses.

The nectar-rich flora attracts many other insects too; day-flying moths are abundant, including six-spot burnet and the silver Y. The wood tiger moth is particularly plentiful in the sheltered bowls of the chalky slopes around Cattistock. This is an attractive day-flying moth, which is easy to observe as it frequently rests at ground level.

Other invertebrates occurring in healthy numbers on the chalk hills include longhorn beetles, crab spiders, meadow grasshoppers and yellow meadow ants. Anthills are a typical feature of the thin soils on chalk and are constructed by the yellow meadow ant. Typically, yellow meadow ants swarm from these 'castles' on humid days in late July or August.

BIRDS

One of the summer visiting birds to appear early in the year on the chalk downlands of north Dorset, where it recovers from its long-haul migration flight, is the wheatear. Typically, this white-rumped bird sits atop fence posts on the steep downs, making frequent sorties, chasing and darting after early insects.

The skylark and meadow pipit both nest on the ground in lush areas of sward, forming their cup-shaped nests in the grass, while linnet and goldfinch build their nests in thorn and gorse bushes. In springtime, the meadow pipits sing in the air as they slowly descend from explosive, vertical songflights and skylarks hover excitedly high overhead emitting their chattering songs. In late summer, flocks (or charms) of tinkling goldfinches flutter around the thistle and knapweed seedheads.

▲ The Duke of Burgundy fritillary has declined in Dorset to the point where it has been lost from many of its former haunts.

Kestrels regularly hunt over the downland slopes, hovering almost motionless as they watch for signs of movement in the tussocks below.

The anthills, which quickly become colonized by wild thyme and rock roses, also attract that most flamboyant of birds, the green woodpecker, as it probes the anthills with its bill and long sticky tongue searching for ant eggs, its staple diet.

Jays are especially fond of hopping around the anthills too, poking their beaks into the earth mounds. Known in birding terms as 'anting', a jay will stir up a nest and crouch over it with wings spread to encourage the ants to crawl onto its plumage. The agitated ants attack the bird with toxic chemicals, like formic acid, in defence of their nest. Such poisons are very effective against other invertebrates and thus help the bird to reduce populations of parasites living within its own plumage, a kind of insecticidal shampoo!

MAMMALS

Hares are typical of chalk downland. In the northern chalk belt, where they are most abundant, the courtship of these mammals may be witnessed, as two animals stand on their hind legs kicking at each other with their front feet. Hare boxing, as this is known, is often mentioned as taking place in March, along with the saying about 'mad March hares'. But this behaviour can actually occur at any time of year and is usually the result of unreceptive females fighting off amorous males. Maiden Castle, together with the surrounding fields and arable hinterlands, are ideal habitats to see this magnificent animal. Unlike rabbits, hares do not burrow, but lie up in coverts or hedges and sometimes even in the open with their long ears flattened against their bodies.

▲ The brown hare is fairly common on the chalk downlands of north Dorset and may also be seen around Maiden Castle.

Woodland

Dorset's woodlands broadly fall into three main categories: broad-leaved, coniferous and mixed. Some of the finest examples of mature, broad-leaved woodland within the AONB exist at Powerstock Common, Bonsley Common, Woolland Hill and parts of Blandford Forest. Elsewhere in the county there are further broad-leaved woodlands at Duncliffe, Fifehead and Piddles Wood. Ancient broad-leaved woodland is the purest forest habitat, supporting the maximum species of wildlife. The magnificent primeval oak wood of Powerstock Common is considered by many as Dorset's finest remnant of the ancient wildwood, which covered southern England after the last ice age. It can be an awesome experience just to walk in these woods in the knowledge that they have existed continuously for around 10,000 years!

From Eggardon Hill the view to the north takes in the massed crowns of these ancient oak trees. Deep

OLD NICK'S GROUND AND BALLARD DOWN

Old Nick's Ground and Ballard Down, which both fall within the AONB, are some of the finest examples of chalk downland. The flora and fauna typical of chalk are well represented at these sites. Reach this area from the footpath up to Old Harry rocks from the National Trust car park near the Bankes Arms pub in Studland. Some of the wild flowers occurring here include such species as crosswort, kidney vetch, pyramidal orchid, lady's bedstraw, yellow-wort, marjoram, bladder campion and wild carrot. A nationally uncommon flower that can be seen here is the Nottingham catchfly, so named because it was first found on the walls of Nottingham Castle. It does not catch flies, but releases a heady perfume at night, which attracts moths and other nocturnal insects to pollinate it.

▲ A carpet of bluebells in early May, in a small broad-leaved plantation near Beaminster.

inside this primeval landscape the twisted trunks of the oaks stand amongst dense hawthorn thickets and clumps of pendulous sedge.

Between Dorchester, Wareham and Poole, there are huge tracts of conifer plantations. These are the forests of Wareham, Puddletown and Moreton. Such large areas of coniferous woodland do not support much native wildlife, but they have become important habitats for some species. These evergreen woodlands have been planted on heathland sites, and along the rides and in the clearings heathland plants still dominate.

There is more mixed woodland in Dorset than either coniferous or deciduous. This is because recent plantations have tended to be a mixture of hardwoods and conifers. Examples of mixed woodland can be seen in Ashmore Wood in north Dorset, Blandford Forest and Hooke Park near Beaminster. In east Dorset, where the Scots pine occurs naturally, many of the woodlands are a mix of silver birch, Scots pine and pedunculate oak. The Arne peninsula is a classic example of where these three tree species dominate.

FLORA

Woodland wildflowers are most abundant in spring, having evolved to adapt to the conditions of their natural habitat. Plants like ramsons, campion, bluebell, stitchwort and yellow archangel have each developed short, early flowering seasons in order to coincide with the maximum availability of sunlight under trees. By the time the foliage of deciduous trees opens and the dark shadow of the canopy is cast across the woodland floor, these flowers will have set seed and this stage of their annual task will be complete. The colour of spring is yellow at the beginning, with celandines, daffodils and primroses, eventually reaching a crescendo of blue as a tide of succulent, nodding bluebells engulfs Dorset's woodlands by early May.

After the canopy is in full leaf, it is only in the rides, clearings and along woodland edges where native wild flowers can thrive. Of these, St John's wort, sowthistle, nipplewort, ragwort, wild angelica, yellow pimpernel and enchanter's nightshade are all plants occurring in woodland during the summer. In some mature oak

woodlands the curious bird's-nest orchid *neottia nidus-avis* rises from the leaf litter in June, where few other plants can tolerate the deep shade. It is so-called because its mass of underground roots resembles an untidy bird's nest.

In late summer and autumn, as most other plant forms have set seed and are dying back to become dormant for the winter, there comes another spectacular display of shape and colour, as fungi appear in the woods in the form of toadstools and brackets. These strange, otherworldly life forms are fruiting bodies, which have evolved to release the organism's life-giving spores. The main body of the organism is the mycelium, comprising minute tubes, often thinner than cobweb strands, that feed on decaying and sometimes even living organic matter. Fruiting fungal bodies can appear very quickly, often just overnight. The stinkhorn is one such fungus, which gives off an odour similar to that of rotting flesh. Flies are attracted by the scent of this flimsy structure. As they crawl over it, frantically searching for meat, they break the fungi down and pick up the fungal spores on their own bodies to carry them off elsewhere.

One of the most attractive toadstools found in the east of the county is the fly agaric. This is the toadstool typically depicted in fairy tales and children's story-books. The bright-red cap is decorated with creamy white spots, which are the shrivelled remains of a sheath that protected the fruiting body as it pushed itself out of the ground. Whilst the fly agaric may be handsome to observe, it should never be touched, as it is very poisonous.

The most poisonous of all fungi occurs in Dorset's oak woods, and may be seen at Powerstock Common, Duncliffe Wood and Brackets Coppice. The death cap, as it is aptly known, grows in the vicinity of old oak trees. Very small amounts of its toxin can prove fatal if consumed, and there is no known antidote, so this toadstool should be avoided.

INVERTEBRATES

Most of the county's range of woodland butterflies can be found in the rides and clearings of Dorset's large,

▲ Fly agaric toadstools, attractive to look at but poisonous to eat.

mature woodlands like Piddles Wood, Bracket's Coppice or Powerstock Common. At all of these sites, in order to maintain open areas for butterflies, volunteers carry out coppicing regularly. On warm spring days the orange tip and brimstone are two of the earliest woodland butterflies to appear as they search for nectar and food plants on which to lay their eggs.

The brimstone has a longer flight period than that of any other British butterfly species as it over-winters as an adult. An insect hatching as a butterfly in July may still be flying the following June. The brimstones we see in

▲ A brimstone butterfly at rest on a fresh bluebell flower in spring.

spring will have spent the winter hiding in evergreen foliage. The insect's angular wing shapes enable it to remain undetected when asleep within the leaves. The orange tip is restricted to the months of April and May as this butterfly produces only one generation each year.

The wood white can be seen at Powerstock Common in healthy numbers, but this is the only remaining site for this insect in Dorset. It is a small white butterfly with rounded wings and a lethargic flight. The silver-washed fritillary is relatively common and thrives in many of Dorset's broad-leaved woodlands. In high summer silver-washed fritillary butterflies visit bramble and hemp agrimony flowers on sunny days. The white admiral has similar habitat requirements to the silver-washed fritillary, but is confined to just a few sites in the north of the county, Duncliffe and Fifehead Woods being the most likely places to find it.

Although the purple hairstreak is common, it is a difficult insect to observe, as it tends to stay high up in the treetops feeding on honeydew left on the leaves by aphids. It can be seen on the edges of mature oak woods.

Butterfly species more associated with heathland, such as the grayling, green hairstreak and silver-studded blue, also occur on the fringes and in clearings of the conifer plantations of east Dorset.

BIRDS

The nuthatch is a smart little woodland character that wedges hazelnuts into crevices, cracking the casings open with its strong, sharply pointed beak. One of the characteristics of the nuthatch is the bird's ability to climb down tree trunks headfirst.

In autumn and winter, bramblings may be seen amongst flocks of chaffinches, feeding on beechnuts. Flocks of siskin also gather in winter to feed mainly on alder seeds, uttering their twittering contact notes as they search for seeds in the treetops.

The jay is essentially a woodland species, giving away

▲ In flight, the great spotted woodpecker displays the pattern of white spots on its wings that give the bird its name.

its presence with a loud, raucous screech when it spies humans or other potential enemies. This colourful member of the crow family collects acorns in the autumn and buries them for later consumption, often forgetting where the nuts have been left. This results in oak seedlings coming up in spring, which is generally agreed to be how oaks arrived here in the first place. At the top of the woodland avian food chain are two members of the hawk family: the sparrowhawk and common buzzard. Buzzards nest high in the treetops of woods and copses, and although they occur across the county they are far more numerous in west Dorset than they are in the east. Buzzards can take live prey in the form of small rodents and rabbits, but generally they are scavengers and feed on carrion. The sparrowhawk is the supreme woodland hunter, feeding on bird species ranging in size from tits and warblers to pigeons and jackdaws. The process of evolution has resulted in male and female sparrowhawks of different sizes. The larger female is more equipped for incubating eggs and can take larger prey than the male. The different sizes of the sexes in sparrowhawks enable them to cover almost the entire range of woodland birds in their diet.

In spring, motivated by the urgent need to reproduce, and stimulated by lengthening daylight, birds from the south migrate northwards to breed. In effect, these birds live in perpetual summer, arriving here with the warm winds of April. Several of these migrants are linked to woodland and are heralded by the monotonous tune of the chiffchaff, followed by the melancholy, cascading jangle of the willow warbler and the wood warbler's accelerating song, which has been described as similar to the sound of a spinning coin on a marble slab.

Conifer woods support far fewer invertebrates and are therefore not such appealing habitats for many bird species. But there are a small number of bird species associated with conifers including the goldcrest, crossbill, coal tit, long-eared owl, sparrowhawk and hobby.

Crossbills use their specialized beaks to extract seed from pinecones in the conifer plantations of Wareham Forest. Goldcrests weave their tiny hammock nests under conifer twigs. Both the sparrowhawk and hobby show a preference for stands of mature conifer trees for their nest sites.

The bird species most often associated with woodland are the woodpeckers. Green, lesser and great spotted woodpeckers all breed in Dorset's broad-leaved woodlands. One of the most characteristic sounds in the countryside in late winter and early spring is that of great spotted woodpeckers drumming. These handsome birds rapidly bang their beaks on resounding, hollow boughs to announce themselves and establish their territories.

Although the green woodpecker nests in woodland, its staple diet is ant eggs, which it finds away from the woods in areas of short turf. The lesser spotted woodpecker has been in decline for many years, and is now found only occasionally, nesting in some of the larger oak woods. This is a difficult bird to spot, as it tends to feed high up in the tree canopy.

The tawny owl is strictly a woodland species, preferring broad-leaved and mixed woodland to conifers. It is a large, mottled brown bird with forward facing eyes, which gives it binocular vision. Tawny owls are woodland hunters, feeding on a diet made up almost entirely of mice and voles. Just about every small wood or copse in the county will support a pair of tawny owls. This is an extremely vocal bird, regularly announcing its territory boundaries with a series of long, quavering hoots after dark. In early spring the tawny owl chooses a nest site, which is usually in a hollow tree. Eggs are laid at two-day intervals and incubation begins with the laying of the first egg. This ultimately results in a staggered brood of different-sized owlets. During prolonged wet weather, tawny owls can be hard-pressed to find sufficient food for a growing family. The variation between the sizes of chicks enable the more advanced owlets to consume their smaller siblings, thus ensuring that at least one member of the brood survives in inclement weather.

Young tawny owlets depart from the safety of their nest holes before their flight feathers are fully developed, and to begin with they are flightless. They can often be seen in spring during daylight hours, sitting on low branches or even on the ground. This is a natural stage in their development and they should be given a wide berth, especially as adult tawny owls will defend their young vigorously.

MAMMALS

The wild mammals typical of broad-leaved and mixed woodland habitats across the county include deer, badgers, woodmice, the common shrew, the grey squirrel, field and bank voles and dormice, the latter thriving in hazel coppices. Roe deer are rarely seen in large groups, but may be encountered at any time of year. These secretive native deer lie up in the dense cover of woodland during daytime and graze in adjacent fields at dusk and dawn.

Badgers live in underground chambers in woods and copses. The badger is nocturnal and it is therefore unusual to see them above ground in daylight. Badger cubs are born during February and remain safely below ground until they are between six and eight weeks old. Freshly excavated soil at badger earths in mid-winter is conclusive evidence of preparations for nursery accommodation. Badgers either dig fresh chambers each year or renovate old ones in which to raise their young. This method of spring-cleaning helps to prevent a build-up of parasites from previous seasons. Badger cubs can be heard throughout spring and early summer, squeaking and arguing as they explore their home range above-ground with their parents.

The woodlands around west Dorset support a herd of fallow deer. It is widely believed that these animals are the direct descendants of the first fallow deer to be introduced to Britain in Norman times and they are known as the Old English Fallow. In the woods they are difficult to see, as they are mostly very dark brown in colour. However, white (or leucistic) individuals are not uncommon. Fallow deer are much more gregarious than roe deer and it is not unusual to see large herds, especially during the winter months. The main body of the west Dorset fallow herd is centred on Powerstock Common. In autumn, the guttural groans of rutting

▲ An adult male badger patrols its territory on the edge of the woodland after dark.

bucks echo through the trees as they argue over females coming into season. Sadly, this old English strain of deer is now threatened by recently escaped local-park fallow, which may integrate with the wild herd.

The grey squirrel is an alien species from North America that has adapted to life in the UK and thrives throughout Dorset. Grey squirrels live mainly in the trees but become a menace in high summer when they develop bark-stripping tendencies. A grey squirrel is capable of killing a forty-year-old broad-leaved tree in just a few minutes by completely stripping the bark from around the base, thereby 'ring barking' it. In autumn, grey squirrels collect hazelnuts and acorns for their winter food supplies.

The red squirrel is our native species, but today it can only be found in Dorset in woodlands on the islands of Poole Harbour. The red squirrel is not as robust as the grey and it is generally believed that the latter drove out the former in direct competition for food and territories.

It is in the autumn when Dorset's broad-leaved woodlands exude an enchanting ambience as the natural world lays on its final flourish of the living year. As shrubs and trees become dormant, their green summer colours are replaced by the warm hues of the season. These autumn colours usually peak at the end of October to the beginning of November and can be seen in the form of trees, shrubs, leaves, berries, seedheads and ferns. Beech woods are the most colourful and are especially attractive on damp, dull days. Some of the best beech woodlands in Dorset worth visiting for autumn colour in late October include Ashmore Wood, Hooke Park and Lewesdon Hill.

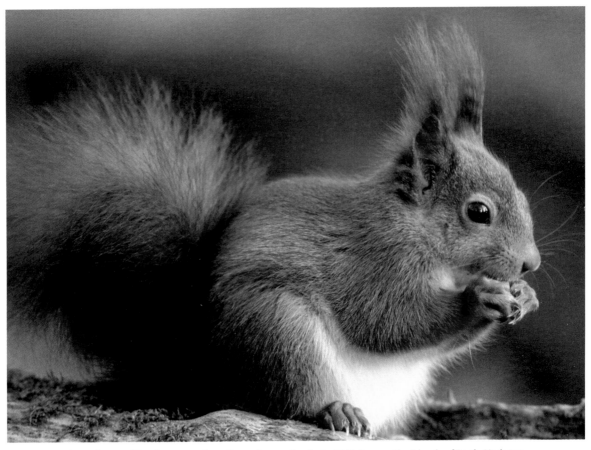

▲ Although the red squirrel has long gone from Dorset's woodlands, it still thrives on the islands of Poole Harbour.

DUNCLIFFE WOOD

Duncliffe Wood is one of the largest woodlands in north Dorset and is also the highest point in the Blackmore Vale. This 213-acre ancient natural woodland was traditionally coppiced in the past. It is now owned and managed by the Woodland Trust to encourage a broader range of woodland wildlife. The wood is made up of a variety of tree species, including pedunculate oak, field maple, wild cherry, hawthorn, beech and ash, with some remaining areas of hazel coppice. It is especially good for woodland butterflies including the silver-washed fritillary and the white admiral. Duncliffe Wood is also famous for its display of bluebells, which carpet the wood during April and May.

The coast

The diverse range of geological features of the Dorset coast equate to a remarkable variety of different habitats: sheer cliffs, chalk downland, estuary, sand and pebble beaches, saltmarsh, lagoon, rockpools, reedbeds and islands. In fact, studying the Dorset coast from end to end not only reveals the entire Jurassic timeline but also uncovers a huge range of flora and fauna. Some very rare plants occur on Dorset's coast, as well as the county's very own butterfly species.

FLORA

The flora of the Dorset coast varies immensely between the different habitat types. Many wild plants that would not be found in salt marsh, for example, thrive in the inhospitable habitat of the blue lias terraces of Black Ven, east of Lyme Regis. Common centaury, selfheal,

marjoram, scarlet pimpernel, birdsfoot trefoil, teasel and marsh helleborine are all represented here in healthy numbers. Buddleia bushes readily self-seed here, attracting a myriad of insects, especially butterflies like red admiral, small tortoiseshell, marbled white, green hairstreak and brimstone.

The shingle beach at Cogden is peppered with cushions of colour in spring as it becomes garlanded with a profusion of wild flowers. Drifts of pink sea thrift, sea kale and yellow horned poppy smother the shingle. At the edge of the beach, areas of short turf support ground-hugging plants like tormentil and spring cinquefoil. Closer to the shore clumps of succulent sea sandwort sprawl over the pebbles.

At the Abbotsbury end of Chesil Beach, there are some remarkable plants growing in the shingle like biting stonecrop and sea pea. The latter literally emerges from the pebble beach and is considered to be one of the most impressive stands of the species in the country. On the causeway between Ferrybridge and Portland, there is a vast abundance of wild flowers, many of which are uncommon. In some years, the extremely rare purple broomrape (a parasitic plant hosted by yarrow) shows off its erect flower stems here.

There is a rich diversity of flora to be found along the sea cliffs and in the abandoned quarries on Portland, including unique races of rock sea lavender and Portland spurge.

In Tout Quarry, common broomrape, a root-parasitic plant of clovers, occurs annually. This is a variable species and may also be parasitic on some members of the hawksbeard family. The much more common diminutive eyebright decorates the path edges in early summer. This cheerful little flower has the intriguing nickname of 'gentleman tailor'. Other species that occur in the quarries include horseshoe vetch, marjoram, wood sage, bee orchid and wild rockrose.

Two of the most dramatic displays of wild summer colour on Portland are provided by red valerian and vipers buglos. Buddleia bushes are well-established in the quarries, with butterflies and other insects attracted to the heady scent of the shrub's nectar.

On the cliffs around Kimmeridge Bay there is a

▲ Sea thrift smothering Cogden Beach in late May.

profusion of colour in spring with a sumptuous medley of sea thrift and sea campion mingling with sprays of kidney vetch and eastern rocket.

Although the early spider orchid is rare in the British Isles, one would not think so when walking along the east Dorset coast in spring. Between Langton Matravers and Dancing Ledge during April, this gem of the orchid family can be extremely abundant, often occurring in stands of thousands of individual plants. Another national rarity, the early gentian, can be found on the limestone cliffs from Durlston to St Aldhelm's Head in spring, with another colony on Portland.

The chalk downland flora on the cliffs at Handfast Point and Ballard Down is extraordinary, with a huge expanse of colourful chalk-loving plants. In mid-summer large clumps of greater knapweed prove to be irresistible for many insects, especially cardinal and longhorn beetles as well as the nationally rare Lulworth skipper.

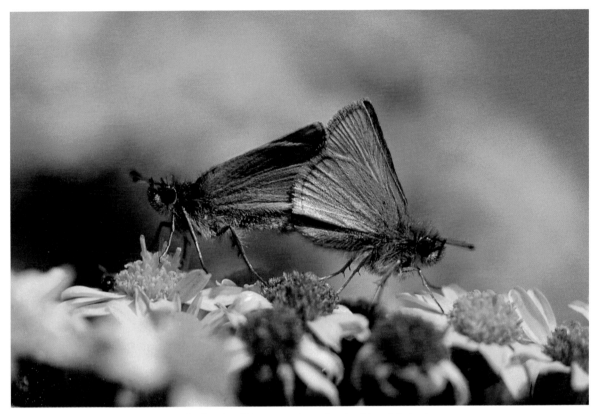

▲ A mating pair of Lulworth skippers display the plain straw-coloured undersides of their wings.

INVERTEBRATES

The Lulworth skipper is abundant here and is Dorset's very own butterfly species; it was first discovered at Durdle Dor in 1832. Although many colonies of this insect have been found since, they are almost entirely confined to the Dorset coast between Old Harry and Burton Bradstock. The Lulworth skipper can be distinguished from similar species by the fan of light spots (known as the 'sun-ray') on the forewing of the female, and also the plain, straw-coloured undersides of the wings of both sexes.

The blues are also well represented along these cliff tops and include common, Adonis and small blue. Other butterflies, which are also addicted to the nectar of the knapweeds, include marbled white, wall brown, brown argus and both small and large skippers.

Sub-species of silver-studded blue and grayling butterflies, more usually associated with heathland habitats, can both be found thriving in some of the Portland quarries. In the past, rare species of Odonata have bred in one of the deepest quarries, including scarce blue-tailed damselfly and red-veined darter.

BIRDS

The physical variations in Dorset's coastline attract a wide range of bird species throughout the year. Open waters attract wildfowl, tidal mudflats are feeding grounds for waders and the sea cliffs provide roosting and nest sites for gulls, crows, doves, starlings and pipits, amongst others.

The Isle of Portland is famous for birds, as it protrudes eight miles into the English Channel, forming one of the main migration highways into and out of Britain during spring and autumn. It also frequently hosts rare birds that have been blown off course, especially during winter.

The herring gull is the bird most people associate with the seaside and it occurs all along the Dorset coast.

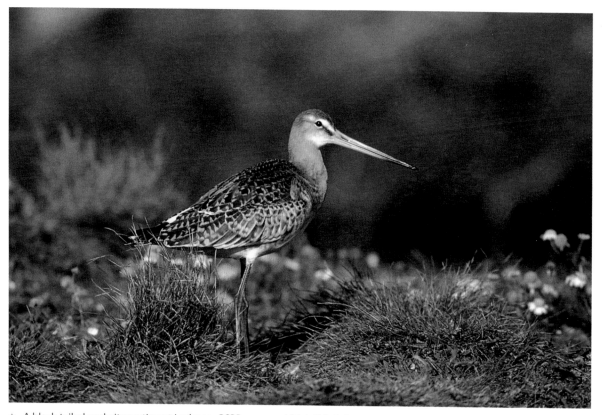

▲ A black-tailed godwit roosting at Lodmoor RSPB reserve at high tide in late summer.

Within the face of the perpendicular sandstone cliffs of West Bay and Burton Bradstock, the lateral seams of sandstone rock provide nesting ledges for herring gulls and other birds in the summer months. Herring gull chicks often fall prematurely from their nests and clamber about in a flightless state on the beach, vigorously defended by their parents, even against humans. Many locals in Lyme Regis and West Bay consider this large gull to be a nuisance, partly because of its habit of nesting on flat roofs of houses and partly because some bold individuals harass humans for food.

Fulmars make their nests in hollows in the cliff faces or on ledges and can be seen at West Bay, Durlston and Portland. They begin to occupy their precarious nest sites in early spring. As they jostle for position, quarrelling occurs over prime locations, giving rise to an extraordinary noise resembling cackling laughter. These are fascinating birds to watch as they glide and soar without ever seeming to flap their rigid wings. The bird

habitually plunges towards the cliff where at the last split second it winnows to free-fall away from the rock face.

The fulmar's ability to spit a glutinous substance at any potential nest intruder makes it the peregrine falcon's only enemy. Should a peregrine perch near to a fulmar's nest it risks receiving a coating of splodge, which can congeal and prevent the falcon from flying, thereby starving it to death.

During the 1960s, the peregrine falcon became almost extinct in southern England. This drastic decline was due to the use of toxic chemicals in agriculture. Poisons like DDT found their way up the food chain, ultimately affecting the shells of peregrine eggs. As a result, the birds laid unusually thin-shelled eggs, which broke when they attempted to incubate them. After the banning of the use of such chemicals, the peregrine population gradually recovered and the bird is now back at all its former haunts in Dorset. Peregrine falcons regularly hunt along the cliffs of Old Nick's Ground, as

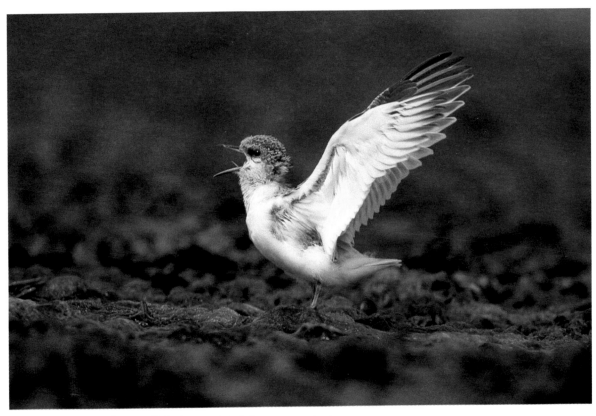

▲ A newly fledged little tern calls for its parents to bring more sand eels.

well as at Durlston, Portland and West Bay for stock doves and occasionally racing pigeons. This lord of the air is the fastest known creature on Earth, capable of reaching speeds of up to 180 mph in a prolonged dive.

Ravens often nest on coastal cliffs and are easily identified by their massive size (larger than a buzzard), their wedge-shaped tails and their deep guttural calls. Ravens gather driftwood, rope and other debris with which to build their large, bulky nests on wide cliff ledges. The impressive tumbling courtship flight of the raven may be witnessed at Portland or West Bay in late winter, as they soar, nose-dive and even fly upside-down, displaying their wedge-shaped tails.

Many small bird species breed in the extensive reedbeds of Lodmoor, Radipole and Bexington during the summer. The most prolific of these are the reed and sedge warblers, which together maintain a constant babble of incessant song throughout the nesting season. The reed bunting nests amongst tussocky sedges and

reeds and is present at these sites all year. The male can be easily identified by his striking black head and monotonous wheezy song. The explosive song of the Cetti's warbler punctuates the ceaseless drone of other birds as he proclaims his territorial ownership with bursts of loud chirruping. Bearded tits are permanent residents in these reedbeds and small parties of them can sometimes be seen on fine days during winter as they feed on the reed seeds.

During the summer, England's westernmost colony of common terns nest on man-made islands directly in front of one of the viewing platforms at Lodmoor. There are also common tern and sandwich tern colonies on man-made islands in the Brownsea lagoon. These 'sea swallows' can often be seen diving for sand eels near to the Studland ferry jetty at Sandbanks.

The jewel of the tern family in Dorset is the little tern, which bred annually at the Ferrybridge end of Chesil Beach until recent years. Sadly, this tern colony

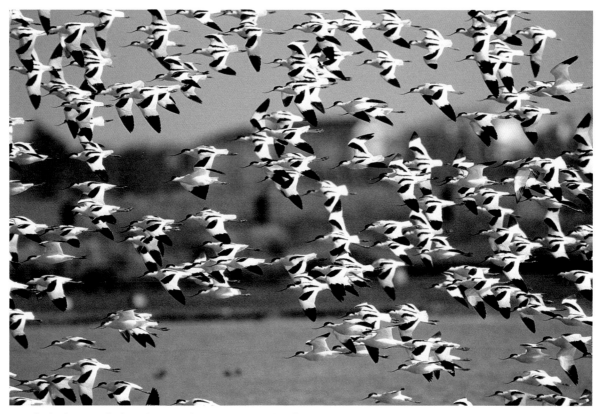

▲ A flock of avocets flashing their wingbars in unison as they fly over the Brownsea lagoon in winter.

is now only a faint shadow of its former self, as this bird has many potential predators when nesting on the shingle. These nest robbers include gulls (who have seen a population explosion over recent decades), foxes and even hedgehogs, who can journey across the shingle beach at night in search of tern eggs.

Colonies of cormorants nest on Gad Cliff and on the near-vertical cliff next to Old Harry opposite the two chalk stacks known as the Pinnacles.

Rock pipits flit amongst the seaweed on beaches along the coast at low tide. The rock pipit is resident all year on the Dorset coast, feeding on invertebrates it finds in seaweed or on the cliff faces and rocks. These confiding little birds busily scurry about in cliff-top vegetation searching for insects at high tide.

Poole Harbour is an internationally important place for migrant birds throughout the year. During the spring and autumn passage, many species drop in to refuel before continuing their journeys. Summer brings the

terns and other breeding birds and it is an important site in winter, as many species of wildfowl and wader seek the relatively warm climate of the south coast.

Poole Harbour boasts one of the largest wintering colonies of avocets in Britain, which can number over 1,400 individuals. At high tide avocets congregate in the Brownsea Island lagoon. The avocet is the most elegant of wading birds, gracefully sweeping its upcurved bill from side to side to detect its prey by touch. It feeds on insects and small crustaceans.

One of the great success stories of the resident bird population is that of the little egret. In the past, the little egret was a nationally rare bird, but during the early nineties it became a more frequent migrant to the south coast and first bred in Dorset in the mid-1990s. Now there are over forty pairs breeding in the county and it is common to see them stalking fish in bays and inlets along the coast.

The cacophony of bird sounds on the coast in

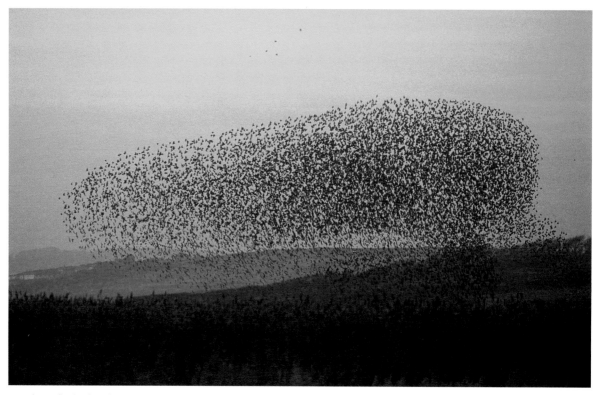

▲ A large flock of starlings pour into the Bexington reedbeds to roost on a mid-winter afternoon.

winter reflects the vast accumulation of waders and wildfowl that builds up during the colder months. Wigeon, shoveller, tufted duck and teal feed in the sheltered waters of Radipole Lake and the Fleet Lagoon. Red-breasted mergansers settle on the Fleet Lagoon and in Poole Harbour. These sawbill ducks have moved south for the winter from Scotland and Iceland, where they breed. Their elaborate courtship display is played out in mid-winter, when a group of drakes surround a female to compete with each other for her attention by performing complex head and body contortions.

Elsewhere Brent geese honk loudly as they fly over Poole Harbour and along the Fleet Lagoon between the tides. These birds breed in the high arctic and fly south in autumn to benefit from our milder winter.

On the tidal stretches of the Fleet, Poole Harbour and Stanpit Marsh, a variety of waders probe with specialized bills for food on the mudflats. At high tide, these birds roost on higher ground as they wait for the feeding areas to become exposed again. Lodmoor, for example, often holds thousands of birds at high tide in winter, including large flocks of lapwing, golden plover and black-tailed godwit. The evocative calls of these and other waders echo across the water as the tide recedes and birds start to move. Flocks of redshank, dunlin and ringed plover twist and turn in perfectly orchestrated unison as they rise and fall, drifting like smoke across the mudflats. Turnstones forage amongst the pebbles in small flocks at Ferrybridge and Christchurch, and the haunting cries of curlew epitomise the wildness of the Dorset coast in winter.

Purple sandpipers arrive on the coast from their Arctic breeding quarters to spend winter on the rocks of Portland and Lyme Regis. Oystercatchers form flocks, flashing their black and white wing markings when taking to the air. The quick erratic flight and rasping call of the snipe distinguishes it from other wading birds, especially in times of intense cold when it is forced to visit freshwater bogs and creeks.

▲ An adult marsh frog, photographed at Bexington in spring.

One of the most exciting birds to observe on the Dorset coast is the short-eared owl. These birds habitually hunt in daylight on winter afternoons on Portland and the wild fringes of the Fleet. Silently, the owls float low over rough ground with wavering flight, gliding and wheeling on stiff, long wings as they search for voles. In recent years, the number of short-eared owls over-wintering in Dorset has increased significantly.

In some years during winter, the reedbeds of Bexington are used by starlings for their night-time safe haven with up to 60,000 birds congregating here to roost in the reeds at dusk.

REPTILES AND AMPHIBIANS

Dorset boasts more resident reptile species than any other county in Britain and all of them can be seen along the coast. All six native reptiles are here as well as two aliens, the wall lizard and the green lizard, which both breed in Dorset. Adders occur along the Dorset coast and may be seen basking on sunny banks on the cliffs and dunes in spring. Adders have favourite sunbathing spots, which are never far from dense cover. Like all reptiles, the adder is a cold-blooded creature, which needs to warm up in the sun in order to become energized and active.

It is thought that the wall lizard first came to Portland on ships collecting stone. It is a native of mainland Europe and has established strong colonies on the island in some of the defunct quarries. It has been breeding on the island for at least thirty years and can be seen basking on stones late in the day in both the Tout and Cheyne Wears quarries.

In recent years the marsh frog has established breeding colonies in the brackish water between Cogden and Bexington. This handsome amphibian is a native of mainland Europe, and was first introduced to a garden pond in Kent in 1935. The marsh frog habitually sits out of the water on the bank side; when disturbed it will leap spectacularly into the water.

MARINE WILDLIFE

The vast area of rock exposed at low tide immediately east of Lyme Regis is known to be one of Britain's top rock-pooling sites. Broad Ledge, as it is aptly named, is rich in seaweeds, crustaceans and other sea-life, found in the numerous rock pools.

Kimmeridge is recognized as a nature reserve for the marine wildlife found in its seawater and rock pools. There are a wide variety of seaweeds, sea anemones and other invertebrates along with the various fish and shell-fish that inhabit this marine environment.

The rocks and waters of Kimmeridge Bay form part of the Purbeck Marine Wildlife Reserve, which stretches from Worbarrow Bay to Chapman's Pool. It is the only underwater nature reserve in the county. The bay's geographical position is halfway along England's southern coastline. The Atlantic and Gulf stream influence meets the North Sea influence at this point and, as a result, many of the underwater species overlap here.

The primitive life forms of barnacles and limpets are exposed at low tide. They remain stuck fast to the limestone rocks in such a way that it is difficult to imagine them as living creatures. A close look at the limestone surface reveals intricate zigzag patterns on the rocks. These are made by grazing limpets using their abrasive tongues to mark the stone. Limpets feed on algae, which they scrape from the surface of the rocks. Their 'tongues' are lined with thousands of 'teeth' or denticles. As the tide returns to submerge them, they once again become active and start to browse, moving slowly over the rocks.

The Fleet Lagoon supports over 150 species of seaweed, thirty kinds of fish and huge numbers of marine invertebrates, sea urchins, starfish, brittle stars, worms and anthropods.

MAMMALS

The rabbit (*Oryctolagus cuniculus*) is present on Portland, digging its burrows in the earth amongst the quarry workings. It no doubt forms the staple diet for the resident foxes. There is much superstition surrounding *Oryctolagus cuniculus* and Portlanders refuse to mention it by name as these burrowing mammals are thought to

have caused catastrophic stone falls in the past.

Otters are often seen in bays and inlets along the coast. These are not sea otters as such but animals that live on Dorset's rivers.

BROWNSEA ISLAND

Brownsea Island is an exciting location for wildlife-watching at any time of the year. In spring and summer, insects include most of the heathland species. Nightjars nest on the island as well as Dartford warbler. There are resident Sika deer and red squirrel populations. In winter, the Brownsea lagoon is one of the best places in the county to watch wading birds, including spoonbills and the large avocet colony.

Heathlands

All of Dorset's heathlands were once covered in high, temperate forest but, during the Bronze Age, man began to clear the trees for fuel, building materials and for agriculture. This deforestation process continued right up until the middle of the last century. With the forest canopy gone, nutrients in the soils were washed down through the free-draining gravels in east Dorset, leaving behind highly acidic surface conditions, ideal for acid-loving species. This dramatic change from high forest to lowland heath has been documented by pollen preserved in peat bogs, with a marked increase in the pollens of heather and grass at the expense of tree pollen.

In the past, the huge expanse of lowland heath that stretched from the Poole basin to Dorchester was considered little more than worthless wasteland. Little by little, man reclaimed these wild places for building development and agricultural use. It was not until the heaths had become seriously fragmented that their environmental importance was realized. As a result of this destruction, no other habitat type in the world is as rare as the lowland heaths of east Dorset.

It is the sheer wildness of heathlands that makes one feel totally immersed in the natural world. On cold winter mornings, ghostly mists drift over the bogs and pools. In spring the heath is decorated with a mosaic of

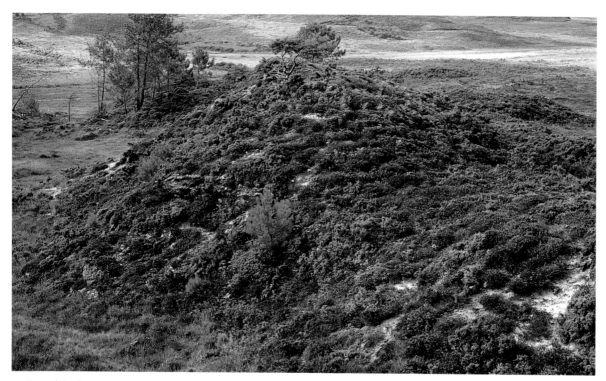

▲ One of the finest examples of wet and dry lowland heath can be enjoyed at Godlingston Heath, Studland.

white blackthorn and yellow gorse blossom. When the heather is in bloom in summer, the landscape is transformed with shades of pink and mauve and in autumn, as the silver birch trees and bracken change to golden yellow, the heath is arguably at its most spectacular.

Heathland is generally divided into two distinct habitats, wet heath or dry heath. Both of these habitat types occur on the same sites, providing a rich diversity of flora and fauna. In summer, there is an added dimension of sounds, ranging from birdsong to the buzzing of insects, which bring the heaths to life.

FLORA

The plant life of heathland is dominated by heathers, which make a dramatic impact on the landscape as they come into bloom. The colouring of the heaths begins in June with the deep reddish-purple flowers of bell heather mingling with the rose-pink tint of cross-leaved heath. By the end of July, ling (the most common heather in Britain) adds its pinkish-purple hue as it too bursts into flower. But the real gem of the county's

▲ A close-up of the flower spikes of the rare Dorset heath.

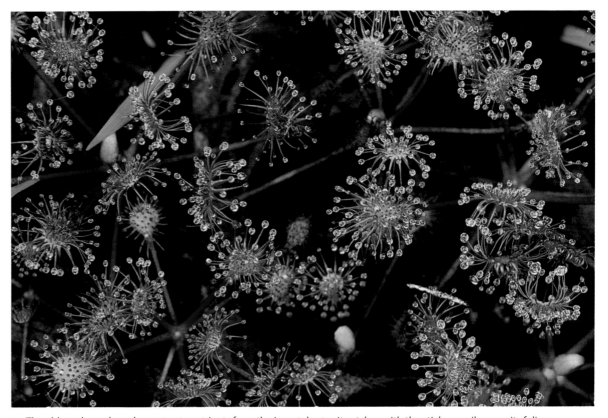

▲ The oblong-leaved sundew extracts nutrients from the invertebrates it catches with the sticky mucilage on its foliage.

heathland flora is its very own heather species, the Dorset heath. The first impression of this plant is of dark-pink bell heather, but its structure is different with the flowers borne on tall spikes. Probably the best place to see this rarity is on Hartland Moor, alongside Soldier's Road, east of Stoborough.

The acidic bogs, characteristic of the heathlands, support some rare and unusual plants with smatterings of bog asphodel and wispy stands of cotton grass occurring in the wetter areas. During summer such rarities as marsh gentian, marsh heleborine and bog orchid can be found.

Around the perimeters of these bogs, three species of insectivorous sundew plants grow. These fascinating plants have evolved to exist in the poorest of conditions, gaining the nutrients they require from insects. The upper surfaces of sundew plant leaves are covered with red tentacles constantly secreting sticky mucilage. Insects, attracted to the bright red colour of the plant,

become stuck on the tentacles. The plant uses enzymes to dissolve these stranded insects and to extract nitrates and other nutrients from their bodies, which it consumes for its own sustenance.

Many of the heathland areas of Dorset are peppered with rhododendrons. This uninvited alien species originated in the Far East. It thrives on the acidic, peaty soil of the heaths, and if it were not robustly controlled it would quickly smother all other plant life. It is vigorously kept in check by volunteer working parties to prevent it from dominating the heathlands.

INVERTEBRATES

Heathlands are not habitats that support a great range of butterflies, unlike downlands and woods. But the butterflies that do occur here are nationally uncommon. The silver-studded blue, although rare elsewhere in Britain, is abundant on Dorset's heaths. In some years it can be so prevalent that several will fly up from every

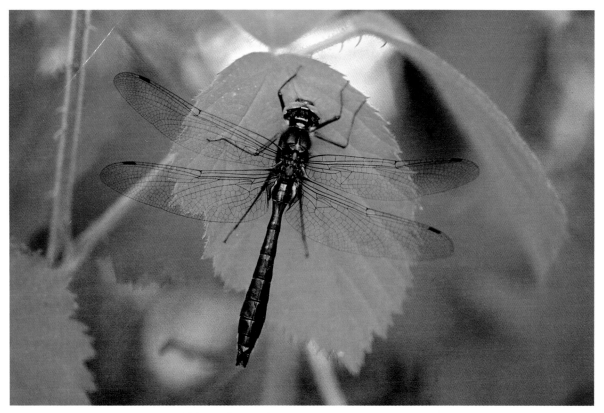

▲ The striking metallic downy emerald dragonfly is on the wing on Dorset's heaths during May and June.

clump of heather when disturbed. The wings of the male are a rich violet-blue on the upperside, with a series of black spots centred with metallic blue specks on the underside. It is the presence of these silvery specks that give the butterfly its name. The silver-studded blue has one generation per year and during the flight period the females lay their eggs on gorse, broom or heather. The best time to observe these attractive blue butterflies is on summer evenings in early July when they habitually settle on the heather, spreading their wings to soak up the weakening rays of the evening sun.

In July and August the fast-flying grayling butterfly is on the wing, displaying distinct eyespots on its forewing. Butterfly eyespots have evolved to avoid predation by birds, by converting the image of an insect into one of a face. This insect truly is the master of disguise, displaying a motley camouflage pattern on the under-wing. When it comes to rest on the ground, the grayling immediately hides the eyespot on the forewing by

tucking it behind the camouflaged surface of the hind-wing. In the final part of the vanishing trick, it tilts its body away from the sun to avoid casting a tell-tale shadow and the butterfly literally disappears.

At the edge of some of the drier heaths, buddleia bushes have become established and attract a wide range of insects in late summer, including butterflies, hover-flies and sometimes the hummingbird hawkmoth. This day-flying moth hovers in front of flowers, dipping its long proboscis deep into the florets to sip nectar.

The emperor moth is Britain's only silk moth and can be found on Dorset's heaths. Males fly by day, but they are difficult to spot as they are very fast insects, and you may only notice an orange blur as one passes by. Female emperor moths remain still during daytime, patiently waiting on heather or gorse for the males to find and mate with them. The attractive caterpillar of this insect is quite distinct. It measures up to sixty millimetres in length and has a lime-green base colour

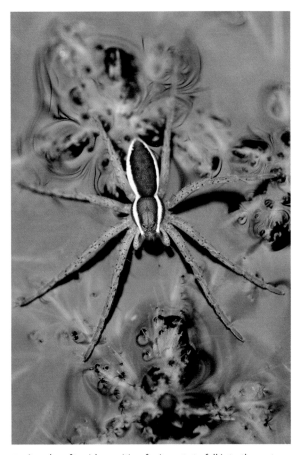

▲ A male raft spider waiting for insects to fall into the water.

On the heaths later in the summer, four-spotted chaser, ruddy darter, keeled and black-tailed skimmers and migrant hawker are on the wing. It can be fascinating to watch them darting in and out of the sunbeams, attacking the columns of gnats on warm, summer afternoons.

In permanently wet heathland areas, especially where purple moor grass persists, the large marsh grasshopper can be found. This is the largest grasshopper in the British Isles with adult females measuring up to thirty-nine millimetres in length. Throughout August and September, males can be heard calling, which they do by flicking their hind legs against their forewing to produce a snapping sound.

The lowland heaths support an almost infinite number of invertebrate species. Two others of particular note are the bee-killer wasp and the raft spider. Male bee-killer wasps make their burrows in sandy banks while females hunt for honeybees. The honeybees are brought back to the burrow and pushed into a chamber. The wasp lays its eggs in an adjacent chamber. When the grubs hatch they feed on the dead bee carcases. This presents a worrying prospect for the honeybee population, which has already seriously declined in recent years due to the combined effects of disease and inclement weather.

The raft spider (or swamp spider) is one of the most impressive spiders restricted to wet heathland, where it lives in boggy pools. It floats on the surface of the water and is attracted to surface vibrations caused by drowning insects, upon which it feeds.

BIRDS

The stonechat gets its name from its alarm call, which resembles the sound of two pebbles being knocked together. Stonechats typically sit on the very top of bushes, scolding passers-by with their 'chat' calls. Yellowhammers, meadow pipits and linnets sing from the gorse bushes on the heaths in spring.

The nightjar and hobby are two summer visitors that breed and hunt on the heaths. The hobby is a small falcon, feeding principally on insects, especially dragonflies, throughout the summer. It is confined mainly to

with transverse black bands, bearing raised warts that can be yellow or pink.

Wet heathland habitats support a wealth of dragonflies. These are the top predators of the invertebrate world, feeding on small airborne insects. The legs of dragonflies and damselflies are festooned with stiff spines. In flight, they hold these bristly legs in front of themselves to form a basket shape into which prey is captured. Notable species specific to the Dorset heaths include the downy emerald and the hairy dragonfly. Both of these insects are early summer species and are on the wing during May and June. The downy emerald is a medium-sized dragonfly with a dark-green, metallic appearance. The male of the species is especially attractive due to its waisted abdomen. The hairy dragonfly, so called because of its noticeably downy thorax, is the first hawker dragonfly of the year to be on the wing.

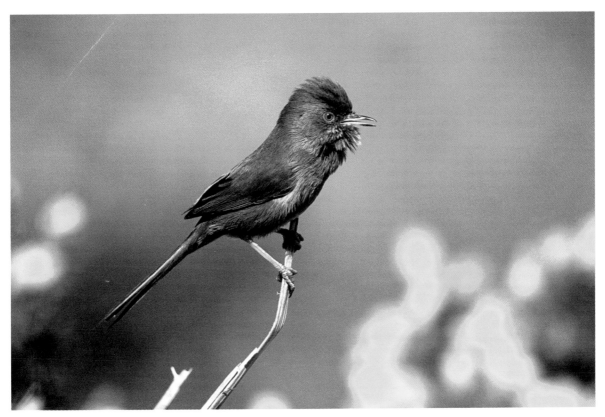

▲ A cock Dartford warbler, singing from a favourite perch amongst gorse bushes in spring.

the south coast of Britain, and in Dorset it is relatively common on the heaths. By August, hobbys begin to turn their attention to swallows and martins as, like the swallow, the hobby migrates south for the winter, catching and feeding on young martins and swallows during the journey.

In the daytime, nightjars rest, usually on low branches, lying motionless, relying on their camouflage markings to remain hidden. Nightjars are moth-catchers and become active around dusk when the strange 'sewing machine' songs of the males may be heard. These twilight hunters habitually swoop low over the heather after dusk to catch moths and other night-flying insects in their large, open gapes.

The Dartford warbler is synonymous with heathland and is present all year. It is a stubborn little bird and, unlike other warblers, which spend colder months in warmer climates, it remains here throughout the winter. It ekes out a living by flitting tirelessly between the gorse

bushes in its diligent search for insectivorous food.

The savage winters of the early sixties reduced the Dorset and Hampshire populations of the Dartford warbler to just a handful of birds, which were confined to the heathlands. But in the decades that followed, the trend for milder winters enabled the bird to recover from this tiny gene pool and to surpass its former numbers. The bird has continued to increase in recent years and is now found in sub-optimum habitats, away from heathland, where there are stands of gorse or stunted blackthorn.

REPTILES

The wild creatures most associated with heathland are reptiles. There is a stirring of reptile activity in March and April, as all of Dorset's six resident reptiles emerge from hibernation to prepare their breeding agendas.

The smooth snake is Britain's rarest native reptile and has its stronghold on the heathlands of east Dorset and

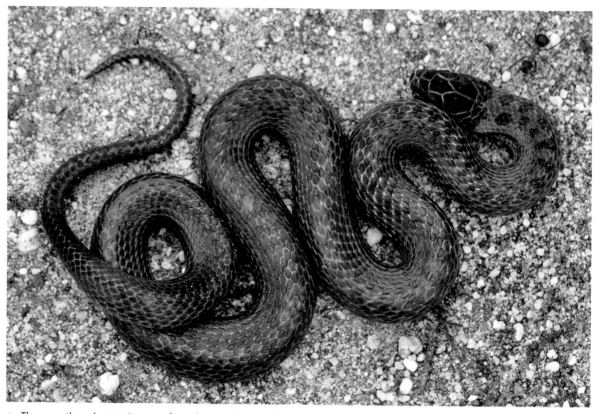

▲ The smooth snake gets its name from the smoothness of its scales. Other British snakes have a slight ridge through the centre of each scale.

the New Forest. The smooth snake gets its name from the unkeeled scales of its body, which are completely flat. This reptile is one of the most difficult wild animals to observe as it rarely basks out in the open, like an adder or grass snake, but rather entwines itself through dense vegetation. The prey of the smooth snake is made up principally of lizards, but it will also take young snakes, slow worms and occasionally mice and voles. The adder's diet is much more varied, feeding mainly on small mammals, but also taking birds, frogs, newts, lizards and even large slugs. The grass snake prefers a diet of amphibians, and is therefore seldom found far from water.

The sand lizard is common on the Dorset heaths, but elsewhere in the country it is a rarity. The male sand lizard is stunningly attractive, especially during the breeding season in early summer when its lime-green markings intensify. These robust lizards may be seen basking on sunny banks, especially at the end of the day when they will be soaking up the last embers of the sun's warmth. Sand lizards spend the winter months in underground burrows.

The common lizard and slow worm both occur in abundance on the heaths, but are not solely restricted to these habitats.

MAMMALS

None of Dorset's wild mammals are specifically tied to heathland, but rabbits, foxes and roe deer are all often seen. The mammal most likely to be encountered on the heathlands is the Sika deer. Sika were first introduced to Brownsea Island from the Far East in the 1870s. Some of these animals left the island by wading across to the mainland at low tide, and established a colony on the salt-marsh of Poole Harbour. As this colony grew, the Sika eventually moved into the wild heathlands.

▲ A male sand lizard in breeding condition, photographed at Winfrith Heath in spring.

Throughout the autumn, rutting takes place. A strange call, resembling a squeaky gate opening, gives away the presence of a Sika stag as it calls to announce its rutting territory. The males or stags maintain rutting stands with their harem of hinds until they are defeated in a challenge. Challenges between mature males occur frequently, where they clash antlers ferociously until one of them gives in. The winner must then rest and gather strength before another challenger sees an opportunity. Sika calves are born in late May and remain close to their mothers until mid-winter.

Open countryside

For the most part, Dorset's open countryside comprises farmland, dotted with villages, parks and copses. Much of this agricultural landscape is managed for arable

THE ARNE PENINSULA

The Arne peninsula is an excellent location for observing a wide range of wildlife, from rare and interesting plants, to unusual insects and birds, to the huge numbers of Sika deer.

The area comprises a vast expanse of lowland heath, peppered with stands of silver birch, Scots pine and oak woodland, giving way to the saltmarsh of Poole Harbour. The RSPB manage this nature reserve and it is possible to enjoy a walk across heathland, through woods and by ponds down to the edge of the saltmarsh.

A fine example of wet and dry heath can be seen at Winfrith Heath, a nature reserve owned and managed by the Dorset Wildlife Trust. This heathland, together with the neighbouring reserve of Tadnoll, make up one of the largest tracts of lowland heath remaining in Britain today. There is easy access to both reserves, where the typical range of heathland wildlife can be seen.

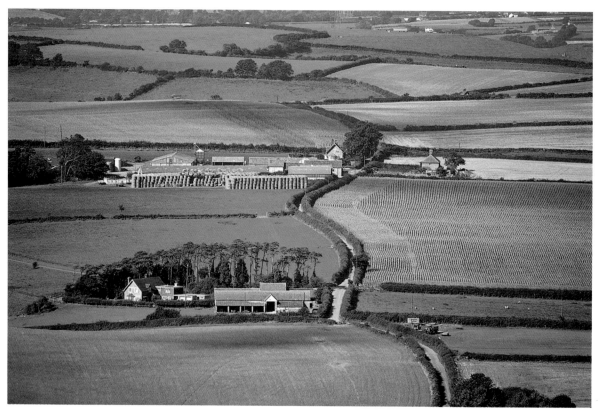

▲ A patchwork of farmland fields west of Eggardon Hill.

crops, especially in the north and east of the county where fertile soils occur on relatively level ground. In west Dorset, arable crops are grown where possible but, due to the topography, the hills and valleys are mainly managed by grazing with cattle and sheep. Standing on a place like Eggardon or Hambledon Hill, it is easy to imagine the view laid out before us to be quintessentially English countryside. But for most wild creatures and plants, this patchwork of fields is little more than a hostile desert. Fields that are managed for grazing regimes or for crops have very little to offer wildlife due to the monoculture. On the other hand, meadows that are managed traditionally for hay allow native flowers to bloom and set seed, thereby providing nectar for insects.

Generally, grass fields evolved on soils containing a percentage of clay in the sub-soil. The presence of the clay assists water retention by preventing moisture from draining away. This benefits the natural grasses and herbs that otherwise would not survive in free-draining

and therefore drier conditions. With the advance of agricultural scientific progress, fertilizers high in nutrients like phosphates were developed in order to increase yields. Due to the consistency of the underlying clay, fertilizer nutrients do not drain away but remain within the soil and therefore change its chemistry. Certain grasses benefit from these fertilizers and dominate the sward, crowding out the naturally occurring grasses and herbs. Such regimes, repeated over time, with their effects compounded by the widespread use of weed-killers, have rendered much of the original vegetation of farmland lost, probably forever in most situations.

It is often argued that field systems are man-made habitats and therefore we have the right to continue to manage them for our own benefit. It would be folly to suggest that there should be a reduction in agricultural production for the benefit of wild plants. We should not forget that the agricultural industry is producing our food, but it is only very recently that the drastic decline

of nature has become apparent, and now farmers are trying to help. Many farmers have joined schemes such as the higher-level biodiversity plan. In many cases, seed from traditional hay meadows is being sown on improved grasslands in an attempt to bring back naturally occurring vegetation. Leaving strips of uncultivated land around field edges is also becoming a more popular practice. These rough headlands around field margins allow wild flowers and insects to thrive alongside crops, often aiding pollination. Although we think of bees as the primary pollinating insect, there are many other invertebrate pollinators as well, including wasps and hoverflies, for example.

The saving grace for wildlife in the open countryside is the hedgerow. As well as providing shelter, hedges also reflect the woodland-edge habitat and thus support much woodland wildlife. In addition, hedges provide the chance for plants to bloom and set seed, especially where fields are not ploughed or grazed tightly to the edge of the hedge bank. In the autumn, the rich harvest of fruit and nuts produced by hedges is an important bounty for wildlife, as it is their larder for the winter months.

FLORA

Hedgerows on agricultural land interspersed with copses can be rich in native flora. Spring is the time for hedgerow blossoms in the Dorset countryside, starting with blackthorn and wild cherry blossom and followed by hawthorn, guelder rose, wayfaring tree and elder. Blackthorn can be in flower for quite a long period, especially during mild springs when it can bloom from March through to early May. But in years when cold weather persists, it is held back for a sudden explosion of white flowers during April. The old country saying about 'blackthorn winters' is based on coincidence as this shrub does not induce low temperatures but blossoms at a time when cold weather can still occur.

The succession of wild flowers in open countryside begins in spring with the yellows of dandelions and daffodils. Wild daffodils put on a spectacular show in fields and hedges in west Dorset during March and April. The Marshwood Vale in particular is famous for

▲ The magnificent lizard orchid appears on the roadside near the village of Slepe in some years.

its native wild daffodils. In early spring, clumps of primrose and wood anemone adorn roadside banks in country lanes across the county, while in late spring the road banks explode in a frothing mass of cow-parsley, resembling delicate lace. The white parsley is punctuated here and there with splashes of red campion flowers.

Several orchids are plants of open countryside, occurring especially on thin soils. One of the rarest of these to be found in Dorset is the lizard orchid. This magnificent orchid does not show itself every year, but when it does it can be seen on the roadside verge near Slepe and is at its prime by the end of June.

Grassy hedgerow banks that have not been sprayed or cut can produce an impressive, vibrant mix of native

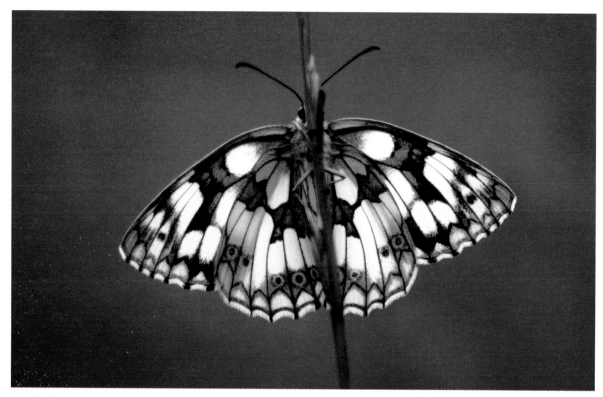

▲ A freshly emerged marbled white butterfly at rest.

wild flowers in the summer months. Some of the species typically occurring on roadside banks include knapweed, agrimony, betony, fleabane and sneezewort, all rich in nectar to attract a wealth of insects. Many of these are traditional hay-meadow plants, which have survived in hedgerow banks and field headlands.

Later, during high summer, regimented blocks of the tall spires of pink rosebay willowherb are dotted with the creamy white flower heads of hogweed.

Flower-rich hay meadows are sadly very much a thing of the past, but where pasture is still principally managed for hay the summer flowers include buttercup, ragged robin, oxeye daisy, mullein, field and hedge woundwort, figwort, vetches, corky-fruited water-dropwort, goatsbeard and yellow rattle. These hay-meadow flowers attract many different species of insect, including butterflies like common blue and marbled white. Some of the finest examples of these now-rare habitat types can be seen at the Dorset Wildlife Trust's reserve at Kingcombe Meadows in west Dorset.

INVERTEBRATES

Butterflies have long been considered an indicator species by conservationists, in so far as where a healthy population survives in a specifically managed habitat then the habitat is more than likely suitable for other wild creatures too. Based on this theory, some nature reserves are actively managed principally for the benefit of butterflies, invariably also resulting in a rich variety of plants.

The proliferation of high-summer butterflies in open countryside reaches its peak in August with the emergence of some notably abundant species. The meadow brown, Britain's commonest butterfly, occurs throughout the county and may be encountered along hedgerows and in hay meadows. The meadow brown feeds on thistles and scabious along with the smaller, but also very common, hedge brown or gatekeeper. The red admiral, painted lady, peacock and small tortoiseshell butterflies are all members of the same family and frequently visit gardens to feed on the nectar of

cultivated plants like buddleia, sedum, catmint and Michaelmas daisy.

The peacock, red admiral and small tortoiseshell all spend the winter months as adults, but the red admiral generally does not survive the Dorset winter. A few isolated individuals may just make it in the warmth of an outhouse or garage but the vast majority of the millions of red admirals that are present here in spring will have flown up from southern France or Spain. They mate in spring and their offspring appear in late summer when they sun themselves on hedges and in gardens. In the autumn these offspring die and the species is replenished by another influx of adults arriving from the continent the following spring. A similar fate applies to the painted lady, although this species cannot survive the Dorset winter at all, not even in an outhouse.

The holly blue is a hedgerow butterfly, which appears in spring like an electric-blue flicker as it flies erratically through the hedge-tops, searching for holly or ivy on which it lays its eggs.

Colonies of marbled white butterflies can survive on relatively small headlands in open countryside or even roadside verges with plentiful late-summer native flowers. Marbled whites can be seen on the wing from late June through to August, as they flit tirelessly on papery wings amongst the knapweeds and thistles.

Sadly, some species of butterfly have disappeared from Dorset and others are just hanging on by their fingertips. The white letter hairstreak was fairly common in the county until the disastrous loss in the 1970s of the elm trees on which it laid its eggs. A colony of this butterfly was recorded in the Beaminster area until the mid 1980s, however, and they may still be seen at a couple of sites in Dorset, one of which is Alners Gorse. From Powerstock Common, the dark green and pearl-bordered fritillaries have been lost. While the marsh fritillary still hangs on, it is recognized internationally as a threatened species.

The reasons for the decline in butterfly species can be complex and are often difficult to rectify. In fact, in spite of in-depth study and research it is still not fully understood why some insect species are declining. It may well be that we simply expect too much from our nature reserves and that they have become too fragmented to sustain certain species. The reserves where some of these species still occur in open countryside are just tiny oases compared to the vast majority of surrounding farmland.

Social wasps are common in the hedgerows, especially in late summer when colonies will have reached their peak. Common and German wasps nest in crevices in walls or holes in banks. The median wasp is an aggressive insect, larger than the common wasp, and a relative newcomer to Dorset. It builds its rugby ball-shaped nest in a tree or bush. As a general rule, social wasps are armed with potent stings, although some are less aggressive than others. Dorset's largest social wasp, the hornet, may be awesome in appearance but it is the least likely to sting, except in defence of its nest.

BIRDS

One of the birds most often associated with open countryside and farmland is the lapwing. In winter, especially during hard weather, flocks of lapwing gather on fields to forage together and to roost. In spring, on the low-lying meadows in the east of the county, the flirtatious courtship of the lapwing is played out with an elaborate tumbling display of aerobatics.

Flocks of redwings and fieldfares gather in the coldest months to forage in fields for earthworms and other insectivorous morsels. In very cold conditions they may be joined by flocks of golden plover on the stubble fields. Redwings display a distinct liking for holly berries, and a flock will tend to strip one tree completely before moving on to the next. As the smallest member of the thrush family, the redwing is particularly vulnerable if it should suddenly turn cold, as the larger thrush species (blackbird, fieldfare and mistlethrush) will dominate in competition for any food. Redwings, blackbirds and fieldfares will also retreat to gardens and orchards to squabble over windfall apples in freezing weather.

The largest member of the thrush family, the mistlethrush, is a permanent resident in Dorset. The male of this species delivers his melancholy song from the tops of the tallest trees, often during inclement

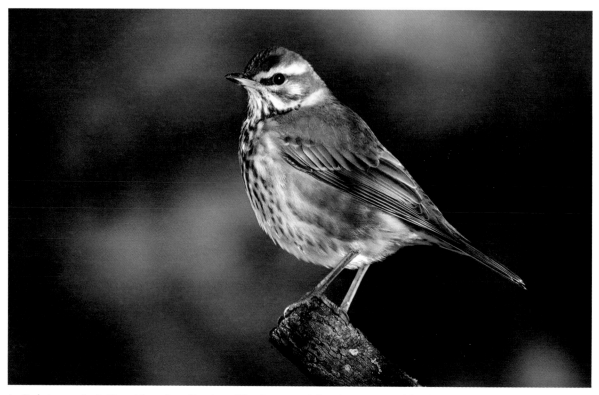

▲ Redwings arrive in Dorset from Scandinavia and Russia to spend the winter in our milder climate.

weather, earning himself the nickname 'stormcock'.

Crows are solitary nesters and more often than not they will use the same nest or nest site high up in a hedgerow tree year after year. Rooks on the other hand nest communally, usually in trees in the vicinity of farmland and often close to villages. Rooks and crows start building or renovating their old nests early in the year. There is an old Dorset country saying that suggests that if rooks build high then the weather will be good. Other bird species that nest early in the year include the heron and raven.

The little owl used to be quite common in Dorset, occurring in open countryside, especially where there were old hedges with mature oak trees. But according to recent records the little owl has become fairly scarce here. The name 'little owl' is derived from the size of this small, stout owl, which only stands at about twenty centimetres tall. It was introduced into Britain over a century ago, and as it became established was soon accused of every crime in the gamebird calendar. As a

result, the little owl (or screech owl as some Dorset country folk incorrectly refer to it) was heavily persecuted up until quite recent times. It is now protected by law, and it is illegal for anyone to attempt to kill these birds or to interfere with their nests. The little owl's bright-yellow eye ring and its habit of bobbing up and down in an excitable manner make this a comical bird to watch. Such characteristics also give an impression of determined fierceness.

On farmland throughout the county, the common buzzard is one species you are guaranteed to see at any time of year. This large hawk soars in the sky above the fields on broad, moth-like wings, searching for carrion or watching for the movement of small mammals below. Although buzzards can be seen almost anywhere in the county, the population density of the bird is highest in the west, which is probably due to the topography. A hilly landscape will produce more thermal activity than a flat one. Adult buzzards provide their fledglings with a daily supply of small rodents and it is not unusual to

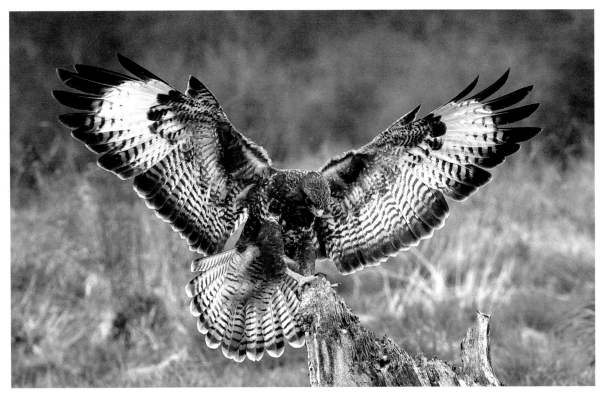

▲ A female common buzzard alights on a regular perching post in west Dorset.

observe the tumbling flight of two young buzzards locked together as they grapple with food.

In summer, the ranks of bird life in the countryside are swelled by the arrival of summer migrants, as villages across Dorset play host to martins, swallows and swifts. Swallow fledglings become eligible fodder for the sparrowhawk and hobby when they take their first flights and are therefore supervised closely by their anxious parents.

In the arable fields of mid-Dorset, the corn bunting recites a curious rattle of tinkling notes. On summer days, this seed-eating finch-like bird sits on hedges or fence posts, constantly uttering this monotonous song, which has often been likened to a bunch of keys jangling.

The whitethroat is a summer visitor that breeds on hedgerows throughout the county. This warbler can be heard throughout May, June and July, uttering its jumbled, scratchy song from the tops of hedges.

The barn owl was once a very familiar sight in the Dorset countryside, often seen gliding silently over grassy rides or hay meadows on thistledown wings at dusk. Population levels of this ghostly hunter have declined to a point where it occurs in only a few isolated pockets around the county. Its demise has been put down to a number of issues, the most obvious being loss of habitat. Damp water meadows and fields are the perfect habitat for barn owls, because such conditions support their principal prey: voles. But undrained fields are generally of poor quality for farming. Therefore, during the second half of the twentieth century, it became commonplace to drain fields for agricultural use. During the 1950s and 60s, harmful chemicals like DDT were also in widespread use in agriculture. These chemicals found their way up the food chain with disastrous effects on the fortunes of predatory birds. A dramatic decline in the barn owl population resulted. Where large-enough areas of ideal habitat still occur in Dorset, the barn owl can still be seen, at places like Lower Kingcombe, West Bexington and in the low-lying plains of the Blackmore Vale.

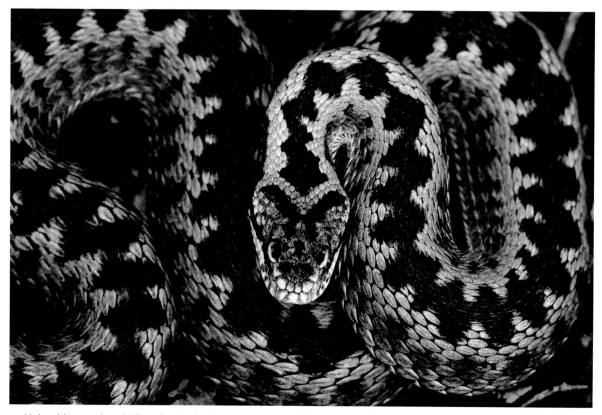

▲ Male adders can be told from females by their dark, almost black, zig-zag markings.

REPTILES

The adder, grass snake and slow worm are all reptiles found in open countryside, although none are specifically tied to any particular habitat. Adders may be seen basking on south-facing field banks or wood piles. Slow worms have so many potential predators that evolution has taught them to remain hidden. They gain warmth for energy by laying under sun-soaked stones or pieces of tin. Grass snakes do not give birth to live young but lay eggs. As cold-blooded creatures they are unable to incubate their own eggs so they lay them in decaying organic matter like compost bins or silage heaps, which generate sufficient warmth for incubation.

MAMMALS

The mammals of open countryside will include most of the terrestrial species, but those of particular note are the fox, hare, rabbit, deer and bat. Although bats are gener-

ally associated with trees and woods, most species in Dorset hunt in open countryside. There are around fifteen species of bat recorded annually in the county, the most common of which is the pipistrelle.

The red fox continues to survive in much of Dorset in spite of heavy persecution. Some areas of countryside in Dorset have seen a serious decline in local fox populations, as hunting foxes with dogs, snaring and shooting are all commonplace across the county.

The fox mating season typically lasts from mid-December until late January, and the haunting sound of foxes calling after dark is heard in all habitat types across the county at this time. The husky mating cry of a vixen carries far into the frosty darkness, sounding more like a distress call than an alluring one. She calls to proclaim her desire to mate, and may even be served by more than one dog fox.

Fox cubs are born during April, and remain beneath ground until they are one month old. The first evidence

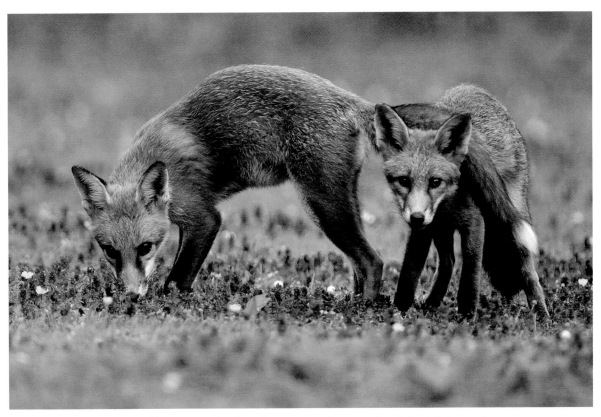

▲ Driven both by curiosity and hunger, growing fox cubs are frequently seen out and about during daytime.

of their presence is the harsh sound of squabbling youngsters in early May.

During spring, vixens may be seen hunting in broad daylight, while cubs play outside their dens. Although opportunists, foxes live almost exclusively on a diet of invertebrates and small rodents, especially rabbits.

Deer tend to lie in cover during daytime, coming out to browse in fields at dusk. Dorset is home to four species of deer, which are the Sika, muntjac, fallow and roe. The roe is the only native species and is the one most linked to agricultural land. It is quiet and secretive and for most of the day remains hidden in hedge thickets and copses. Roe deer do not form herds but occur in small groups of just a few individuals at most. They emerge from the undergrowth at dawn and dusk to browse grasses and crops in the open fields. Typically, if disturbed, a roe buck will run off a short distance before stopping and barking gruffly.

The brown hare features in arable areas of Dorset, as this is an animal which thrives on fresh new shoots of grasses and crops. The brown hare is most common in the north east of the county, which borders the arable prairies of Wiltshire where they are especially abundant. There are small populations in west Dorset, mainly in the Marshwood Vale and in the landward margins of the Fleet. Like many other species of wildlife, the brown hare is in decline, but in spite of this it still has no legal protection and may be shot at any time of the year.

Rabbits are prolific on farmland and, despite the effects of disease, they appear to be on the increase. This may be due to a decline in predators like the stoat and fox.

West Dorset is also one of the strongholds for the dormouse; although this is principally a woodland mammal it also lives in hazel hedgerows and small coppices. Other small mammals of Dorset's hedgerows include common shrew, woodmouse and both bank and field vole. All of these are common and are preyed upon by hawks, owls, stoats, weasels and foxes.

ALNERS GORSE

Alners Gorse is a magnificent relic of the ancient Blackmore Vale Commons, a world of rough scrubby grassland, dotted with oak trees and thickets of wild shrubs, a living remnant of times past. The site is owned and managed by Butterfly Conservation and, although it is primarily an insect reserve, there is a wealth of other wildlife to be seen and enjoyed as well.

To catch sight of the brown hairstreak in August is a special prize. Seldom seen elsewhere in the county, the brown hairstreak thrives here along with its close relatives: the purple, green and white-letter hairstreaks.

Waterways

Dorset's ponds, lakes, streams and rivers together support a huge abundance of wildlife. Plants, invertebrates, reptiles, amphibians, birds and mammals all exploit the waterways in one way or another.

FLORA

The riverbanks are home to many specialist plants that like to keep their roots damp, like yellow flag, great willowherb, meadowsweet, purple loosestrife, water forget-me-not, mimulus and watermint, to name just a few. But the fortunes of these native wild flowers are changing rapidly due to the spread of the non-native Indian balsam *Impatiens glandulifera,* which was introduced into southern England from the Himalayas. This is a tall, vigorous plant with large leaves that block out the light for smaller, native species. Its spread across Dorset has been swift and it is now seen in huge accumulations, crowding the banks of many rivers and streams and smothering entire native plant communities. Another introduced wild flower thriving on the banks of some of Dorset's rivers is the largest wild flower in the county: the giant hogweed. This massive umbellifer can grow up to three and a half metres in height with flowerheads measuring forty-five centimetres across. This enormous flower should not be touched with bare hands as it causes severe skin irritations. It can be seen along the River Brit near Beaminster and also on the banks of the Allen in the north of the county.

INVERTEBRATES

The animals that make up the teeming mass of wildlife on and in the waterways range from tiny nymphs of insects to aquatic birds and mammals. In these waters, the food chain begins with the lowliest of invertebrates: the nymphs and larvae of gnats, midges and flies.

Evolution has given many species of flying insect the ability to exploit two completely different habitats: water and air. Mayflies, dragonflies, mosquitos and stoneflies, for example, all spend the early part of their lives underwater, feeding on smaller creatures, or in turn becoming food themselves for fish or other predators. Some members of the dragonfly family can remain underwater for up to three years. During their aquatic stage, dragonflies and damselflies are fierce predators, eventually emerging to hunt in the air, mate and lay eggs. The banded demoiselles and the beautiful demoiselle are two species of damselfly that fly close to streams and rivers, where they both lay their eggs on floating vegetation. During their airborne stage they prey upon gnats and midges in flight. The beautiful demoiselle is found on the faster-flowing streams and rivers in the south and west of the county. The female demoiselle mesmerizes her mate by flashing her white wing spots as she hovers tantalisingly above floating vegetation. The banded demoiselle favours Dorset's larger, slower waterways like the Frome and the Stour.

Dragonflies are primitive insects that have been around since the time of the dinosaurs. They are mostly associated with water, as it is either in, on or near water where females lay their eggs. Some prefer fast-flowing streams, while others seek out still ponds and lakes. A few are specific to calcareous conditions and some thrive in the acidic bog pools of lowland heaths. Some species require very specific habitats in which to breed. For example, the southern blue damselfly can only be found on streams that flow through open heathland.

The overall flight period for dragonflies and damselflies in Dorset is from May until September. The earliest common species to emerge are the large red

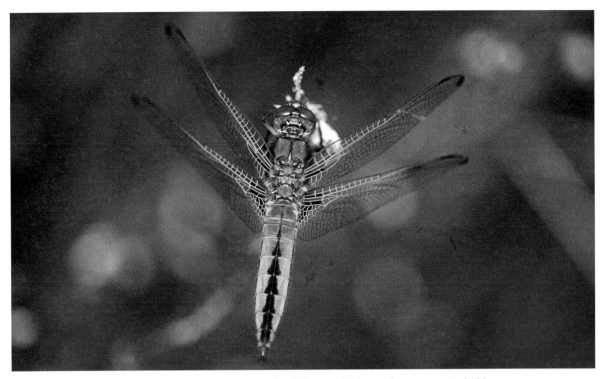

▲ A freshly emerged male scarce chaser. As he matures, the abdomen will change from orange to sky blue.

damselfly and the broad-bodied chaser. When the insect is ready to leave the water, the mature aquatic nymph climbs out onto vegetation, typically a reed stem. The outer skin of the nymph splits open as the adult dragonfly or damselfly wriggles itself free. From this point it can take several hours for the insect to expand its wings by pumping the veins full of blood. Some of the large hawker dragonflies emerge overnight, but many of the smaller species emerge during daytime.

The main differences between dragonflies and damselflies are the size of the insect and the shape of the wings. Dragonflies are large, robust insects with powerful flight; their front wings differ in shape to their hind wings, and their wings are held at right angles to the body when the insect is at rest. Damselflies (sometimes referred to as 'Devil's darning needles') are smaller, with weak flight and identical wings that are held along the length of the body when at rest.

Some of the more spectacular hawker dragonflies to be seen in Dorset include the golden-ringed, emperor, brown and southern hawker. The brown hawker is a large dragonfly that patrols the water's edge at a number of sites in north and east Dorset. The emperor, Europe's largest dragonfly, tirelessly patrols his breeding pond or lakeside. The golden-ringed dragonfly is an impressive creature as it has the longest body of all British insects. The female lays her eggs directly into the water in quick-flowing, stony-bottomed streams.

The migrant hawker was once considered to be a summer visitor to southern England from mainland Europe, but it is now a resident, breeding in Dorset. Unlike the other hawkers it tolerates its own kind and in some years, when conditions are favourable, huge numbers of migrant hawkers can build up by late summer.

The scarce chaser is a medium-sized dragonfly and, as its name suggests, is internationally scarce. The scarce chaser occurs on the red data list of endangered species. Dorset, however, proves to be one of its strongholds in Britain and there are healthy populations of this species on the Stour, Frome and Moors rivers. Adult dragonflies of this species are on the wing during June and July. Newly hatched males display an attractive bright-orange

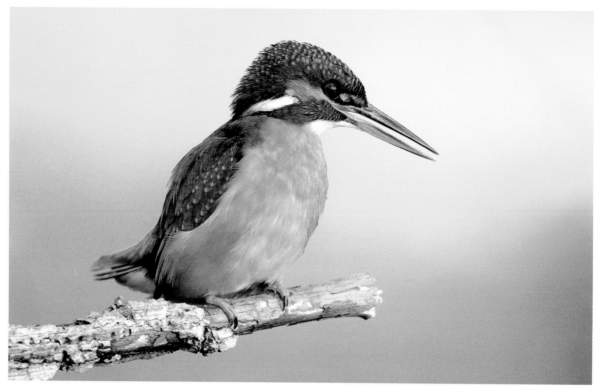

▲ An adult female kingfisher keenly studies the water beneath her.

abdomen, which gradually turns pale blue with prunescence as the insect matures. Upon maturity, males occupy territories along the rivers where eggs will be laid. Dark-blue smudges on the pale abdomen are evidence that a male has mated.

BIRDS

One of the most iconic wild creatures of Dorset's waterways is the kingfisher. It is also one of the easiest birds to observe because it is so predictable in its habits. The bird flies only inches above the water's surface; it regularly uses favourite perches and patrols its territory constantly all through the year. You would only need to sit for twenty minutes or so on the bank of any of Dorset's unpolluted rivers to see one. The cobalt blue of the kingfisher has evolved because the bird mostly flies low over water, which reflects the colour of the sky. The most likely threat from enemies is from above and therefore the bird's blue plumage blends with its immediate surroundings.

The high-pitched, piercing, piping call of the kingfisher is unmistakeable. When fishing, this small bright-blue dart of a bird stares intently into pools, bobbing its head and constantly changing its angle of view. It will dive off a perch and splash, beak-first into the water, returning to the perch with its prize. The bird slaps the quarry repeatedly on a post or stone to stun or kill it. It always swallows fish head-first to avoid being choked by the gills opening as the fish slides down its throat.

The grey heron is the supreme predator of life in Dorset's rivers and lakes, and may be seen stalking prey in small ponds or streams as well as larger water bodies. The heron is highly adaptable and can catch insects and amphibians as well as fish. Its long legs enable it to wade into quite deep water, and its pick-axe bill can tackle large fish. The heron's greatest attribute, though, is its patience, as it can stand motionless for long periods of time, waiting for the moment to strike.

A close relative of the heron, and a relative newcomer to Dorset's rivers, is the little egret. In the past, this was

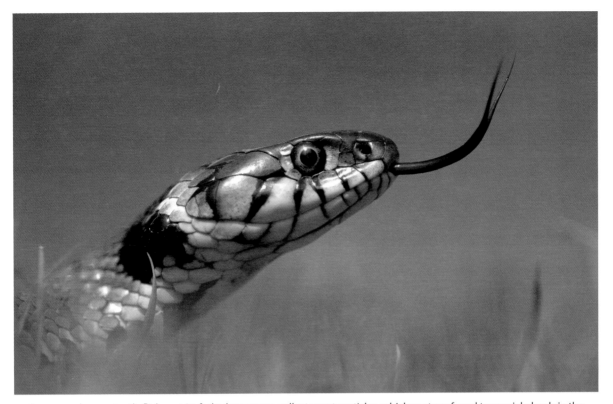

▲ A grass snake constantly flicks out its forked tongue to collect scent particles, which are transferred to special glands in the roof of its mouth.

an occasional visitor, but the little egret has bred in Dorset since the mid-1990s and it is now thought that the egret population actually outnumbers that of the heron.

In the west of the county, where rivers tend to run much faster on account of the more undulating landscape, the dipper is present. This bird is slightly smaller than a blackbird, has dark-brown plumage and wears a distinct white bib. It gets its name from its habit of bobbing up and down when standing on a favourite stone in the river. The dipper is capable of finding food underwater and frequently ventures under the surface in pursuit of caddis fly larvae and other invertebrates. It can sometimes be seen wading into a river with wings outstretched to hold itself down against the current.

Where there are dippers there are usually also grey wagtails because the habitat suits both birds exactly. Although the grey wagtail is predominantly yellow on the body, it is its grey head and shoulders that give the

bird its name. Grey wagtails are extremely vocal in spring and summer, standing on rocks or other perches with their long tails constantly wagging. In summer, they feed mainly on airborne insects and frequently take damselflies.

The most secretive bird of Dorset's waterways is the water rail. This is a mottled brown-grey dumpy little bird with a long, red, slightly down-curved bill. For most of the time the bird remains hidden, as it skulks around in dense sedges or reeds, only showing itself in very cold conditions.

REPTILES AND AMPHIBIANS

The grass snake is associated with ponds and lakes due to its preferred prey of amphibians. Grass snakes are excellent swimmers and more often than not seize amphibians in the water. Young grass snakes feed on tadpoles, froglets and juvenile newts, while mature adult snakes take full-grown frogs and toads.

Frogs become active early in the year when they return to breeding ponds to mate. A remarkable nocturnal sound, which can only be heard for a few nights, is the guttural, chirring songs of massed croaking bullfrogs. Frogs in Dorset can spawn as early as mid-January, but late February is the more usual time. Tadpoles developing into tiny froglets remain underwater until late June or July when they emerge to continue their growth. Common frogs become sexually mature at three years of age. Adults live mostly out of water and are nocturnal in their habits, feeding on insects, slugs and worms in damp, boggy habitats where there is plenty of shade.

Toads follow a similar pattern of development to frogs. Toad spawn is laid in strings of black eggs, usually wound around floating vegetation. Common toads can easily be distinguished from frogs due to their warty skin.

Three species of newt occur in ponds and lakes in Dorset: the smooth, palmate and great crested. The latter animal is given special protection due to its scarcity.

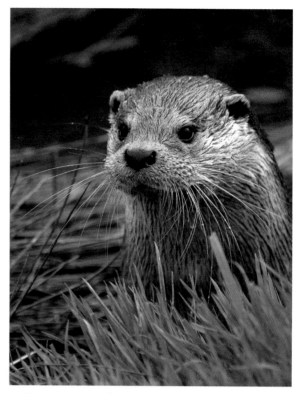

▲ The otter is now often seen in waterways across the entire county.

MAMMALS

Wherever there is unpolluted water there are fish, which attract predators of both the avian and mammal variety. The North American mink has been the scourge of many of Dorset's rivers after they escaped from fur farms during the 1970s. The mink is an aquatic predator and is just as eager to kill mammals or birds as it is to devastate fish populations. Certainly the mink has been blamed for the drastic decline in water vole populations across Dorset.

Due to the effects of human persecution and pesticides washing into rivers, the otter disappeared completely from Dorset, as well as from most other English counties. But this iconic mammal's fortunes began to change when the otter hunting ban was brought into force in 1978. The ban, together with improved quality of rivers, gave the animal a chance to bounce back. Gradually it has recovered and is now recorded on waterways throughout the county on a regular basis. Otters are regularly seen during daytime a

great deal more than they were in the past. This might be because they have lost some of their fear of man, or perhaps it is due to the need to spend more time hunting and fishing. The native otter is a direct competitor to the North American mink and, being much larger than the mink, it is thought that its recovery has been responsible for the marked decline of the ferocious alien. In time, this should help the water vole to recover also, as the water vole and otter exist more or less happily side by side. Hopefully, as the otter continues to expand its range we will see fewer mink and more water voles once more.

It may well be that as humans we have romantic ideas of riverbank life akin to *Wind in the Willows*, and there is something very magical about a stroll along one of Dorset's rivers on a summer evening. But for the creatures that live there, this habitat is little short of a battle zone, as the water which attracts so many fascinating birds and animals is also a magnet for their enemies.

A Selection of Dorset's Towns and Villages

The villages of Dorset generally reflect the availability of local building materials. As Dorset is primarily an agricultural county, villages there traditionally grew up around the manor house and church, with the stone manor surrounded by more humble dwellings. Some are enchanting places with delightful thatched cottages, with gardens set in attractive and historic landscapes, some are mainly of brick and others of the local stone.

But now the centre of a village can be a little difficult to find. For many there is no shop or post office, meaning that there is no natural hub where people can meet and talk. A car is generally thought to be an essential item, as buses may only run once or twice a week, if at all. Many villages have high numbers of holiday homes, or second homes, which results in fewer people having an interest in keeping the village vibrant and alive with activities. It also means that less money is being spent in the local shops as many of the visitors come with their cars already full of provisions.

But this picture is a reflection of what has happened historically – more people moving away and living in towns rather than in the rural areas. Traditional cottage industries such as button-making and glove-making waned with many other rural industries, leaving the villages bereft and in decline. Villages that once grew their own wheat, ground their own flour in the local mill and then baked their own bread are no more. But with food miles becoming an issue, as well as the source and traceability of food being a concern, it seems likely that this trend could well be reversed in the future.

Settlements generally grew up for one of a handful of reasons. In the twelfth and thirteenth centuries, bigger settlements were encouraged by the lords of manors, who sought to increase their revenue by encouraging the growth of markets on their lands. These towns, like Beaminster, Evershot or Bere Regis, grew up serving local needs and remained quite small. Other towns grew due to the existence of a monastery, such as Abbotsbury and Cerne Abbas. Corfe and Cranborne grew up due to royal patronage or protection and other towns grew because of their important location on a trade route, such as Blandford. During the Middle Ages four ports grew in importance: Weymouth, Melcombe Regis, Poole and Lyme Regis, while Wareham and Bridport went into decline due to silting problems.

Abbotsbury

Abbotsbury is a village of traditional stone and thatched cottages, with raised pavements and a rich history. In addition, it is also famed for its swannery, its subtropical gardens and its large, thatched tithe barn, which would have stored all the produce from the estate.

Abbotsbury has been occupied by man for at least 6,000 years and has suffered many vicissitudes over its lifetime. To the north west of the village lies an Iron Age fort or earthwork known as Abbotsbury Castle, one of the many ditched hill forts in Dorset, of which Maiden Castle is the most famous. Later, Abbotsbury became part of the Wessex Kingdom and during the reign of King Canute a monastery was established here, which flourished until the dissolution of the monasteries. With the establishment of a monastery, the village began to

▲ Many of the cottages in Abbotsbury date back to the sixteenth century and have incorporated fragments from the old abbey.

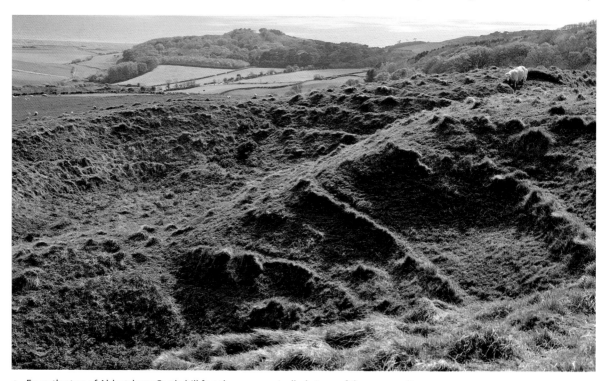

▲ From the top of Abbotsbury Castle hill fort there are unrivalled views of the surrounding area.

▲ Abbotsbury Swannery was established by Benedictine Monks during the 1040s in order to provide food for their lavish banquets.

▲ The Benedictine monks built Abbotsbury tithe barn in the 1390s and it is apparently the largest thatched building in the world.

▲ Ashmore is a remote village from which magnificent views of the Cranborne Chase and beyond can be seen.

grow and prosper, but during the middle of the four-teenth century the Black Death and various attacks from both land and sea hampered the growth of Abbotsbury. It fell into poverty and debt. However, by the end of the century it had recovered and a great deal of building work took place, including St Catherine's Chapel and the Great Abbey Barn (the longest in England).

After the dissolution of the monasteries in 1539, the abbey lands were leased to Sir Giles Strangways for twenty years, on condition that all evidence of the monastery was removed, hence several of his former houses have incorporated fragments from the old abbey.

The swannery at Abbotsbury has been in existence for over 600 years, ever since rights to the adjacent seashore and the Fleet were granted to the abbots by Edward the Confessor. The swans had their wings clipped and were bred by the abbots for the use of the kitchen as a convenient source of meat.

The church of St Nicholas in Abbotsbury has some interesting fixtures and fittings. On the pulpit in the church there are holes left by the bullets of the Parlia-mentarians in the desperate battle to capture the village in 1614. At the rear of the church the foundations of the old abbey may be seen.

Arne

Arne was evacuated during the Second World War as the area was to be used for live battle practice. It is a small collection of houses and a thirteenth-century chapel. The view from the altar window is one of the loveliest in Dorset. The church is lit by candlelight.

It is said that smugglers used the shores here to unload their contraband, 1947 being the last instance recorded. The RSPB have one of their reserves here where it is possible to see the Dartford Warbler – a bird that is synonymous with Dorset's heathlands.

▲ Beaminster's prosperity grew from the wool-cloth trade and the manufacture of sailcloth, sack-cloth, rope and twine from locally grown flax and hemp.

▲ Much of the oak nave roof in Bere Regis Church is painted and gilded, like this carved figurehead.

Ashmore

Ashmore is in north Dorset, right on the border with Wiltshire. It is an isolated hilltop village, the highest in Dorset, standing at 700 feet above sea level. The large dewpond in the centre of the village rarely dries, making Ashmore a popular location for artists to come and paint the lovely stone buildings reflected in the still water. The Roman road from Badbury Rings to Bath passes through part of this parish.

Beaminster

Beaminster is set in a bowl, surrounded by green and woody hills, and lies near to the sources of the River Brit and the River Axe. Virtually the whole town is built from local limestone. Few of its buildings date further

back than the eighteenth century due to three disastrous fires in 1644, 1684 and 1781, which between them destroyed much of the antiquity of the town. However, in the church graveyard is a little almshouse of 1630, now the Strode Room.

Bere Regis

The village of Bere Regis has been in existence for more than 1,000 years and it is now bypassed by the main road. It has an old-fashioned main street with most of the red brick buildings dating from after a severe fire of 1788.

The church of St John the Baptist is fifteenth century with an arcade built by the Normans. The pillars have capitals, which are richly carved. The nave roof, which

▲ After the Reformation the length of sermons was restricted to one hour – hence an hourglass could display the remaining time, like this one in Bloxworth Church.

was constructed around 1475 out of oak, takes pride of place. It is crudely carved and gaudily painted, and the twelve apostles dressed in colourful fifteenth-century garb look down on the congregation.

The hamlet of Shitterton, down a lane from Bere Regis, is picturesque with lots of thatched buildings, including a traditional farmhouse at the end of the road.

Blandford Forum

Blandford Forum is a market town in the north of the county lying between Sherborne and Wimborne. In the past, Blandford's location was crucial as it is the crossing place of the River Stour where the Salisbury, Dorchester, Poole and Shaftsbury roads all met. Fire was a constant threat to Dorset towns in the past due to the timber buildings and thatched roofs and Blandford had suffered

from at least three before the great fire in 1731. It meant that a complete rebuild was necessary, which was mostly carried out by two brothers, John and William Bastard, sons of Thomas Bastard (all of whose six sons were associated with buildings of some kind or another). Many of their splendid buildings remain and Blandford is a fine example of a Georgian town and water meadows set by the River Stour. At one time, from 1860 to 1964, Blandford had its own railway station, being one of the stops on the Somerset and Dorset Joint Railway, but the line closed to passengers in 1966.

Bloxworth

The church of St Andrew is small and is renowned for having an hourglass, which is a reminder of when sermons replaced the Mass. Its purpose was to show the congregation how much longer the sermon was to last. The hourglass that can be seen now is not the original; it apparently disappeared in 2003 and has never been returned or found.

Bockhampton (Higher)

Higher Bockhampton is a small hamlet where Thomas Hardy was born in 1840 to Thomas and Jemima Hardy. The tiny thatched cottage, built by Hardy's grandfather, has to be approached on foot, which increases the feeling of remoteness. The cottage is surrounded by Thorncombe Woods and Blackheath, both of which feature heavily in Hardy's novels.

Bradford Peverell

Bradford Peverell is one of the oldest villages in Dorset, situated in the valley of the River Frome where the river could be forded. The remains of the route of the Roman aqueduct from Frampton to Dorchester can be seen. It was the birthplace of John Hutchins, the Dorset historian, in 1698. The church is one of only a few in Dorset to have an ancient spire.

Briantspuddle

Briantspuddle is a particularly charming village lying in the Piddle Valley, which had only about twelve houses until the early twentieth century, when Ernest

▲ Ernest Debenham was adamant that new structures had to harmonize with the older buildings in Briantspuddle. They also had to be sympathetic towards local materials and crafts.

Debenham bought four farms in the area. Ernest Debenham, who was born in 1865, was the grandson of William Debenham, the creator of the Debenham drapery and department store enterprise. He was keen to harmonize new buildings with the old Dorset tradition in his pursuit of a self-sufficient agricultural enterprise. He wanted to support small neighbouring farms with special facilities, which would then benefit from economies of scale. Trees were one of his great passions and a good deal of planting went on during his era. There is no pub or church in the village.

Bridport

Bridport is a market town on the River Brit, famous for its rope- and net-making industry, which influenced the locality in the Middle Ages onwards with its demand for flax and hemp. The country around Bridport was planted with hemp in large quantities for the people of Bridport to then turn into rope. The streets of Bridport are wide, which allowed the twine, yarn and rope to be dried after being spun and twisted in the long gardens behind the houses. According to the Domesday Book Bridport contained 120 houses, as well as a mint and a priory in the time of Edward the Confessor (1042–66). In 1253 Henry III granted the town its first charter. It has a Georgian town hall built in 1785 with a distinctive clock tower and a cupola which was added twenty years later. Market days are Wednesday and Saturday, and they attract huge numbers of people from miles around.

Broadmayne

Broadmayne is a large village to the north of the South Dorset Ridgeway. There is a field there called Poor Lot reflecting the right of poorer villagers to collect wood

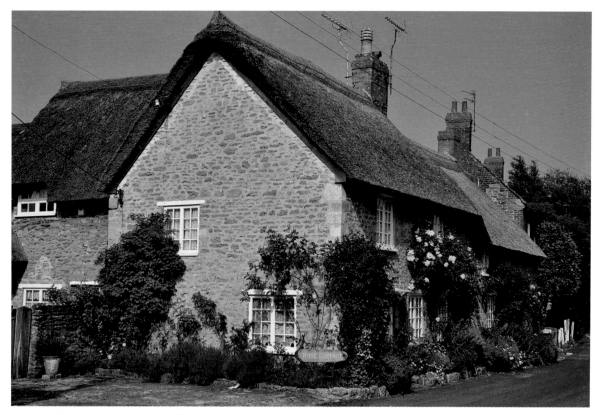

▲ One of Burton Bradstock's pretty thatched cottages.

and gorse for their fires from the ridge. The church of St Martin, built of Portland stone, was restored from 1865 by John Hicks with his draughtsman Thomas Hardy. Broadmayne bricks are easily recognizable by their speckled appearance. There is a sheepwash that survives in the river at Broadmayne, which reminds one of the practice of washing the sheep in early summer a few weeks before shearing. This cleaned the fleece of the dirt and grease that had built up over the winter months. Local rivers were often used for this purpose. The men would stand for hours in the water scrubbing each sheep as it came through.

Broadwindsor

Broadwindsor is one of the larger villages of Dorset. It is also one of the highest villages in the county and is surrounded by the rolling west Dorset hills. Both Lewesdon and Pilsdon Hills, which battle for the title of the highest hill in Dorset, are close by.

Broadwindsor is renowned for the flight of King Charles II after his escape from the Royalist defeat at Worcester in 1651, when he was disguised as a woman. He spent the night here at the Castle Inn. It was burned down in 1856 but a cottage on the site carries a plaque commemorating his stay.

Broadwindsor is also known for the Rev. Thomas Fuller who made his congregation roar with laughter during his sermons, which was rare in the 1600s.

Burton Bradstock

Burton Bradstock is a delightful village set back from the sea on the River Bride. It has many thatched cottages built of local stone. The River Bride flows past Burton's one-sided main street. The village contains a labyrinth of byways behind the main street: Donkey Lane, Darby Lane, Shadrack – a myriad of wonderful names, each with a story to tell. Grove Mill, built in 1803, has an inscription stating that it was the first flax-swingling mill

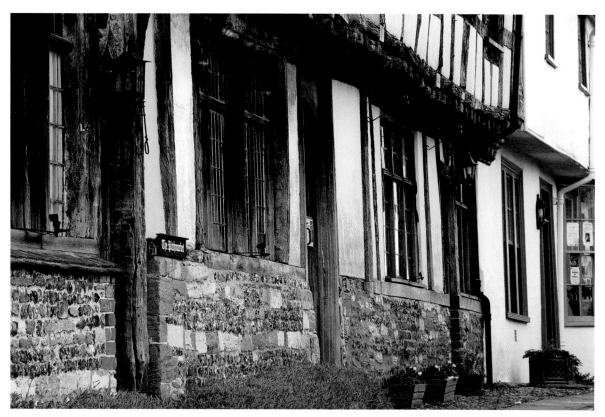

▲ Medieval timber-framed houses, like this one at Cerne Abbas, are not often seen due to the frequent occurrence of fires in towns and villages in past centuries.

in the west of England (such mills used machinery to separate the flax fibres). Grove Hill House also once produced linens and sailcloth from the three mills in the village. Indeed, Burton Bradstock became a flourishing centre of the flax and hemp industry due to Richard Roberts, who built up a large business that was based on flax and hemp products.

Chesil Beach begins here and extends eastwards as far as Portland. Smuggler Isaac Gulliver is said to have opened up a western connection here and used the beaches of Burton Bradstock to unload his contraband. He bought a farm at the foot of Eggardon Hill and planted a clump of fir trees on the top of it as a landmark for his ships, his farm being a useful centre for his customers from Bath and Bristol.

Cerne Abbas

Cerne Abbas is a delightful village with much of interest.

It is situated in the heart of Thomas Hardy's Dorset and was of much greater significance and importance before the railways came to the county. When they arrived, Cerne was bypassed, which led to its decline in prosperity (in a similar way to Beaminster). Cerne Abbas is perhaps best known for its hillside chalk carving of a giant which is 180 feet high with 7-foot-long fingers holding a 120-foot-long club, but which is of uncertain origin. The most picturesque part of this historic town is Abbey Street with its fifteenth-century cottages beside a stream, which runs alongside the road. The New Inn, a sixteenth-century coaching inn, is said to have its own ghost.

The Benedictine abbey, which was founded in AD 987 and dominated the area for hundreds of years, was destroyed after the dissolution of the monasteries in 1539 and is no more. However, much of the stonework is still evident as some of the material from the abbey

▲ Charmouth has one steep main street descending through it.

was used in other buildings within the village. The River Cerne meanders gently through the village and the Wessex Ridgeway passes nearby on its way to Lyme Regis from Ashmore.

Chaldon Herring

Chaldon Herring or East Chaldon, as it is also known, is a small village. It is best known for its association with the three Powys brothers who used the surrounding landscape as inspiration for some of their literary works. The novelist Sylvia Townsend Warner also lived here for some time. Nestled between the notorious smuggling villages of Osmington Mills and West Lulworth, Chaldon was also a well-known location for smuggling and was home to at least four smuggling families. The Five Marys, which lie a short distance from the village on the chalk ridge, are ancient barrows. The pub, the Sailor's Return, is a popular destination.

Charmouth

Charmouth lies in a gap in the coastal hills on the banks of the River Char and consists broadly of one steep street lined with an assortment of buildings. The beach is split in two by the river. The blue lias clay cliffs on either side of the beach are renowned for deposits of fossils, particularly ammonites. Indeed, Mary Anning found a strange fossilized creature in the cliff face in 1811 when she was only twelve years old. The ichthyosaurus is now housed in the Natural History Museum!

Charmouth has found fame on additional fronts also: Catherine of Aragon stayed here in 1501; in 1651 Charles I's escape to France was foiled at Charmouth by the actions of a cautious wife – the Queen's Arms, which was then a hostelry, is now famous for the stay of that fugitive; furthermore, Jane Austen is known to have been a frequent visitor to Charmouth, describing it as a place of 'high grounds and extensive sweeps of country, and, still more, its sweet retired bay, beached by dark

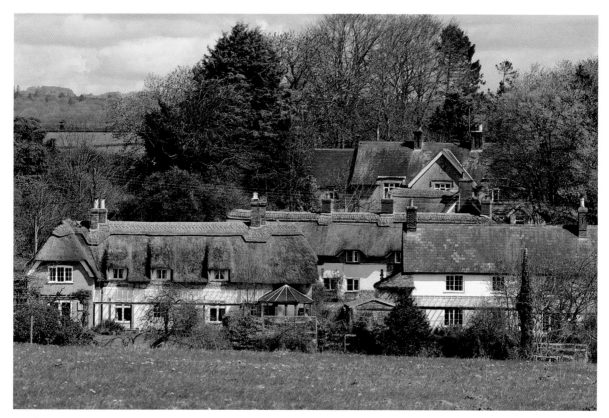

▲ The picturesque village of Chettle, with many traditional thatched cottages, located in the Cranborne Chase.

cliffs where fragments of low rock among the sands make it the happiest spot for watching the flow of the tide; for sitting in unwearied contemplation'.

Earlier than these references, Charmouth is mentioned in the Domesday Book. It was then owned by the Abbot of Forde, who sent monks from Forde Abbey on foot to collect the rents. It is said that the Queen's Arms even has the initials of Thomas Chard, the last Abbot of Forde Abbey, carved on the side of a door.

Chedington

Chedington is a small village that is the source of two rivers: the Axe and the Parrett. The views from the roads along the ridge near the village are quite stunning. The pub, the Winyards Gap, is in a cutting of the chalk hills tucked beneath ancient earthworks. Historically this was a well-used route as it was through here that King Charles I marched in 1644.

Chettle

Chettle is a small rural village in a wooded valley with many thatched cottages as well as the red-brick Queen Anne Chettle House. It is situated in the rolling hills of the Cranborne Chase. There are two long barrows close by, which are believed to have been dug over 2,000 years ago.

Chideock

Chideock is a small village situated in a valley one mile from the coast and sliced in two by the main A35. The road is lined with pretty cob and sandstone cottages, many of them with thatched roofs. The village lies one mile north of the coastal hamlet of Seatown.

Chideock has a turbulent past. A castle, which changed hands many times during the Civil War, once stood there, but now all that remains of it is an earthworks marked by a cross. Golden Cap, the highest hill on the Dorset coast, and indeed the south coast, is close by and was once used by a smuggling gang as a lookout post.

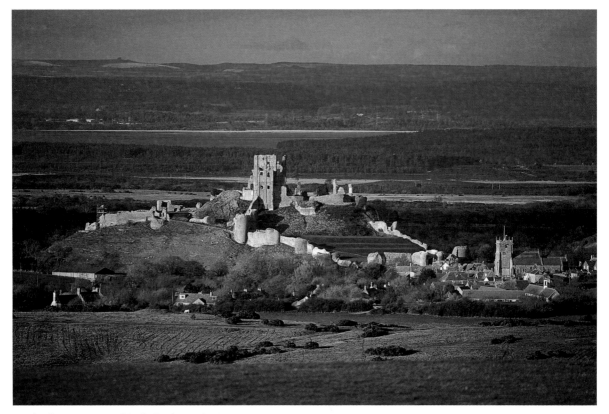

▲ The dramatic ruins of Corfe Castle emphasize its strategic importance.

Christchurch

Christchurch lies on the confluence of the River Stour and the River Avon in the far east of the county. It has its own natural harbour. There has been a settlement here since before Saxon times when it became important as a trading port. As well as two rivers it also boasts two castles and a priory church with a rich history.

Corfe Castle

Corfe Castle is in the centre of the Isle of Purbeck. It sits in a gap in the hills, surrounded by heathland. The castle is in a key position. Historically, its steep banks and sturdy stone made it one of the most unassailable fortresses in Britain. The castle was built of Purbeck stone with flint in the core and is an unmistakable landmark. Its history is full of treachery and bloodshed, the best known of which concerns the fate of King Edward the martyr who was murdered in 978. In 1572 the castle

passed out of royal possession when Elizabeth gave it to Sir Christopher Hatton, making him Admiral of Purbeck. It was later bought by Sir John Bankes in 1635, who was a Royalist. Parliamentary troops stationed themselves inside the church of St Edward the Martyr during the Civil War (1642–46) and used it for stabling their horses and men as well as using some of the masonry for target practice. Shot marks can still be seen inside and outside the church. In 1660 the castle was destroyed by Parliamentarians.

There is an interesting tradition of the Company of Marblers, held on Shrove Tuesday, where quarrymen invaded the town and held a court where young apprentices were initiated at a ceremony. This included the carrying of a quart of ale into the court as veterans tried to steal it. The ceremony also included the kicking of a football through the streets to Ower, in order to preserve the right of way to the harbour.

▲ Edmondsham Church lies a little way from the village.

Cranborne

Cranborne lies on the River Crane in a well-wooded area of chalk downland. It has been immortalized in the novels of Thomas Hardy as well as in a poem by Rupert Brooke, who celebrated the local pub. It was once a large market town, but with no turnpike road or railway it fell into decline. The area has been the location for many royal hunting parties, in particular King John's in the thirteenth century and Henry VIII's; in fact, Henry VIII founded the hunting lodge in the village.

The village once had a monastery, which was destroyed during the dissolution of the monasteries. Part of that building still survives in the form of the church's fifteenth-century tower, which was built of stone and flint. The village has many attractive cottages built mainly of red brick. Cranborne Manor itself, which was originally a hunting lodge, is now the location of a garden centre with extensive gardens.

Dorchester

Dorchester is the county town of Dorset with a web of roads radiating from it.

It was founded by the Romans in about AD 70. It was then called Durnovaria; Hardy calls it Casterbridge in his novels.

The Bloody Assize of 1685 was held here when the infamous Judge Jefferys was sent to Dorchester to punish the Monmouth Rebels after the battle of Sedgemoor. The Hangman's Cottage, below the prison, is a reminder of when hangings were a frequent event in the town.

The Crown Court in West Street is where the six Tolpuddle Martyrs were sentenced to seven years trans-portation for the 'crime' of trying to achieve a living wage for their families. These farm labourers were trying to form a group known as 'The Friendly Society of Agricultural Labourers'. On the opposite side of the road are the only timber-framed buildings remaining in

Dorchester. Two literary statues watch the town's antics – those of Thomas Hardy and William Barnes. Little remains of Roman Dorchester except the Roman town house and the Walks. The Roman Amphitheatre at Maumbury Rings, sited by the Dorchester South railway station, was in existence 2,000 years before Roman times and was originally a sacred circle or henge of the Late Stone Age. A rare hexagonal letterbox stands at the corner of South Street dating from about 1866. The Napper's Mite in South Street was originally built in 1616 as an almshouse for the poor and aged but is now a restaurant. Poundbury, to the north west of Dorchester, is the location of an ancient earthworks through which the Roman aqueduct came, bringing water from Notton for Dorchester via an open channel. The new development of Poundbury, which lies to the west of the town, was built on prime agricultural land and dominates the skyline.

Edmondsham

Edmondsham is a rural village on the edge of the Cranborne Chase with a plethora of attractive brick houses. Edmondsham House, which dates from 1589, is best-known for its gardens, which are open to the public on Wednesdays and Sundays at 2–5 p.m. between April and October. The pretty church sits a little way from the main village. The village pump, dated 1884, sits in a prominent position at the top of the village underneath a structure of four timbers with a pyramidal tiled roof.

Evershot

Evershot is at the source of the River Frome. It is the second highest village in Dorset, about 700 feet above sea level, and lies to the east of the ancient Wessex Ridgeway. Evershot is an increasingly rare village: not only does it have a church, but it also has a post office and shop, a doctors' surgery, a primary school, a bakery, an inn, a hotel and some light industry. A few centuries ago it also had a weekly market and an annual fair.

In 1865 Evershot suffered a devastating fire after a sustained dry period, which damaged or destroyed up to twenty properties, leaving a hundred people homeless. Thatch was once again the principle reason for the conflagration.

The Acorn Inn once brewed its own ales with water drawn from the source of the River Frome just behind the church. Thomas Hardy was a regular here in 1893 when he was working on the enlargement of the Dower House (now a hotel). Evershot is the Evershead of Thomas Hardy's novels and his most famous heroine, Tess from *Tess of the d'Urbervilles,* had breakfast in a 'cottage by the church', now called Tess Cottage.

During the railway boom in the nineteenth century, Evershot was provided with a halt at Holywell, about two miles away from the village.

Farnham

Farnham is a secluded village full of thatched cottages on the Cranborne Chase. In the centre of the village there is a public house called the Museum, which gives a clue to the history of the village. General Pitt-Rivers, a Victorian soldier and wealthy landowner in the district, who is also considered to be the father of modern archaeology, had a fascination for antiquities. He studied and analyzed these antiquities to discover more about past lives, which he then sought to communicate with anyone who was interested in his ideas and theories. The museum at Farnham, which he built, contained many pieces from Woodcutts, a Romano-British village that he had excavated on the Cranborne Chase. It was an immensely popular tourist attraction at the time. Now, however, the museum is no more; the Pitt-Rivers collection resides with larger museums in Oxford and Salisbury.

Fifehead Neville

Fifehead Neville contains the foundations of a Roman house, which were found nearby. Some of the other remains can be viewed in Dorchester Museum. One of the few surviving packhorse bridges in the country is still intact here and can be seen over the River Divelish, which flows close-by. It has two pointed arches and is medieval in origin. The church dates back to the fifteenth century, and an old twisted yew tree forms an umbrella over the lynch gate. In the churchyard is a very large table tomb – about twenty by fifteen feet and nearly six feet tall. The mother of the Rev. William Barnes lived in this village.

▲ Packhorse bridges, such as this at Fifehead Neville, were often built on trade routes. The sides would be low so that the panniers of the packhorse would not be damaged.

Fleet

The village of Fleet lies close to the lagoon of the same name but most of the village was destroyed by a storm on 23 November 1824, when the sea broke through the Chesil Bank. The storm swept a ninety-five-ton sloop (a sail boat with a single mast) called *Ebenezer* onto the Chesil Bank above the village. It was hauled down to the Fleet Water and then towed to Weymouth. The new church, built further inland to replace the church that was destroyed by the storm, was completed in 1829.

Fleet has been a renowned centre for smuggling over the centuries, which no doubt inspired John Meade Falkner to write his novel *Moonfleet* (1898). It is a tale of smugglers in the eighteenth century based around the Dorset coast.

Fontmell Magna

Fontmell Magna is a large village with meadows and streams on one side and high chalkland down on the other. There is evidence of pre-Roman settlements here. Strip linchets, on the hill above the village, show evidence of early farming practice. In the Domesday Book, the Fontmell Brook is said to have powered three mills. Fontmell Down, an area of great natural beauty to the east of the village, is a nature reserve.

Fontmell Magna's church clock plays a tune every three hours. The church bells are almost certainly from Shaftesbury Abbey. Villagers used to gather under the 'Gossip Tree' in the heart of the village, but it was killed by Dutch Elm disease and was chopped down with much ceremony in 1976. A young lime tree has been planted in its place.

Halstock

Halstock has many interesting past residents, remembered in St Mary's churchyard. The village itself sits astride the Harrow Way, a Neolithic track running from Kent to Devon via Stonehenge. The portion of Harrow

▲ This letterbox is at Barnes Cross, Holwell, which is a remote village in the Blackmore Vale.

Hilton

Hilton is a small, pretty village with a stream, surrounded by wooded hills close to Milton Abbas. The church (All Saints) is rather remarkable as it has many remnants from the destroyed cloister at Milton Abbey.

Holwell

Holwell is made up of two separate settlements. It is best-known for having the oldest letterbox still in use in the country at Barnes Cross. The box was made by John M. Butt & Co. of Gloucester around 1853–56 and has the cipher of Queen Victoria on it. The slot for letters is vertical as opposed to horizontal and the box itself is octagonal.

Ibberton

Ibberton is on the slope of the downs overlooking the Blackmore Vale. It is on the spring line where the clay and chalk meet. It nestles in the lee of Bulbarrow Hill on a tributary of the River Stour and is reached down narrow, wooded, winding roads. The Church of St Eustachius is in a prominent position on the slope of the downs, and is reached by a steep grass path.

Iwerne Minster

Iwerne Minster is a large village that derives its name from the River Iwerne, which is a tributary of the River Stour. Its church is felt by some to be one of the best in the country with an impressive spire that was halved in size in the nineteenth century.

Kimmeridge

The village of Kimmeridge itself is set back from the coast with its cottages and humble church. A toll road continues to the coast where one can see the remains of a stone quay, which was built to deal with the shale trade. Tramways were built down to the jetties, but the quay never paid its way, and it was destroyed in a storm in 1745. However, oil now is produced from a single oil well. The nodding donkey there pumps the oil to the surface and it is apparently the most productive single onshore well in the country.

Lane between Halstock and Corscombe is known as Common Lane. At the Halstock end is a Roman villa, built on the site of an Iron Age farm. Although it has been excavated, it is now completely grown over. The Quiet Woman pub, which is now a private residence, has kept the memory alive of a Halstock woman who in the sixth century was beheaded by her own brother outside the church.

Hammoon

Hammoon is a small low-lying hamlet on the River Stour. A road flanked by willows and liable to flooding crosses the River Stour before entering the hamlet.

Hammoon Manor is arguably one of the most charming manor houses in Dorset. It was built around 1500 and has a thatched roof and Tuscan columns as well as mullioned Tudor windows.

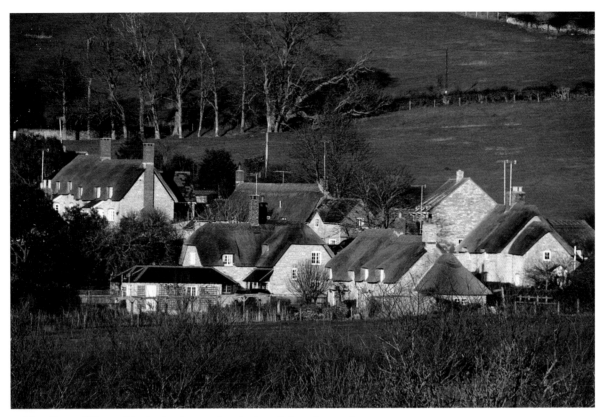

▲ The village of Kimmeridge is about a twenty-minute walk from the coast.

Kimmeridge Beach is a well-known fossil-hunting destination. The Kimmeridge Folly, or Clavel's Tower, is a familiar landmark and was built in 1831. It has recently undergone a complete restoration and was moved inland at the same time to prevent it from falling into the sea due to erosion.

Langton Herring

Langton Herring is a small village a few miles north west of Weymouth. During the Second World War the Essex regiment was billeted here and in the surrounding area. The Bouncing Bomb was tested here in 1942 and 1943, as the Fleet was an ideal location with long stretches of open water. It was also a well-known location for smuggling and smugglers, many of whom ended up as convicts.

Langton Matravers and Worth Matravers

Both Langton Matravers and Worth Matravers are on the Isle of Purbeck. They have been built of grey stone with stone-slated roofs, and both are scarred with quarry workings. At one time there were around 100 quarry mines in the parish, but today there are only a handful of open-cast quarries. The residents of the villages used to be involved with stone quarrying, but now there is an abundance of second homes, with few miners around. Tilly Whim and Winspit are coastal quarry sites nearby from where blocks of stone, in calm weather, would have been lowered from the caves by timber derricks onto waiting craft. Likewise, at Dancing Ledge, the stone was lowered to a large sloping ledge, then carried to a shipment point. Here, the trammels or ruts made by the carts that moved the stone can still be seen.

The church at Worth Matravers is one of the oldest in Dorset. Pretty stone cottages are grouped around a duck pond in the middle of the village, built of stone hewn from Worth's field. The whole area is honeycombed by centuries of quarrying.

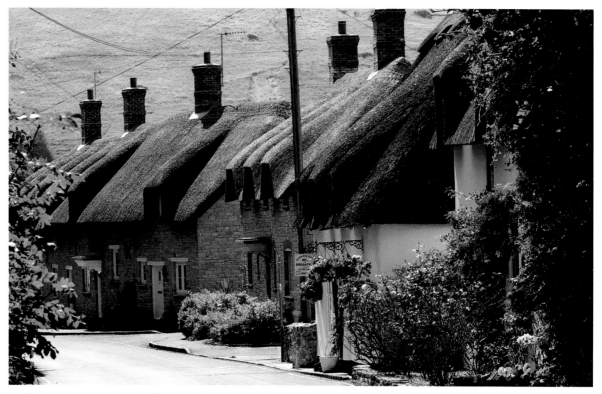

▲ Day trippers at one time could come from Weymouth to Lulworth Cove and West Lulworth by steamer.

Loders

Loders is a pretty little village on the River Asker with a long street lined with stone cottages dating from the seventeenth century. There is a pub and a school, as well as the church of St Mary Magdalene. Loders Court, with its distinctive gardens, surrounds the church.

Long Crichel and Moor Crichel

These villages are situated between the Rivers Gussage and Tarrant. Crichel House is thought to be one of the loveliest residences in the country, reflected in a thirty-acre lake. In 1742, the original house was burnt down and the then-owners removed all the village, except the church, so that the house could be rebuilt in a perfect setting amongst green slopes, terraced gardens and park-land trees. The inhabitants of the village were moved to Newtown to the south. It sounds similar to Milton Abbas (see p. 152)!

The church of Moor Crichel, dedicated to St Mary,

was rebuilt in the nineteenth century in elaborate Italian style. It is said that it contains a brass portrait of Isabel Uvedale who gave her husband thirteen children 'to his joy'.

At Long Crichel, three miles away, a skull found in 1939 had signs of an operation carried out over 4,000 years ago.

East Lulworth

East Lulworth is a pretty little village surrounded by woods. Its castle was completed in 1609 and soon after it was purchased by the Weld family, who still own it today. At that time it was considered to be the best-built Jacobean castle in the country, although it is designed as a hunting lodge and residence rather than a fort, since it has no moat. King George III was a frequent visitor to the castle. The Roman Catholic chapel was the first to be built after the Reformation. The Weld family lived in the castle from 1640 until August 1929, when it was destroyed by fire.

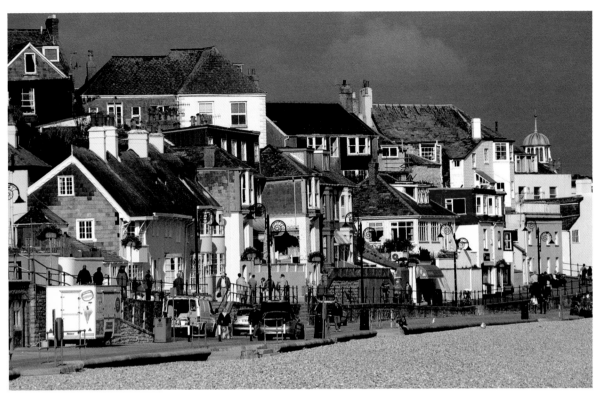

▲ Lyme Regis has been a popular holiday destination for centuries.

West Lulworth

The oldest houses in the quaint honeypot village of West Lulworth are to be found near the cove itself. They are grouped around a freshwater spring and form a spring-line settlement. In the past the villagers depended upon fishing and agriculture and probably some smuggling, but now the tourist trade and army camp support the residents.

To reach the village by road you have to pass the main entrance of the army camp, Gunnery and Tactical School, which is linked to Bovington Camp. The camp was built just after the First World War. Some of the surrounding area has restricted access as tank-firing practice is a regular occurrence. The army ranges extend over some 7,000 acres to the north and east of Lulworth, which is some of the most beautiful countryside and coastline to be seen. There are many barrows and tumuli in the parish as well as Iron Age trenches.

Two literary connections of interest: Keats (1795–1821) spent his last day on English soil at Lulworth in 1820 when his boat the *Maria Crowther*, which was bound for Italy, was becalmed off the cove; it is also said that Rupert Brooke dropped his copy of Keats into the water here.

Lyme Regis

Lyme Regis lies at the mouth of the River Lym and is the most westerly town of the county. It is a market town with a maze of narrow winding streets perched on the side of a cliff. Due to the precipitous surrounding hills the views from Lyme are stunning. Lyme owes its emergence as a port to the construction of the breakwater known as the Cobb, which is 183 metres long and finished in Portland stone. This was built in the late thirteenth century and provided a protection for ships in this hostile stretch of coastline. It also protects the town from erosion by the sea. Edward I gave Lyme its Regis and its first charter in 1284.

Lyme Regis was the landing place of the Duke of Monmouth in 1685 prior to the Battle of Sedgemoor. He was accompanied by (amongst others) *Robinson Crusoe* author Daniel Defoe.

Lyme Regis became a favourite destination for visitors from Bath in the late eighteenth century, including Jane Austen, who recorded her impression of Lyme Regis in *Persuasion*. Indeed, the holiday industry has flourished here ever since.

The town has been used for filming John Fowles' *The French Lieutenant's Woman*. It has also gained fame for the wonderful fossils to be found close by.

After schoolgirl Mary Anning found the first complete specimen of an ichthyosurus here in 1811, the prehistoric discoveries continued. A plesiosaurus followed in 1824, and four years later, Anning found the first pterodactyl in Britain. The cliffs around Lyme Regis are dangerous and landslips are frequent, which results in new fossils being exposed regularly.

Maiden Newton

Maiden Newton has a mixture of old and new buildings and it has been a junction both of rivers and railways. It is on the confluence of the River Frome and the River Hooke, which has already passed through the Tollers. It also has a railway station, which is on the line from Weymouth to Bristol and beyond. Until the latter part of the last century there was a branch line running from here to Bridport, but it was axed in 1975.

The church has some architectural features from Saxon, Norman, early English Gothic, Decorated and finally Perpendicular or Medieval periods. It also bears bullet holes from two conflicts, hundreds of years apart. The Civil War holes are scars from the guns of Cromwell's men in the ancient north door (possibly the oldest door in England, made in 1450 – it has neither a lock nor a latch). A bullet fired from a German aircraft during the Second World War penetrated the window above the altar.

Mapperton

Mapperton is renowned for its manor house and gardens, which nestle in the undulating hills and valleys to the east of Beaminster. It is a small hamlet, but in the seventeenth century it was much larger. Although there has been a church in Mapperton since 1291, the ground is not suitable for burials as it is so hard and stony, which once resulted in the dead being taken to Netherbury for burial. The coffins were carried down Dead Man's Lane. This arrangement was apparently no problem until the bubonic plague hit the population of Mapperton, and the Netherbury folk, fearful of permitting disease-ridden bodies into their churchyard, refused to let the coffins in. (Now Mapperton's dead are generally buried in the churchyard of the nearby village of Melplash.)

Martinstown

Martinstown is a pretty village with just one main street along which the Winterborne, or winter stream, flows. The various barrows close by are evidence that there has been a settlement here for centuries. Being adjacent to the South Dorset Ridgeway there are also examples of strip lynchets nearby. A well-preserved circular sheep-washing pool, which is also a Grade II listed building, can be seen near the pub.

Milton Abbas

Milton Abbas lies on chalk downland and is famous for its row of identical semi-detached houses. They were built like dolls' houses, down either side of a single street.

Originally the old village was situated on green lawns in front of the tenth-century Benedictine abbey. The new model village was created by the arrogant and ruthless Squire Joseph Damer. On purchasing his mansion he decided to re-site the village in an alternative location, as it is today, because he disliked the proximity of the old town to his property. The mansion was built in 1774. It stands together with the abbey in a beautiful wooded valley close to a lake. It is now a public school and was used as one of the settings for the television serial *To Serve Them All Our Days*.

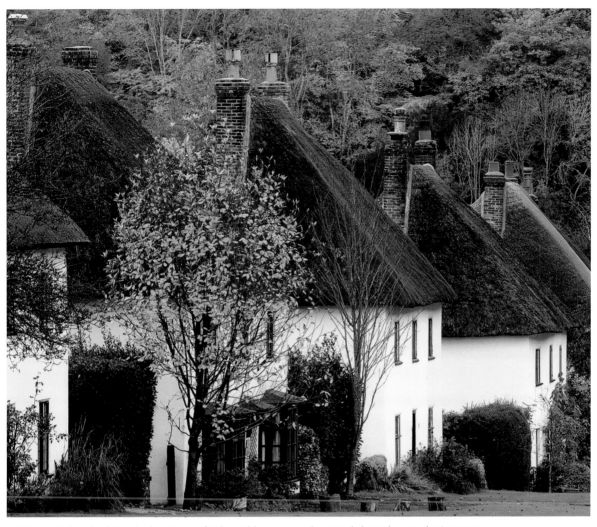

▲ The semi-detached thatched cottages of Milton Abbas are evenly spaced along the one sloping street.

Minterne Magna

Minterne Magna is at the source of the River Cerne and is wedged between some of the highest hills in the Dorset Downs including Telegraph Hill and Dogbury Hill. Minterne House was originally the manor of the Abbey of Cerne until the dissolution of the monasteries in 1939, when it was left to Winchester College. It was then used for educational purposes. It has been the home of the Digby and Churchill families for the last 350 years and is now the home of the twelfth Lord Digby. It sits in the centre of this tiny hamlet, surrounded by its garden of beautiful woodland walks, with a chain of small lakes, waterfalls and streams. It has been used as a location for many films and television programmes.

Moreton

Moreton is a village situated on the River Frome. James Frampton, owner of the manor in 1832, gained notoriety for presiding over and seeking the Tolpuddle Martyrs' transportation to Australia. The village's grey stone church, built in 1776, was damaged by a bomb in 1940: all its windows were destroyed. The five apse windows were subsequently fitted with fine, clear glass engraved by Laurence Whistler. It is possibly the only church in the world where this is the case. All the

◀ ▲ The beauty of the church windows at Moreton is indescribable. They need to be seen in person.

windows are engraved to depict different kinds of light: candlelight, sunlight, jewel-light, starlight and lightning, and are an absolute delight to behold. T.E. Lawrence (Lawrence of Arabia), who used Cloud's Hill near Moreton as a holiday cottage, and who then moved there permanently in 1935, was buried in the churchyard at Moreton after his tragic motorcycle accident in the same year.

Netherbury

Netherbury is a large, attractive village. It was once one of the largest parishes in the county of Dorset. Indeed, Netherbury Church was the mother church of Beaminster, Melplash, Salway Ash and Mapperton until the nineteenth century.

Netherbury is located astride the River Brit, surrounded by several narrow and steep-sided lanes. It has no pub, shop or post office, although in 1900 there

▲ The pub at Osmington Mills was the home of Emmanuel Charles, the leader of a most notorious gang of smugglers.

were five public houses. Before school became compulsory in 1880 (Netherbury Grammar School for boys was one of the first in the county) children between the ages of seven and twelve were recorded as agricultural labourers, thatcher's assistants, ploughboys, mason's labourers, house servants and flax factory workers, these roles no doubt having to supplement the paltry wages of adult farm labourers at that time. The village's workhouse, a thatched three-storey house, can still be seen. Close by is Pilsdon Penn, an Iron Age earthwork nearly a thousand feet tall, which is the second highest point in Dorset.

Osmington

Osmington is an enchanting village built of grey stone. John Constable, the famous English painter, spent part of his honeymoon in the vicarage at Osmington in 1816, and while there he also completed his paintings of Osmington Mills, Weymouth Bay and Portland Bill. His best-known painting of the area is *Weymouth Bay* and it hangs in the National Gallery.

Osmington Mills is the first place travelling east from Weymouth that is accessible by road. The Smuggler's Inn, cosily snuggled in its own little valley, is in an idyllic spot with a stream running down to the sea. The inn is aptly named, as it was once the home of the leader of the most notorious gang of smugglers in the area during the eighteenth and nineteenth centuries.

Poole

Poole Harbour is one of the world's largest natural harbours and today is a thriving Channel port. The mud flats and salt marshes provide feeding grounds and roosting sites for many birds. The commercial port works alongside this sanctuary with cross-channel ferries, cargo vessels, fishing vessels and recreational yachts all managing to bob along together. Historically, as Wareham declined in importance as a port, Poole's

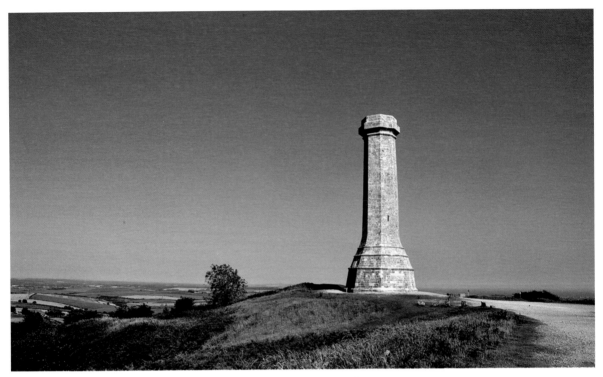

▲ The monument to Sir Thomas Masterman Hardy (1769–1839) was erected in 1844.

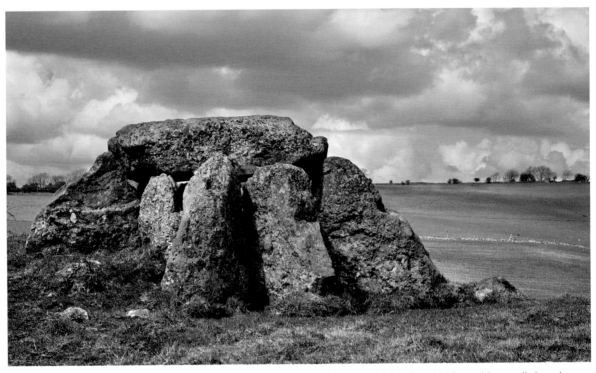

▲ This long barrow on the Ridgeway above Portesham was constructed as a burial chamber, which would normally have been covered with a mound of earth. It consists of nine upright stones supporting a capstone.

▲ The seas around Portland mean that night-time frosts are rare and winters are generally mild.

prosperity grew. In 1248 Poole acquired a charter and it grew rapidly and prospered. The prosperity of the town was largely based on the fishing fleet, which specialized in cod from the distant Newfoundland grounds. The catch would be dried and then shipped to the Caribbean or to Europe, returning with Caribbean rum and sugar, or dried fruit, wine and olive oil from the Mediterranean.

Portesham

Thomas Masterman Hardy (Captain Thomas Hardy) lived at Portesham from when he was nine years old. He was one of Lord Nelson's commanders at the Battle of Trafalgar (1805) on his flagship *The Victory*. He is commemorated by a monument on Black Down – Hardy's Monument – which towers above the village as well as being visible from miles around.

The church of St Peter in Portesham contains the unusual tomb of William Weare. He wished to be buried neither in the church nor out of the church, so his tomb is half outside the church, with the other half inside!

The Ridgeway above Portesham is riddled with many ancient monuments and earthworks. The Grey Mare and her Colts is a long barrow. It was built nearly 6,000 years ago to bury an early resident of the Ridgeway. Then there is a nearby cromlech, or dolmen, called the Hell Stone, which is at least 5,000 years old and is an example of a chambered long barrow with a stone interior. It is said that the devil flung it from Portland Pike as he was playing quoits.

Portland

Portland is a tied island joined to the mainland by Chesil Beach. Chesil means pebble and at Portland the Chesil Bank is forty feet high and 600 feet wide at its base. Portland is four and a half miles long and one and three-quarter miles wide and is considered by some to be rather bleak with its precipitous cliffs. It is world-famous for its stone, which is scattered all over the island in a disorganized and shambolic fashion. The population of Portland grew rapidly in size in the nineteenth century because of the prison, the military

▲ A walk on Eggardon Hill, an Iron Age hill fort on top of the world, is an uplifting experience.

establishments and the prosperity of the quarries. In 1801 the population was 1,619 and a hundred years later in 1901 it was 15,199.

There are eight settlements on the 'island': Fortuneswell, Easton, Chiswell, Wakeham, Southwell, Castletown, Weston and the Grove.

Powerstock

Powerstock is a remote village with two well-known pubs. It lies in the beautiful hills of west Dorset with the River Mangerton running through the valley. It used to have a railway station (at Nettlecombe across the valley) but that line was shut in 1975. Powerstock Forest was a royal hunting forest in the eleventh century where the monarchy and aristocracy held certain rights. Eggardon Hill, an Iron Age hill fort, is a short distance away. From it, magnificent views of the west Dorset landscape can be seen.

Puddletown

Puddletown lies on the River Piddle at a crossroads. It was once known as Piddletown. It is well used by Hardy in his writing as Weatherbury. Athelhampton House is close by on the old A35.

Shaftesbury

Shaftesbury used to be called Shaston and is like a crown on a hilltop. It is one of the highest towns in England, standing at over 700 feet above sea level on a high ridge of upper greensand. It is unique in Dorset as most of the towns are built along river valleys or at their mouths. The town was founded by Alfred the Great. He built its ancient abbey (now in ruins), and his daughter was its first abbess.

Shaftesbury's Saxon hilltop settlement was no doubt built there because of the location's commanding position with limitless views over the Blackmore Vale. Nearby Gold Hill is an ancient cobbled street that has been featured in many calendars.

▲ Hardy had many family associations with Stinsford Church and he regarded it as a very special place.

King Edward the Martyr's remains were eventually buried in Shaftesbury Abbey and for many years Shaftesbury was a town of pilgrimage due to the belief that King Edward's tomb had healing properties.

Sherborne

Sherborne is probably the most attractive town in the county with its mellow stone buildings. It is a market town with a railway station and an awe-inspiring abbey. The abbey started as a Saxon cathedral, when it was the seat of the Bishop of Wessex, then in 998 the cathedral became a Benedictine abbey until the dissolution of the monasteries in 1539. It was finally bought by the people of Sherborne in the 1540s, and remains their parish church. It continues to be a feature of the town to this day. For many, this beautiful church is the cathedral of Dorset. After the dissolution of the monasteries, the monastic buildings became Edward VI's Sherborne

School and his crest can be seen both at the entrance to the school and on part of the abbey church. The Conduit, which was built as a lavatorium or washing place for the monks in the cloister of the abbey in the early sixteenth century, was moved after the dissolution to form a small market house.

The town has a plethora of historic buildings including almshouses, castles, schools and silk mills. Sir Walter Raleigh was given the old castle by Elizabeth I in 1592, but as it was so cold Raleigh built a small manor in the park, which is now known as Sherborne Castle.

Stinsford

Stinsford is a tiny village just outside Dorchester. Many generations of Hardys lie buried in the churchyard. Thomas Hardy's heart is buried here in a grave with his first wife, Emma, beneath a tree in St Michael's churchyard. Stinsford is Hardy's Mellstock in *Under the Greenwood Tree*. It also contains the grave of C. Day-Lewis, novelist, poet, literary critic and lay theologian, who died in 1972. He was a great admirer of Hardy and wished to be buried as close as possible to Hardy's grave.

Studland

Studland is a very old settlement with many Roman and Bronze Age burial sites. The nearby Studland and Godlingston Heaths are both National Nature Reserves, owned and managed by the National Trust. The wide, sandy beaches of Studland are some of the most popular in Britain, and provide possibly the safest swimming in Dorset. The church of Saint Nicholas, which is the only virtually complete Norman church in Dorset or indeed the country, is dedicated to the patron saint of sailors. The present building is almost entirely twelfth century and the square tower appears unfinished. It has been suggested that smugglers used this church for the storage of contraband in the eighteenth century. There is a grove of yew trees in the churchyard, one of which is believed to be 500 years old. The sloping churchyard offers a wondrous view of the cliffs to Ballard Down. The Agglestone, north east of the village, is said to have arrived here because the devil was throwing stones at Old Harry from the Isle of Wight.

▲ The Agglestone is a great lump of sandstone perched in the middle of Studland Heath.

Sutton Poyntz

Sutton Poyntz is a small distance from Weymouth and is surrounded by a variety of hills. The River Jordan is at the centre of this small picturesque village. It emerges at the base of a steep scarp, which has contributed to there being a settlement here for thousands of years. The river, which is Weymouth's principal water supply, emerges through a geological fault line at the base of the South Dorset Ridgeway, having filtered through the chalk of the downs.

The village is steeped in history: archaeology has uncovered evidence from the Neolithic, Bronze Age, Iron Age and Roman periods. The river made it an ideal place for milling, and the millpond has created a beauty spot particularly enjoyed by ducks. It is the Overcombe of Hardy's novel *The Trumpet Major*.

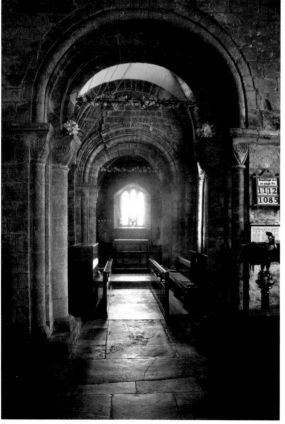

◄ Under the eaves of Studland Church there are many Sheela Na Gigs – quasi-erotic stone carvings – usually found on buildings of Norman origin.

▲ Swanage has many historic buildings as well as having a superb sandy beach for a traditional family holiday.

Swanage

Swanage is a town on the Isle of Purbeck and was a great smuggling centre and fishing port. It was also a stone shipping port, exporting stone from the local quarries by ship. In 1859 a tramway replaced the moving of stones from carts to barges, thus eliminating an inefficient system. The tramway went from the 'bankes' to the pier. A second pier was built in 1896; this was used by pleasure steamers visiting the great seaside resort. After the railway came in 1885 the holiday destination expanded, and much of the quarried stone was then sent out by train. The railway was closed in 1972. Fortunately it is now back in operation, with the Swanage Railway Company running steam trains from Swanage to Norden and back. Since 2009, locomotives from Network Rail have been able to visit.

Near St Mary's Church, at the Mill Pond, Church Hill, are some of the most picturesque cottages, which originally housed quarrymen and fishermen. One of these quarrymen was responsible for the cutting of the Great Globe, a forty-ton block made up of eight sections of Portland stone upon which is a map of the globe. Around the globe are slabs representing the eight points of the compass and other slabs provide relevant astral information. It is reached by a path from Durlston Head.

Sydling St Nicholas

Sydling St Nicholas is a charming village with ancient thatched cottages and tiny connecting bridges lining the banks of the little Sydling Water. Sydling Water, a chalk stream, is a tributary of the River Frome and joins it at Grimstone. Watercress is grown nearby, about a mile from the village.

There is a fireplace in the church porch where parish meetings were apparently once held. The font is possibly over 1,000 years old and the clock, which is dated 1593, is said to be one of the oldest in England. It is faceless but strikes the hour. The yew trees in the churchyard are also said to be over 1,000 years old. The millstone grave in the churchyard marks the death of the last miller in Sydling.

▲ The last miller of Sydling died in 1926.

The spreading chestnut tree in the middle of the village is a focal point and was probably planted in 1881. Some of the house names provide evidence of past activities – Bakery, Brewery and East House (East India Company). The old bakery and brewery are protected buildings.

Tarrants – Gunville, Monkton, Launceston, Rawston, Rushton, Hinton, Keyneston and Crawford

Tarrant Gunville is at the source of the River Tarrant. The river empties into the Stour at Tarrant Crawford where there is a nine-arched bridge as well as a Norman church with wall paintings still visible. Crawford is now a tiny place, but was obviously of much greater importance when the small monastery was founded. There is a ford at Tarrant Monkton along with many traditional thatch and cobb cottages. Tarrant Rushton has an ancient church which is shaped like a cross with all four arms of equal length. The church at Tarrant Hinton has

▲ The River Tarrant is a tributary of the River Stour.

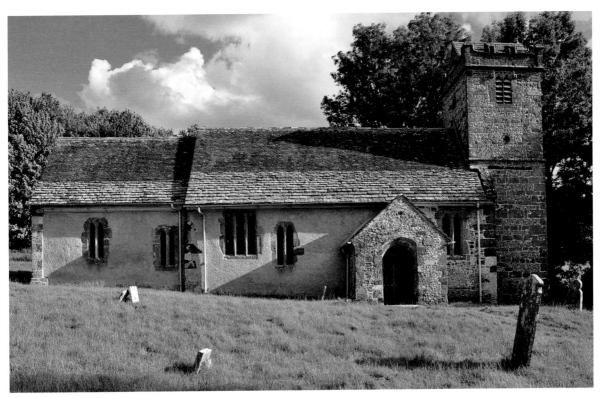

▲ Inside the church at Tarrant Crawford, there is a series of fourteenth-century wall paintings.

many interesting features, including a 1909 Art Nouveau lectern made from brass and iron. Tarrant Hinton is the venue for the Great Dorset Steam Fair. This whole valley is an unspoilt, agricultural landscape with sheep on the downs and mixed farming in the lower-lying areas.

Toller Porcorum and Toller Fratrum

These two villages are on the banks of the River Hooke (once known as the River Toller). Toller Porcorum was also known as Swine's Toller due to the number of pigs that were bred here. From 1862 to 1975 the village of Toller Porcorum had a railway station on the Bridport line. Toller Fratrum lies at the close of a dead-end road with a beautiful manor house and farm buildings at the end. Its church, dedicated to Basil the Great, has an interesting cylindrical font, covered with simple figures and a two-bodied monster. It dates from the twelfth century, as does the fragment of carved stone that shows Mary Magdalene washing the feet of Christ. The

granary stands on traditional staddle stones. The landscape around Toller is influenced by the traditional farming methods that have been used here for years: arable farming on the upland and a network of small fields with dense hedged boundaries on the valley slopes.

Tolpuddle

This small village is on the River Piddle. It came to fame when a group of six local labourers banded together to make a pact beneath a giant sycamore tree. They decided to ask for an extra three shillings a week at a time when wages were to be reduced by a shilling. These good men, who had deep Christian beliefs, were trying to 'save their families from starvation and degradation'. They formed the Friendly Society of Agricultural Labourers. For their activities, George Loveless and his five companions were sentenced by a judge to transportation to a penal colony in Australia for seven years, 'not for anything they had done, or intended to do, but as an example to others'.

▲ Staddle stones, such as this from Toller Fratrum, were generally used to raise a granary off the ground, thereby protecting the corn from moisture and vermin.

The harrowing story of the Tolpuddle Martyrs can be seen in the museum in the village. The name of this village now reverberates around the world in the well-established trades union movement.

Tyneham

Tyneham was taken over as part of a tank firing range just before the beginning of the Second World War. The residents were given one month's notice to leave; all 225 were evacuated in December 1943, never to return to their homes. This ruined and derelict village is open at certain times of the year, when the firing range is not in use. A glimpse of the history of the village can be seen in both the old schoolroom, which is preserved as if the children had just left, and the church, which doubles as a museum.

Upwey

Upwey is a pretty little village with a river meandering through it. It is also a suburb of the town of Weymouth. The River Wey's source is here. The spring, known as Upwey Wishing Well, can be seen in a damp dell, and has been a tourist attraction since Victorian times. The little church is fifteenth-century and very beautiful. You pass it as you climb the long winding hill to the Ridgeway, where you will find commanding views of Portland. It was from this spot that Thomas Hardy wrote the opening scene of *The Dynasts*.

Wareham

Wareham lies between the Rivers Piddle and Frome. It was once the centre of the Isle of Purbeck and a very important port up until 1347. Its importance dwindled as the silt prevented the port from accommodating larger boats and Poole then took over in significance. The quay is now used for pleasure boats to Poole Harbour.

Wareham has a long history of warfare with attacks and defences influencing how the town has grown up. It was a Roman settlement but grew to its greatest importance in Saxon times, when it was repeatedly ravaged by the Danes. King Alfred developed a policy of town planning that was based on fortifications. The impressive earth walls were built around Wareham in this period. Fire has also influenced the present day town: in 1762, when about two-thirds of the town was destroyed by fire, strict instructions were given that thatch was not to be used in the rebuild.

The oldest church in Wareham is St Martin's, which is of Saxon origin and which remains largely in its original state. The chancel arch is more than 1,000 years old. The church also houses an effigy of Lawrence of Arabia by Eric Kennington. It was originally designed to be in Salisbury Cathedral.

The church of Lady St Mary was also Saxon in origin although much was replaced in 1846. It contains a hexagonal font bowl on an octagonal base, which is unique.

▲ The derelict village of Tyneham is now managed by the Ministry of Defence and access is limited.

West Bay

West Bay is a curious name since the coast here is harbourless, with no bay or shelter. The port itself has also silted up rather easily in the past. All through its history the harbour has had to struggle against the elements – the south-westerly winds and the high tides – yet it managed to import hemp and flax from Russia and timber from Scandinavia. It has also been the centre of much boat-building over the centuries. It is now used on a small scale commercially as well as being a tourist attraction. It seems to be used regularly for television programmes.

▲ West Bay has been the location for TV dramas including *Harbour Lights* and *Broadchurch*.

West Stafford

West Stafford is a pretty village that lies on the South Winterborne in the Frome Valley. Hardy refers to West Stafford as Talbothayes and the local church is where the fictitious wedding of Tess to Angel Clare took place in *Tess of the D'Urbervilles*. East of the parish lies Talbothays Lodge and cottages that Hardy designed for his sisters to live in. Indeed, his siblings, Mary, Henry and Kate were living there at the time of Mary's death in 1915.

Woodsford Castle, a large thatched, once-fortified farmhouse, was built near the village in 1337 and has walls six feet thick.

Weymouth and Melcombe Regis

Both Weymouth and Melcombe Regis towns came into existence as ports in the middle of the thirteenth century with Weymouth on the south side of the river and Melcombe Regis occupying the land to the north (the seaside section and the town centre). They were once two separate places, their boundary being the harbour, and there was much feuding between them. These two boroughs, after years of bickering and incessant quarrelling over shipping and harbour dues, were merged administratively by a charter in 1571, in the reign of Elizabeth I. Earlier, there had been a Roman port and harbour at Radipole on the River Wey, up the estuary from the present town, which was the port for Maiden Castle. At the time of the Domesday survey, Radipole was no more than a small manor of Cerne Abbey and there is no mention of any port.

Both ports prospered during the years before the Black Death of 1348–9 and became major exporters of wool, but both were hit badly by the plague, which started at Melcombe Regis and wrought havoc in the towns.

▲ The row of almshouses in Wimborne St Giles was built in 1624.

The new fashion of sea bathing revived Weymouth's fortunes in the eighteenth century; the first bathing machines were established in 1748. With the visits of George III from 1789 the town became very fashionable and it began to be developed as a tourist destination. With the arrival of the railway in 1857, the town's success as a resort was secured and continues to this day.

All Saints Church at Wyke Regis was the mother church to Weymouth and served the people of the port for many years until Holy Trinity was built in 1836. All Saints Church has a huge cemetery where the remains of scores of victims of shipwrecks on the Chesil Bank lie, including Captain John Wordsworth, brother of the poet William Wordsworth.

Wimborne St Giles

The village of Wimborne St Giles is clustered around a wide green with alms-houses next to the church and park gates. The River Allen runs through the park, which contains a large lake and an avenue of beech trees 1,000 yards long, leading up to St Giles House, the Elizabethan home of the Earls of Shaftesbury. Anthony Ashley-Cooper, the Seventh Earl of Shaftesbury, was one of the great social reformers of the nineteenth century, attacking the social system of Victorian England that forced women and children to work in factories and mines in terrible conditions. He became MP for Woodstock in 1826, standing as a Tory. He married Lady Emily, daughter of Lord Cowper, in June 1830. He died in 1885 after a lifetime of working for the improvement of social conditions for the poor and vulnerable. His funeral service was at Westminster Abbey but the coffin was then brought to Wimborne St Giles, where he is buried. The church itself is full of splendid monuments and ornate fixtures. It was rebuilt in 1732, Gothicized in 1887 and then restored in 1908 after a fire.

Winterborne Came and Whitcombe

The parish of Winterborne Came and Whitcombe is well known for its connections with the Dorset dialect poet William Barnes, who was rector here for twenty-four years until his death in 1886. Barnes – a close friend of Thomas Hardy – preached his first (1847) and last (1885)

▲ The church at Winterborne Tomson is one of the smallest in the county and its walls appear to bow outwards.

sermons at Whitcombe, in the little church, which has no dedication and is now redundant but not quite abandoned, unlike the string of deserted settlements along the south Winterbourne Valley. These settlements were gradually abandoned during the fifteenth and sixteenth centuries as the landlords turned over the land to large-scale sheep farming, which resulted in tenants being unable to cultivate their land or pay their rent. William Barnes is buried at Winterborne Came churchyard, in a simple grave marked by a large cross.

Winterbourne Steepleton

The church here is one of only two in Dorset with an ancient steeple (or three if you include Trent, which is now in Dorset but was once in Somerset). It is believed that in times past it housed a community of clergy, hence its rather grand church and, of course, its name, Winterbourne Steepleton.

Winterborne Tomson

This is a tiny hamlet that could easily be missed by a passing visitor. The small church, which was once in danger of becoming part of the farmyard, is simple and enchanting. It was carefully restored by Albert Reginald Powys in memory of Thomas Hardy, between 1929 and 1931. A.R. Powys (another of the eleven Powys siblings) was Secretary of the Society for the Protection of Ancient Buildings and published a number of books on architectural subjects. He died in 1936 and is buried in the churchyard.

The money for the church's restoration was raised by selling a collection of Thomas Hardy's manuscripts, which had been held by the Society for the Protection of Ancient Buildings. The church contains a plastered barrel-vaulted wagon roof with oak ribs, high pew boxes and a singing gallery. It is now redundant and stands in a grassy yard.

Conclusion – Dorset in the Future

Some things we have no control over. The erosion of the Dorset coast, which has been going on for millions of years, will continue into the future. Dorset's sheer cliffs may appear to be stable, but they are constantly being battered by the wind, rain and sea, resulting in frequent landslides and rock falls. For example, the remains of the stack next to Old Harry fell in 1896 and at some time in the future Old Harry will also topple into the sea. Handfast Point (also known as 'No-man's Land') was connected to the mainland as recently as 1770, and will itself eventually be divided into smaller chalk stacks. We know that during the Iron Age the coast of Dorset was approximately one mile further into the English Channel. On that basis, the likelihood is that in just a few thousand years, the coast will be one mile further inland with villages like Burton Bradstock and West Lulworth under the sea.

At the same time, mankind seems to have little appetite to control its impact on the Earth, with problems such as global warming going largely unchecked. We can only guess at what climatic horrors might be in store for future generations. The visible landscape is also being altered by man, often permanently, with wind farms appearing and industrial estates being built on green-field sites and even on prominent hills, like Gore Cross in west Dorset.

Unless we understand the impact we have on our environment as individuals we will be powerless to protect and conserve what is special. For example, understanding that certain introduced plants are invasive and problematic, such as Indian balsam, perri-perri bur and giant hogweed, would be a first step in solving our homemade problems. The Spanish bluebell is being actively encouraged in many Dorset gardens, because many people are unaware of the danger these aliens pose to our native bluebells. Likewise, the pearl-bordered fritillary and the high brown fritillary butterflies have become extinct in the county, while others are declining. The large garden bumblebee has gone from our gardens and only one wild asparagus plant remains in Dorset. The tree sparrow, as a breeding bird, is also extinct in Dorset. Most of our wildlife nationally is declining. We cannot afford to leave this mess to future generations to look after because unless we can stem the tide of decline, there will be very little for them to care for.

However, as the variety of butterflies that once occurred in Dorset diminishes, we could yet see the arrival of more exotic species from the south as the climate continues to warm up. It is, after all, from North Africa that the painted lady migrates each year. On the other hand, we may also see the arrival of such diseases as malaria, which is spread by insects.

The Dorset landscape could be changed irrevocably unless we decide what is important for us, and the future of the county. There still remain great areas of charm and beauty and many places where historic continuity and development can be observed. Spectacular views, archaeological remains, a profusion of manor houses, farmhouses and cottages are treasures that need to be treated sympathetically. Can we combine efficient industry, agriculture, leisure pursuits and homes in conjunction with the preservation of Dorset's unique historical and natural heritage?

With the backdrop of both nature and man eroding Dorset's natural and man-made heritage, how can we decide what should be conserved and protected? Some difficult decisions will need to be made. What do we actually need? What do we desire for our county and its

people in the years to come? What will actually improve our quality of life? Or has 'what we want now' become the driving force? Will the growing population of Dorset be able to live in harmony alongside the natural and cultural heritage we have inherited?

The Dorset Area of Outstanding Natural Beauty partnership works tirelessly to champion Dorset's heritage, history and holistic well-being, and to keep this county a special place. But it doesn't just protect the area from the pressures and challenges of modern living. The AONB partnership also seeks to maintain the landscape as a working and living environment for the benefit of all. The local economy, wildlife, human health and our well-being are all important issues to the AONB and all need to be finely balanced. The AONB partnership have set up and lead many local projects that are enhancing Dorset and our everyday lives – from the Woodlink initiatives to programmes to help us all learn about these amazing landscapes, to ensuring rural skills don't die out by giving training and grants to advising on water power projects, and more. Much of their work revolves around what local communities wish to develop: community orchards, craft skills, green buildings, restoring local traditional fingerposts – all of which develop the local community and keep it vibrant.

Dorset does not have any big centres of population, away from the conurbations of Poole and Bournemouth. Small pockets of population seem to suit it best. Travel in the county is frustrating, but it is one of the reasons why Dorset has remained relatively untainted, with no motorway. Should we therefore be celebrating small, and embrace that concept?

The only way to really get to know Dorset is on foot, and is this not the best way? If we do not know our environment we will not be able to understand the importance of it. The future must be one of hope: that the people of Dorset can enjoy living and working in the county alongside the preservation of its natural beauty, wildlife and historical heritage. With our desire to enjoy what Dorset has to offer comes the responsibility for us all to look after its splendour and diversity, and to uphold its beauty for future generations.

It seems evident that the unique and beautiful county of Dorset is ours to damage or to enhance and preserve. Our value systems today will be responsible for the environment of Dorset tomorrow. We have choices. Let's hope we use them wisely. Long may the Area of Outstanding Natural Beauty partnership help us to respect and enjoy this magnificent landscape and to safeguard it for future generations.

Index

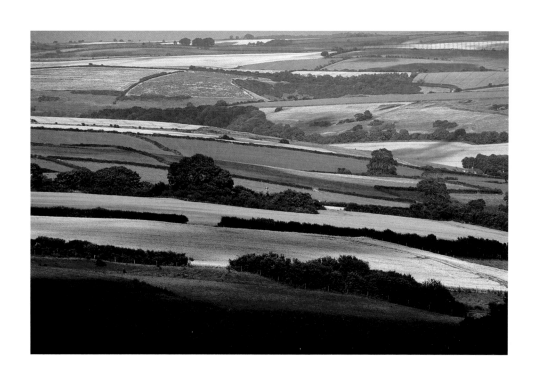